NORTHWESTERN WILDCAT FOOTBALL

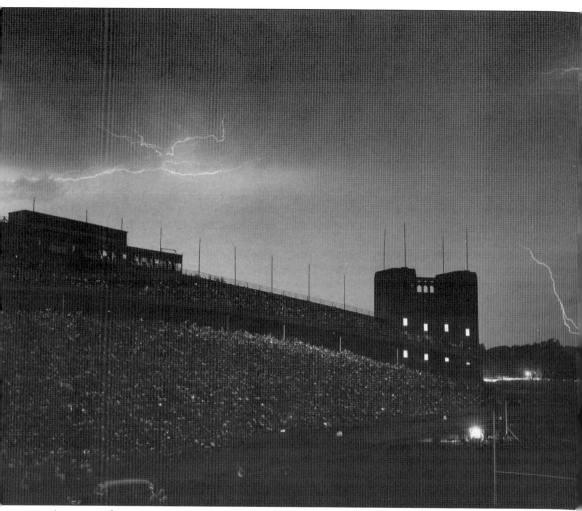

An approaching storm gives venerable Dyche Stadium a grand but ominous appearance during a game in 1953. Dyche Stadium, later renamed Ryan Field, has been home to the Wildcats since 1926.

(*front cover, top*) Otto Graham runs against Notre Dame at Dyche Stadium, November 13, 1943. Graham was Northwestern's leading rusher and passer that season. He went on to break every Big Ten passing record kept at the time. Northwestern has named Graham the university's greatest football player ever.

(*front cover, bottom*) Quarterback Steve Schnur scrambles for yards against the University of Southern California in the Rose Bowl, January 1, 1996. Schnur scored one rushing touchdown against the Trojans and threw for 336 yards. It was Northwestern's first bowl game since 1949.

(*back cover*)Players and fans celebrate wildly at Ryan Field following NU's win against Ohio State on October 2, 2004. The sellout crowd of 47,130 watched the Wildcats and the seventh-ranked Buckeyes battle to overtime in a thrilling night game.

NORTHWESTERN WILDCAT FOOTBALL

Larry LaTourette

ARCADIA

Published by Arcadia Publishing
Charleston SC, Chicago IL, Portsmouth NH, San Francisco CA

Printed in Great Britain

Library of Congress Catalog Card Number: 2005927508

For all general information contact Arcadia Publishing at:
Telephone 843-853-2070
Fax 843-853-0044
E-mail sales@arcadiapublishing.com
For customer service and orders:
Toll-Free 1-888-313-2665

Visit us on the internet at http://www.arcadiapublishing.com

CONTENTS

ACKNOWLEDGMENTS

I would like to thank the Northwestern University Archives for the bulk of the images used in this book. University Archivist Patrick Quinn and his staff—Allen Streicker, Janet Olson, and Kevin Leonard—enthusiastically supported this project and provided me with a wealth of research materials. Northwestern athletic director Mark Murphy and the Athletic Department's Media Services Office, especially Chris Boyer and Mike Wolf, also provided valuable assistance. I'm deeply grateful for the materials, assistance, and advice I received from Matt Sampson, Jerry Lai, Jim Davidson, Bob Cox, Mike Andler, and Stephen Carrera. I am very appreciative to Arcadia Publishing for wanting to tell the story of Northwestern Football in the first place.

Most of all I'd like to thank Carissa, whose advice, patience, and understanding made writing this not only possible, but rewarding. I dedicate the book to her.

PHOTO CREDITS

The following photographs are published courtesy of the Northwestern University Archives: Cover Background; Front Cover (Top); Front Cover (Bottom); page 2; all photographs, pages 18 through 117; page 118 (bottom left); page 119 (top); all photographs, page 120; page 121 (top).

Photographs courtesy of the Media Services Office, Northwestern University Athletic Department: page 121 (bottom), page 123 (bottom).

Photographs by S. J. Carrera, Inc.: page 122-123 (top), page 122 (bottom), page 124 (top), page 125 (top and bottom), page 126 (bottom).

Photographs by Jim Davidson for theozone.net: Back Cover, page 126 (top).

Photographs reproduced courtesy of General Mills: page 119 (bottom). WHEATIES ® is a trademark of General Mills and is used with permission.

Photographs by Matt Sampson: page 118 (top and bottom right).

Photograph courtesy of Jerry Lai: page 124 (bottom).

INTRODUCTION

"Victories that are easy are cheap. Those only are worth having which come as the result of hard fighting."

—Henry Ward Beecher

Not many teams in college football have fought as hard for their victories as Northwestern University. The Northwestern Wildcats have fought the good fight while remaining students first and foremost. They have maintained throughout their history the academic tradition that has truly "spread far the fame of their fair name." Soon after he came to Northwestern, athletic director Mark Murphy explained why he took the job: "The chance to really be a role model nationally for schools and show that you don't have to sacrifice your academic standards excites me. You can have student-athletes that are legitimate students and graduate about the same rate as the overall student body and still have great success."[1]

There have been times that the university's academic level became an easy excuse for not winning. Recent success, however, has disabused anyone of the idea the Wildcats are not capable of competing with any team in the country, given the right motivation and tools. It has also changed the way the NU football program is judged. "We're not going to measure our program by playing good or improvements. You measure your program by wins and losses," Coach Randy Walker said a couple of seasons ago. "This is Big Ten football, it isn't the intramural program."[2]

Walker is also very mindful, however, that his Big Ten players are students and are under tremendous academic pressure. Walker has joked that he can recite each of his players' GPAs faster than their 40 times. A couple of years ago he pulled one player from spring practice so that the player could work exclusively on his studies, even though the player was still academically eligible to practice.

It is in this environment—very high scholastic expectations, rigorous recruitment eligibility standards, and a small, private university standing toe-to-toe with the rest of the schools of the Big Ten—that the Wildcats fight. Maybe surprisingly, maybe not, they have been able to fight and win—or at least compete—for much of their history.

Northwestern's history on the football field extends further back than any other school in the Big Ten, to anarchic games played in the 1870s and 1880s. The team played on mud fields in Evanston, at Wrigley Field, and even at the Chicago Stock Yard. As football in the Midwest began to form its distinctive "smashmouth" style, Northwestern's team also took shape. It was a group of players who came to the school to learn, but discovered and passionately pursued football once they arrived.

Walter Dill Scott was one such player. Lacking the stature of a football player, Scott made up for his physical limitations with his shrewdness and fierce courage on the field. Early in the 1892 season Scott broke his hand. Rather than quit, he wore a boxing glove the rest of the season and helped defeat the University of Michigan in the first-ever game between the two schools. Scott was also an outstanding scholar and went on to become president of Northwestern. He served as president for most of the 1920s, helped spearhead the football program's resurgence during that decade, and often led cheers at Dyche Stadium. Players like Scott, men who might not, at first, have seemed like ideal football stars, but who persevered because of determination, have comprised the core of the Wildcats from the beginning.

There are, of course, so many other players who have brought honor to the Purple uniform, through great victories or, like Scott, by how they played the game. NFL Hall of Famers Paddy Driscoll and Otto Graham, along with the likes of Moon Baker, Ron Burton, Mike Adamle, Darnell Autry, Pat Fitzgerald, Damien Anderson and a host of others have forged countless

moments of greatness that caused generations of crowds to fill the stadium on Central Street with cheering and songs. This book is a history of Northwestern Wildcat Football—it isn't *the* history, and it leaves out more of the great Wildcat players and moments than it should. This story could easily fill five or more books this size.

The team has used many slogans and catch phrases over the years. Probably the most famous slogan the 'Cats have used was Gary Barnett's "Expect Victory." But one of the more recent slogans, and one of the simplest, might do the best job of encapsulating Northwestern Wildcat Football: Trust. When the trust in the team has waned, so have the program's fortunes. Throughout the history of the program, it has been at the times when the university administration, the coaching staff, the players, and the other Northwestern students all trusted in the team that NU has had its greatest success. When the school and the school's leaders put their trust in the team, and the team trusts itself and its coaches, the results have been thrilling, and the victories—always hard-fought—rewarding.

ONE
The Methodists Fight
1876–1905

Northwestern football did not start on a crisp autumn Saturday morning, but on a freezing Tuesday afternoon in February. When Northwestern University students played their first game of American football, on February 22, 1876, the telephone had not yet been patented, General George Armstrong Custer still led the Seventh Cavalry, and nearby Chicago was still rebuilding from the fire that destroyed most of the city four years earlier. Northwestern was a small Methodist school on whose grounds cattle still grazed.

The first football game played at Northwestern, between the university and the newly-formed Chicago Football Club, was one of the earliest played in the Midwest—three years before football was introduced at the University of Michigan, eleven years before Notre Dame began to play, and only six and a half years after Rutgers and Princeton played the first recognized football game. In fact, rules for American football were not documented until later in 1876, at the sport's Massasoit convention. The Northwestern game was sufficient enough a novelty to be covered by the *Chicago Tribune*:

> Yesterday the *Chicago Football Club* visited Evanston to play a game against the Northwestern University students. The game was something new to the University men, and no preparation had been made for the visitors in the way of laying out the playing field. Added to this, the ground was frozen so hard that neither goal-posts or line-stakes could be set up. It was finally agreed to let the University play twenty men against the Chicago team of fifteen, and get along the best way possible under the circumstances.
>
> At 3:15 the game was called, the Chicago captain kicking off. The college men were evidently at sea in regard to the game, for they let Hornsby follow the ball up, and his next kick took it across the line, enabling him to get a touchdown. The try at goal was successful-first to the Chicago. The second goal was a longer tussle, but finally Curtis got the ball, and after a good run touched it down. Hornsby again scored a goal from the place kick. By this time the home players were picking up some of the points of the game, and their greater number made it difficult for the Chicago men to get through such a crowded field.
>
> The game was prolonged a quarter of an hour over the hour agreed upon, and when called the score stood 3 goals for Chicago, to nothing for the University. The latter, though beaten, have some good material to make a team from if they will practice the game under the rules. . . . "[1]

The *Chicago Times* reported that "because of the inability to anchor the goal posts, the novel plan of holding them in position was adopted." The university players were given the choice of goals to defend at the beginning of the game, and they chose to kick with the wind. The *Times* noted also that after Chicago's second goal, the university rallied, and that "of the Evanston men, Asher showed great running form and Kinman played well."[2]

The *Tripod*, the school's newspaper at the time, reported two days later that, "The trial game of football on Tuesday last enthused the boys so much that they formed a Foot Ball Association and intend to give those representatives of [the Chicago Football Club] a hard time to beat them in a scrimmage when they come here again. The officers are F.F. Casseday, Pres't; Ed. Kinman, Vice Pres't; W.L. Brown, Sec'y; E. Monroe, Treas." [3] These four students, along with Asher (the player mentioned by the *Times*) are the earliest known representatives of Northwestern football.

The Northwestern Football Association continued playing for the rest of the 1876 school year, and intramural football games became very popular. On April 27, the *Tripod* stated, "Bandaged heads, broken fingers and shins are becoming fashionable since the advent of the foot-ball mania in our midst." By the end of 1877, The *Vidette* (another early school newspaper) reported that "Foot-ball is raging these days. . . . 'Rough and tumble foot-ball is nightly being engaged upon the campus.'"

The school, however, was growing frustrated with the lack of football games against teams from outside the school. In October 1878, The *Vidette* asked, "Why can we not get up a foot-ball team for those Racine [College] men?" In 1879, the students formed the first varsity football club and likely played a game against Evanston High School (the forerunner to Evanston Township High). The team had finally scheduled a game against Racine College, but eventually canceled it. The following year NU played Lake View High School, but the game was called after only one half was played. Several more games in 1881 were slated, but canceled, including one with Michigan.

By 1882, interest in football had increased on Northwestern's campus, and the NU players accepted a challenge from nearby Lake Forest College. Northwestern played its first intercollegiate football game on November 11, 1882. The *Northwestern*, another precursor to the *Daily Northwestern*, recounted the team's first intercollegiate season a couple of weeks later:

> *By the strenuous efforts of a few lovers of the sport, our boys are now able to play a very respectable foot-ball game, according to the Inter-Collegiate Rules. Lake Forest came here, to see if arrangements could be made for a game between the two institutions. On Saturday the 11th, the first game was played on our grounds. Considering the little practice our boys had, they made a very credible showing, and succeeded in holding their opponents down to the score of one goal from a touch-down, two touch-downs and two safety touchdowns. Although our boys scored nothing, they learned very many points which proved of great service with the next game. They practiced a good deal during the week, and on Saturday went to Lake Forest to play the return game, and there they met with quite a success, their score being one goal from a touch-down, and one touch-down; the Lake Forests only scored two safety touchdowns. Such a result is indeed very gratifying, and we hope it is a stepping stone to future successes.* [4]

The Northwestern football team played its earliest games on a field where Deering Meadow is now located, with no permanent stands and a few dozen curious spectators. The team had no mascot. The "Fighting Methodists," commonly thought to have been the team's nickname during these early years, was never actually used (the sadly pedestrian nickname "Northwesterners" was instead used). However, as Walter Paulison relates in his 1951 history of NU athletics, *Tale of the Wildcats*, one popular player in the 1890s did become known to reporters as "the fighting parson." Guard Charles Wilson was a Methodist minister, and was known for his "aggressive" style of play and for shouting from the sidelines to players on the field to "stop them in the name of the Lord." [5] By 1892, the local Methodist bishop had had enough, and banned Wilson from the game.

The early Northwestern football teams did have one symbol that is still recognized: the color purple. For most of the 1870s, Northwestern's athletic teams used a variety of colors. In 1878,

the baseball team briefly switched to brown and white uniforms (and had abandoned the thankfully short-lived nickname "La Purissimas"[6]). Northwestern athletes noted that the Racine College baseball team wore uniforms that matched its school colors—a novelty at the time—and suggested that Northwestern do the same. In 1879, the school formally decided that it would use black and gold to represent its athletic teams, not being able to choose between the two colors. However, once they realized that black and gold were a combination in use at many other colleges in the region, the students decided to switch to a less common combination. In late fall 1879, the university made purple and gold its official colors, and purple has been linked with the school ever since. By 1892, the student body decided that NU would be better served with only one school color (this was the trend at eastern colleges), and chose royal purple alone.

From 1882 through 1887, the football team continued to practice but played only a couple of games with teams from outside Northwestern. During this period the team, like most college teams in the 1880s, had no coach. It was a truly student-run group. By 1888, the team played its home games on a field a few yards northeast of its original grounds, just east of old Memorial Hall (on the spot now occupied by Andersen / Leverone Halls). NU played a "warm up" game against Chicago's West Division High School on Thanksgiving Day (the first of 13 Thanksgiving games NU has played), and then another pair of games against Lake Forest. As it did in 1882, Northwestern lost its first game with Lake Forest (scheduled at the last minute) but then beat Lake Forest in Evanston.

The 1889 team faced Evanston Township High School, defeating them in a practice game in preparation for the season's big events: a pair of games with Notre Dame in Evanston. The first showdown with Notre Dame, slated for November 9, was canceled due to rain, but the teams managed to play the November 14 game. Since its team's inception in 1887 Notre Dame had only played four games of football, and three of those had been losses to Michigan (the fourth was a win against a prep school). Still, Notre Dame was becoming a notable football team, and the game against Chicago's Methodist school attracted more attention than any football game had in the Chicago area up to that time. Notre Dame prevailed, 9-0, scoring one field goal (worth five points at the time) and one touchdown (worth four). This game, more than any before it, brought football to the forefront of student activities at Northwestern. Some Notre Dame historians claim that the school's nickname originated from this game. Northwestern students, it is said, shouted encouragement to their team to "kill those fighting Irish!"

The 1889 season concluded with a loss to the University Graduates (a team composed of former college players from schools throughout the East and Midwest) and a win against the Chicago Wanderers, another very early Chicago amateur football team, better known for playing cricket.

For its second Thanksgiving game, Northwestern played Wisconsin in Milwaukee in 1890, initiating not only its series with the Badgers, but also a tradition of playing Wisconsin on Thanksgiving that would last, off and on, for the rest of the decade. For the Wisconsin game each member of NU's team for the first time wore the same style of uniform. Before this, Northwestern's players wore whatever they could make or get their hands on that looked like a uniform. The players all wore vest-style jackets and purple and gold-striped knit caps. Fifty students accompanied the team to Milwaukee for the first game with the Badgers. The pre-game festivities included a clay pigeon shoot. Northwestern won the first game with Wisconsin, 22-10.

Student interest in football had increased to the point that, by 1891, the school moved the football field to its third location, this one a little farther north (where the fraternity quads now stand) and expanded it to include practice areas. The university made plans to add permanent stands for the first time. The team also played its first off-campus home game, a scoreless tie with Lake Forest that was held at the Chicago Cubs' old ballpark, West Side Park on Congress Street.

The 1891 team also employed NU's first ever coach, Knowlton Ames, who soon took a leave of absence to "attend to other business"; the other business apparently was to serve as *Purdue's* coach. In Ames' absence, the team captain, Ransom Kennicott, maintained control of the

team. Unfortunately, the team lost again to Wisconsin in its annual Thanksgiving match. However, the team's luck was about to improve

Northwestern had a breakthrough season the following year. Paul Noyes, who had played in 1888 and against Notre Dame in 1889, returned to captain the team in 1892 after playing at Yale for a year. Noyes was essentially the team's coach as well as its captain in 1892, and began organizing the team to an extent not before seen in Evanston. He even began a team training table. After the team's practice game against the Chicago YMCA, one *Chicago Tribune* reporter remarked, "the last week has made great improvement in the football outlook at Northwestern."[7]

Northwestern's first major opponent of the season was Illinois, which was coming off an undefeated season and would eventually rack up nine wins in 1892. Northwestern met the Illini, who wore green jerseys during the game, for the first time in Champaign and battled its downstate foe to a 16-16 tie before darkness fell. The game was an exciting one. Illinois was a larger and stronger team, but Northwestern's training and conditioning kept them even. The team went on to rout Beloit, 36-0, just three days after playing Illinois.

Northwestern traveled to the University of Chicago's new field to take on Amos Alonzo Stagg's team. The University of Chicago had opened its doors earlier that year, and the game was Chicago's intercollegiate debut. Just as it was common during this early era of college football for student-athletes to serve also as coaches (as Noyes was in effect doing for Northwestern), it also was not unheard of for a coach to step in and play with the team. In these first few games at Chicago, Stagg himself played alongside his team, clad in yellow, Chicago's color at the time.

The first game with Chicago ended in a scoreless tie. The closest either team came to a score was when Stagg was called offside. Northwestern got the ball back and future NU star Jesse Van Doozer, along with Alvin Culver, Lewis Ehle, and former captain Ransom Kennicott made a series of runs that put the ball within inches of the Chicago goal. Unfortunately they couldn't punch it through. They did, however, punch just about everything else; notably, the game was a particularly violent one, and several Chicago players were injured. Coach Stagg nearly had his nose broken. The Northwestern men didn't escape injury either. Noyes suffered a neck injury and cut his head open, and Van Doozer broke a rib. The teams agreed to break the deadlock with a second game, to be held at Northwestern in a couple of weeks.

Before the Chicago tiebreaker could be played, Northwestern played the University of Michigan for the first time (NU had previously agreed to play Michigan back in 1881 and 1887, but had to cancel). Northwestern hosted Michigan off-campus, at the 25th Street Playing Field in Chicago. The teams agreed beforehand to play for ninety minutes. Over a thousand spectators were on hand to watch the epic, setting another Northwestern crowd record.

And an epic it was. The greatest game Northwestern had played up to that time was a seesaw battle between two nearly evenly matched teams. NU won the toss and chose to take possession, giving Michigan wind advantage. Michigan eventually scored first, racing to an explosive touchdown, but it missed the try for a goal. (In the early 1890s touchdowns were worth four points, while goals after touchdowns scored two points.) Down four to nothing, Noyes clawed his way to the Michigan goal to even the game. Northwestern's attempt at a goal also failed. Most of the rest of the game was a battle for field position. Finally, Alvin Culver scored and Noyes kicked successfully to make the score Northwestern ten, Michigan four. Michigan then scored quickly, but their kick again failed, and Northwestern hung on to shock Michigan, 10-8.

The win was by far the biggest victory for the team so far, and the university's students went wild. The *Tribune* reported that "Evanston could hardly hold the students. . . . The great victory over Michigan was worthy of a great celebration, and it got it. A big pile of boxes and barrels was set fire to. Every member of the football team was given a ride around the fire. Then, to the deafening music of tin horns, the crowd marched to the Women's Hall, where speeches were made."[8]

The team returned to Sheppard Field four days later and beat Chicago, 6-4. One other major

series began during the season, when Northwestern fell to a powerful Minnesota team. Northwestern won five games in 1892, lost three, and tied two, but that was enough to give the team its first championship. NU had joined two Midwestern intercollegiate leagues that season, and won the pennant of the smaller league, which included Illinois, Beloit and Lake Forest.

Paul Noyes returned in 1893, not only as a player, but officially as the team's coach. Northwestern lost its opener to Denver Athletic, 8-0, and went on to suffer its first losing season since 1886. The team did not fare better in 1894. A.A. Ewing, who replaced Paul Noyes as coach, was taking classes at the University of Chicago. In Northwestern's season opener, at Chicago, Ewing coached against the school in which he was enrolled as a student. Not surprisingly, NU played a sloppy game and lost in a shutout.

On Wednesday, October 31, 1894, Ewing joined Chicago as a player and scored two touchdowns against the Chicago Athletic Association. The following Saturday Northwestern played Illinois, and Ewing and Chicago played Purdue. NU entered the Illinois game without a coach. The team also came into the game without its captain; John Oberne abruptly quit the team in protest. In the wake of Ewing's betrayal and departure, the faculty—for the first time—tried to take control of the team, to the consternation of the players and students. Jesse Van Doozer, the team's rising star who had played promisingly in 1892 and 1893, also left the team. Without a coach, a captain, or its remarkable running back, Northwestern took the field at Champaign and was helpless, losing 66-0. In the strangest twist of all during one of the most bizarre weeks in NU history, Van Doozer served as the referee for the massacre!

The game was the final insult for the remaining players. After coming back to campus Monday morning, the team announced that it was scrapping the rest of the season. The *Chicago Tribune* announced with a bold headline:

> *Northwestern Team Disbands*
> *After a season of discord, strife and defeat, the NU football team has disbanded. The team has been without coach or captain for a week, and yesterday the faithful and remaining Few decided to cancel dates: Nov. 6 Chicago YMCA; Nov. 17 Illinois at Evanston; Nov. 24 Chicago at Evanston. The students feel that the failure is a direct result of the attempt of the faculty to run the team.*[9]

Van Doozer and Alvin Culver announced the same day that they were joining the Chicago Athletic Association's team and were traveling to the East to play colleges there. Culver, however, returned to Evanston a couple of weeks later and made an attempt to reform the team and salvage the year. He faced resistance from the school. The faculty was even more hostile to the idea of the program continuing under student control, and the University president, Henry Wade Rogers, mulled ending the sport at NU altogether.

Culver did not have much to rebuild the team with. There were a couple of former players who agreed to come back, and Culver was able to enlist the help of some of the players on the University's Law School football team. (The various professional schools at Northwestern each had their own football teams at this time. The Law School team, in fact, played Notre Dame the following year). It was a disorganized group, one Culver had put together in just a couple of days, but it was enough to allow Northwestern to keep its date to play Chicago (and NU's current "coach," Ewing) for the season finale. NU lost, but the nearly heroic effort Culver made to save the team and keep fighting, even against superior opponents, reclaimed the respect of students, alumni, and fans.

The 1895 season began with another inauspicious start: NU's replacement coach, Joe Flint, lasted just two games, the shortest tenure of any Northwestern football coach. Again without a coach in the middle of a season, Northwestern asked Alvin Culver, who had graduated, to take over formally as the team's coach. It was a decision that turned around the fortunes of the embattled program.

Culver's former teammate, Jesse Van Doozer, returned to Northwestern. Van Doozer had a

13

year of additional experience. He was promptly made captain of the Northwestern team and switched from halfback to lineman. Van Doozer and the team practiced furiously in early August, determined to return to the team the discipline and organization that it had in 1892. Among the new players Flint brought to the team was Albert Potter, who had played halfback with Baker University.

The greatest moment of the 1895 season came on October 19, when Culver led his team to Chicago to face Stagg's Maroons and virtually the same set of players that Culver took on with his makeshift team the previous year. Now, however, Northwestern's team was efficient, powerful, and eager for revenge. Van Doozer and Potter unleashed their offense in a bruising game, and Northwestern defeated Chicago (and NU's former coach, Ewing), 22-6.

The victories that Potter and Van Doozer helped produce put the Northwestern football program on a solid foundation and gave the team momentum. The small but powerful and highly disciplined team from Evanston did not suffer another losing season for over a decade and was on its way to becoming a regional power.

Northwestern was one of seven Midwestern schools that formed the Intercollegiate Conference of Faculty Representatives in 1895, now known as the Big Ten. Along with Chicago, Minnesota, Wisconsin, Illinois, Purdue, and Michigan[10], NU began playing a conference schedule in football in 1896. Powered by Potter and Van Doozer's offense, Northwestern split two games with Chicago and beat Illinois. All NU needed was a victory in its final game, against Wisconsin, to take the first Big Ten title. Unfortunately, Wisconsin and Northwestern shared a 6-6 tie, but not the title—Wisconsin was given the first championship, and NU came in second.

Culver left, and in 1897 Van Doozer, no longer a student, replaced him as head coach. Van Doozer's only year as Northwestern's coach was a successful one and included one of the strangest games in the school's history. NU played a November exhibition game against a team of alumni, a team coached and captained by Jesse Van Doozer. Both teams at Sheppard Field were coached by the same man, and the varsity lined up to play against its own coach. In addition to Van Doozer, the alumni team brought back Potter, Culver, and—most shocking of all—former captain John Oberne. The all-star alumni crew became, for one week, one of the strongest football teams in the Midwest. The varsity team was faced with a challenge beyond just the strength of the alumni, however. Van Doozer, as varsity coach, knew all their signals. As an alumni player, he could easily intercept the play calls. Varsity quarterback Joe Hunter solved the problem by quickly coming up with new signals, sharing them with the rest of the team, but hiding them from his own coach! Van Doozer's varsity squad beat his alumni team, 25-0.

The coaching parade continued at Northwestern in 1898. William Bannard replaced Van Doozer and stayed with the team for only one season. Bannard changed the team's uniforms, replacing the standard light-colored vests with dark, vibrant purple jerseys, the first truly purple uniforms the football team wore. The team won nine games (out of an all-time team record 15 games in one season), but unfortunately it lost all four conference games it played. After leaving Northwestern, Bannard went on to write *Football, How to Play the Game*, becoming the first of many former NU coaches to write a popular book about football tactics.

The team's next coach, Charles Hollister, lasted four years. After suffering the school's worst shutout loss in history, a 76-0 massacre by Stagg's Chicago team in 1899, Northwestern took revenge by beating the Maroons twice in a row, edging them 5-0 in 1900 and 6-5 in 1901. The back-to-back wins over the powerful team of the Midway gave the Purple (as the team was now being called by the press) high-profile publicity.

The 1901 season started with five straight victories, including the team's first win over Notre Dame. The team edged the Irish, two to nothing, thanks to Harry Allen's sack of the Irish punter behind the goal. Its defeat at the hands of Northwestern was the only loss Notre Dame would suffer that season. The following week Northwestern traveled to Ann Arbor and was shut out by Michigan, stifling hopes for a conference title. One week later, however, Northwestern traveled downstate and faced an undefeated and powerful Illinois team. No team

had yet scored on the Illini, which had beaten its first five opponents by a combined score of 159 to nothing. The Purple stunned Illinois, 17-11.

Van Doozer, Bannard, and Hollister had made and kept Northwestern a very good team, but the school's next coach would make the program truly great. Walter Edwin McCornack was from Chicago, having starred at Englewood High School before attending Dartmouth. At Dartmouth McCornack excelled at quarterback and captained the 1895 and 1896 teams. He then coached at Exeter before returning to Dartmouth as its head coach and pulling off tremendously successful seasons in 1901 and 1902. McCornack left Dartmouth to study law at Northwestern. NU offered him a three-year contract to coach the football team, which McCornack eagerly accepted.

McCornack's first team at Northwestern was his greatest. The 1903 team won 10 games, and suffered only one defeat—its 14th and final game. The Purple opened with seven straight home games, and won every one: North Division High School, Fort Sheridan's football team, Englewood High School (McCornack's alma mater), Naperville College, the alumni team, Lombard College, and the Chicago Dental College's team.[11] On October 7, the team traveled to Saint Louis to take on Washington University as part of Saint Louis' 1903–04 World's Fair (the second of four World's Fair games that NU would play during its history). The Purple blanked Washington, 23-0.

Northwestern then faced Chicago, a team near the height of its power. Even carrying an 8-game winning streak into the match, Northwestern was a 24-point underdog to its host. Hundreds of NU students took the train into Chicago for the game. The band also made the trip and wore new uniforms for the occasion. The Purple had experience and tremendous conditioning on their side, and they held Chicago to a scoreless tie, stunning the 10,000 in attendance. A reporter for the *Northwestern* later suggested that Chicago's players should "eat Butterworth's breakfast food with the goose egg Coach McCornack's protégés gave them." The next week Northwestern traveled to Cincinnati and demolished the Bearcats, 35-0. Northwestern's fourth road game was held on Halloween, at Illinois.

Illinois had won eight and lost one game so far in 1903, while NU had won nine and had the tie with Chicago. The press gave the game at Champaign unprecedented coverage, and for Northwestern a win would mean a possible Western Conference championship. The Purple edged Illinois, 12-11, touching off parties in Evanston that lasted throughout the weekend.

After the victory over Illinois, Northwestern's football team had become a sensation. Interest in the Purple's three remaining games, all home games following the team's successful four-game road trip, was so great that it became clear that the thousand seats at Sheppard Field would not accommodate the demand from fans. So the following week, a bye week for the team, Northwestern arranged to have the remainder of its home schedule played at White Sox's South Side Park (the Sox's home field prior to Comiskey).

No team had yet scored on Notre Dame's physical defense. The Purple also would not come up with a score against the Irish at Sox Park, though it would threaten throughout the match. However, Northwestern's defense also held, and the team came away with its second scoreless tie of the season. Notre Dame continued to hold its opponents scoreless the rest of the season, and its tie with NU was the only blemish on the Irish's 1903 record. For Northwestern, the tie was cause for celebration, and was seen as a giant upset across the country.

Northwestern then hosted Wisconsin and secured its third tie of the season, a six to six gridlock that gave NU a final conference record of one win and two ties. At the time this finish was good enough to give the Purple a third place rank in the Western Conference. Decades later, however, the Big Ten changed its rules stipulating the rankings of its teams based on wins and losses and declared that Northwestern's undefeated record earned it a share of the 1903 conference championship. It was NU's first Big Ten title, but it wasn't celebrated for over 70 years.

The team's final game of its storied 1903 season was played at South Side Park on Thanksgiving Day against the Carlisle Indians, and it was the featured game across the country.

Northwestern had never before garnered so much national attention; in fact, it was rare during the early decades of football for any team outside of the East Coast establishment to grab national sports headlines. However, reporters from all over converged on Chicago for the season's finale.

Carlisle, a team composed entirely of American Indian students and one that played only on the road, was a true national powerhouse and commanded national attention. The team had a reputation for surprises and wild trick plays. Earlier in 1903 two of Pop Warner's stars at Carlisle, Frank Hudson and Jimmy Johnson (a full-blooded Stockbridge Indian from Edgerton, Wisconsin), carried out one trick that became the stuff of legend. Before their marquee game against Harvard, Warner had sewn an elastic strap inside the jersey of Charles Dillon. When Harvard kicked off to start the second half, Johnson caught the ball. Rather than block for Johnson, the team immediately huddled around him, as he took the ball and stuffed it inside the back of Dillon's rigged jersey, just above the elastic. The team then broke the huddle, with all 11 players clutching their chests and running madly. The Harvard players, bewildered, allowed Dillon to run over 80 yards untouched for a touchdown. Although Harvard won the game by one point, Carlisle's trick play, and Jimmy Johnson's quick work with the ball, caused a sensation.

Word of the "Hidden Ball" play spread across the country, as did the news of Carlisle's nine-win season. Prior to the game, Coach McCornack commented on the match and on the trick plays Carlisle had unleashed on Harvard: "If the Indians can work tricks, so can we!" Indeed, NU could: the Purple at the time had a playbook with 128 plays, a ridiculous amount of plays for that era.

The NU-Carlisle match, unfortunately, was no contest. NU had been riddled with injuries and severely weakened by the hard-fought tie with Chicago and the equally grueling tie with Notre Dame. Johnson and Carlisle were at the top of their form. In a driving blizzard at Sox Park, in front of a record 11,000 Purple fans, Jimmy Johnson played his last game for Pop Warner and almost single-handedly beat Northwestern, 28-0. Johnson actually missed four drop kicks during the game, but made up for them with a series of dazzling runs. The *Tribune* reporter at the game marveled, "Captain Johnson is always a wonder!"

After graduating from Carlisle in 1904, Johnson enrolled in NU's Dental School. McCornack and the varsity squad immediately enlisted Johnson. (Until 1906, it was perfectly legal for a school's football team to use graduate students, even if the student had played four years somewhere else.) Johnson quickly became a leader on the squad and began helping McCornack prepare his team. During the next two seasons, Northwestern played 21 games and won 16, tying one. Of the four games NU lost, Johnson did not play in two, due to injuries—his talent and effort were as critical at this point to Northwestern's success as was Coach McCornack's influence on the team.

The 1904 season began with another series of wins for NU at Sheppard Field over warm-up competition. Powered by Johnson's dazzling offense and by a vicious defense, the Purple routed its first five foes 158 to nothing, tying the 1901 team for the school record for straight shut out victories. The streak ran into a buzzsaw, however, when Northwestern traveled to Chicago and fell, 32-0, to Coach Stagg's undefeated Maroons.

Angry over its misstep at Chicago, Northwestern returned to Sheppard Field and took out its frustration by beating Indiana's DePauw College, 45-0. The following week, Northwestern hosted Oshkosh Normal (later known as the University of Wisconsin at Oshkosh) and dismantled the Teachers, 97-0, NU's all-time scoring record. The score could have been even higher but the coaches agreed to end the game early in the second half.

As with the previous season, Northwestern's final home games in 1904 generated so much interest that Sheppard Field was insufficient to handle the crowds. Northwestern decided to keep its game with Illinois at Sheppard Field, but move its finale with Minnesota to the University of Chicago's Marshall Field. Minnesota was a huge draw at the beginning of the twentieth century and could be expected to travel with hundreds of its fans. Northwestern, in

fact, had hosted Minnesota at Marshall Field one time before, in 1901. Although Northwestern was shut out by Minnesota, the 1904 season set the record for the Purple's offense; remarkably, in the course of its eight wins—all shut outs—Northwestern tallied 300 points. This record would hold for nearly 100 years.

The 1905 season seemed like it would be the beginning of a new chapter. The school, in an effort spearheaded William Dyche (Northwestern's business manager), had set aside 12 acres of land northwest of campus on Central Street for its new field, and it built wooden grandstands capable of holding 10,000 spectators. The Purple played four games on the new field before it was dedicated, and again found itself undefeated and unscored upon. On October 14, the school dedicated Northwestern Athletic Field during a game with Beloit College, as it had when it dedicated Sheppard Field. And NU beat Beloit again, this time 18-2. During the game Jimmy Johnson tore through the Beloit defense for 200 yards.

The Purple slumped a little mid-season, tying Transylvania College and losing to Chicago, which was on its way to an undefeated season. However, momentum picked up by the beginning of November, and Johnson continued to score at will. Even with the winning record, NU was woefully short of depth due to injuries and Johnson, now 26 years old, had been banged up terribly over the last two years.

As it would for the next century, Northwestern's relatively small size put the school at a disadvantage, particularly late in seasons, when injuries took their toll and teams relied more on their depth. The Purple were heavy underdogs for their final game of the year (and their only road game), against national powerhouse Minnesota. Sadly, Johnson went down with a career-ending injury just ten minutes into the game, and NU, without its star quarterback and with few uninjured backup players, was doomed. The team fell apart and suffered a 72-6 loss, one of its worst defeats. It was an unfortunate end to another eight-win season that was otherwise a fantastic success for the program. McCornack had completed his contract with the best three-year run in the school's history, and the team had inaugurated its new stadium with record-setting crowds and spectacular performances.

The same types of injuries that had plagued Northwestern toward the end of its 1905 season were taking lives elsewhere. Columbia and other schools announced after the 1905 season that they were dropping football because of concerns over safety. At Northwestern, the faculty debated whether to follow these schools and disband the football team. On March 22, 1906, the board of trustees shocked the Purple players, fans, and alumni by deciding that Northwestern would, indeed, withdraw from varsity football. The faculty committee overseeing the decision wrote that it was ". . . of the opinion that the wisest course for the University to pursue at the present time, and the most likely to secure for our students permanent benefit, is to discontinue all intercollegiate football contests for a considerable period of time, if not permanently."[12]

The school remained a member of the Big Ten and continued to compete in the league in other sports. Football continued to be played at Northwestern Field, but only by class teams on an intramural basis; ironically, many of the intramural games at Northwestern at this time were more vicious than the intercollegiate matches. The faculty announced that if by 1911 the sport had progressed to the point that safety was no longer an overriding concern and the game was no longer taking focus from academics at the school, the team might be allowed to return.

For Coach McCornack, the timing of the news was not entirely bad; he had recently earned his law degree. McCornack left Northwestern and football entirely, setting up a law practice and eventually becoming an assistant to famed attorney Clarence Darrow. For Northwestern, however, the timing of its decision could not have been worse. Rather than serve as the springboard to even greater heights, the successful 1905 season was the finale for old-style football at Northwestern, and it was the team's last winning season for over a decade.

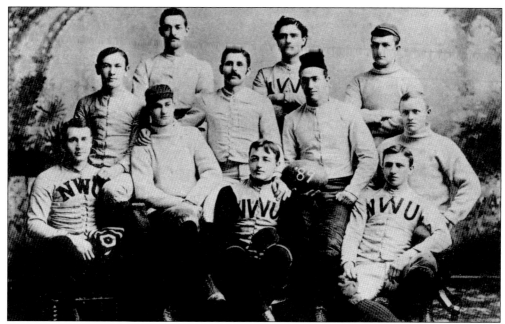

The 1889 team poses in the earliest known photograph of Northwestern football players. This squad, led by Erman Ridgway, met Notre Dame for the first time on a muddy Deering Meadow field. The 200 spectators set an attendance record for Northwestern and became a nuisance during the game, as fans milled about on the field. The Notre Dame fullback caught the opening kickoff and promptly kicked it back to NU. The game was brutal—several Northwestern players were injured, and one Notre Dame player received a broken jaw.

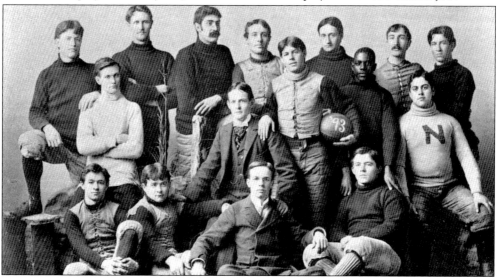

The 1893 team opened the season with a game that was a featured attraction of Chicago's 1893 Columbian Exhibition. Northwestern hosted the Denver Athletic Club at the Exhibition Stockyards Pavilion. It was the team's third off-campus home game in as many seasons, and the first of several games Northwestern would eventually play in conjunction with World's Fairs. The game also was likely the first night football game ever played in the Midwest, with kickoff just after 9:00 p.m.

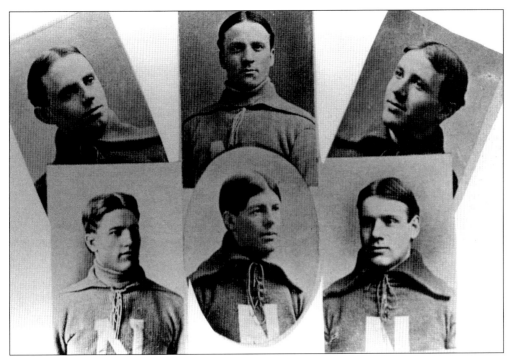

This composite image shows several Northwestern football stars of the 1890s. Kedzie and Kay are on the upper left and center. Alvin Culver (top right) starred for NU in 1892 and '93 and helped keep the team together in 1894. He led the team as its coach the following two years. Jesse Van Doozer (bottom left) left NU in 1894 to captain the Chicago Athletic Association's team. Van Doozer remained with the C.A.A. for a year before returning to NU. He received national exposure while playing the biggest college and amateur teams in the eastern US, and became the first true star of the game to come from Northwestern. Frank Griffith (bottom center) was NU's 1893 captain. John Oberne (bottom right) was the team captain for the first half of the 1894 season.

Jesse Van Doozer and Albert Potter pose in uniform. Potter and Van Doozer became friends and formed a terrifying combination: Van Doozer's strength on the line and Potter's speed became nearly unstoppable. Together the pair of backs began an assault on the field that lasted a year and a half and netted Northwestern six straight wins in 1895 and six more victories in 1896.

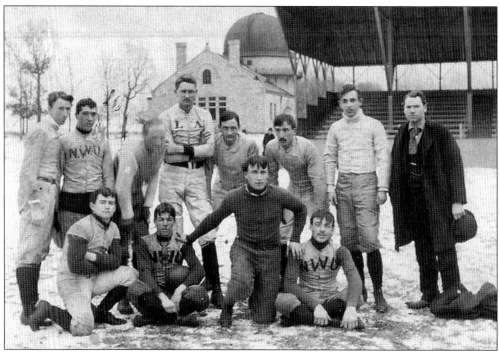

The 1895 team pauses during practice on snowy Sheppard Field. The Sheppard Field south end zone grandstand can be seen in the background. Farther in the background is Dearborn Observatory, in its original location. Crouching in the second row, fifth from the left, is future Northwestern president Walter Dill Scott.

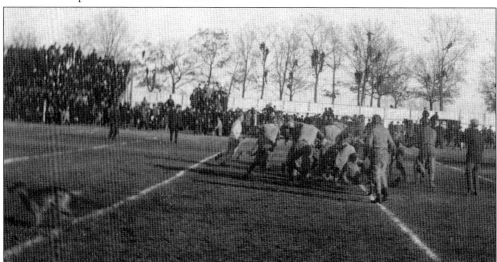

Northwestern plays at Sheppard Field in 1898, shown here in one of the earliest-known action images of the football team. To the left are the east-side stands. The grandstand was on the south side of the field. In the background spectators watch the game atop nearby trees, a common practice at football games at the turn of the twentieth century. A line of horses and carriages can be seen on the sidelines to the right. Even 100 years ago parking was expensive: fans paid $2.00 to park their carriage in the stadium. Also note the dog running freely across the field. The dog was NU's mascot at the time.

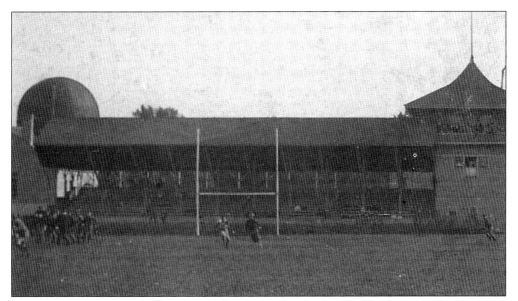

This photo was also taken during an 1898 game at Sheppard Field. Northwestern had built the grandstand, with permanent seats for 700 fans (quickly expanded to hold over 1,000) in 1891. On October 15, 1892, prior to NU's game with Beloit (NU won 36-0), Northwestern formally dedicated its large, pagoda-style grandstand and named the grounds Sheppard Field. The school celebrated with a huge ceremony: members of the faculty gave pre-game speeches, there was a brass band on the field—something of a novelty for a football game at this point—and a standing-room only crowd of over a thousand fans.

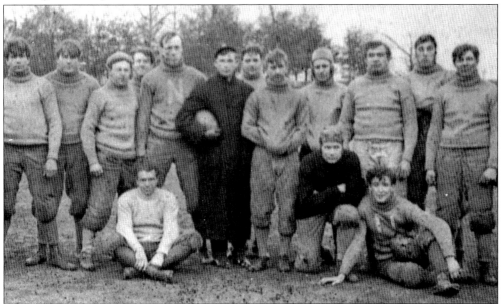

The 1903 team, Coach McCornack's first, lines up at practice. When he arrived at NU McCornack immediately made many changes to the Purple program, including instituting vigorous practices and introducing the tackling dummy, which had not been seen outside of Eastern schools. McCornack's changes paid off quickly, and the team won more games that season than any other in Northwestern history until 1995.

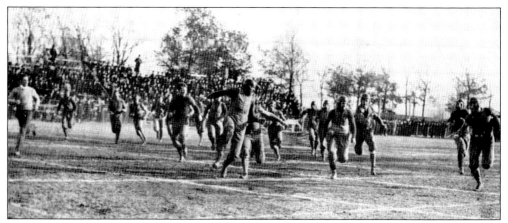

Northwestern met Illinois at Sheppard Field on November 12, 1904, and beat the Illini, 12-6. The photo shows NU running back a kickoff. Jimmy Johnson scored the winning touchdown and added his name to yet another footnote in Northwestern history: his was the last score ever at Sheppard Field. The wooden grandstands, built over 12 years before, were starting to show wear, and during the last four seasons it had become obvious that interest in NU football had overwhelmed Sheppard's capacity. The school decided at the end of the 1904 season to find an entirely new location.

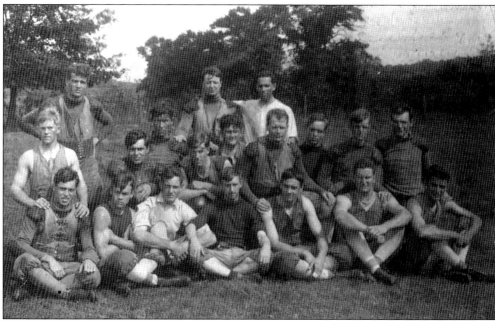

Coach McCornack was the first coach to send Northwestern's team north to Wisconsin for off-campus preseason workouts, nearly ninety years before the first "Camp Kenosha." This photo was taken during a practice break at "Camp Mukwonago," Wisconsin, August 1905. Included in the photo is assistant coach Harry Allen (front row, third from left), the hero of the 1901 Notre Dame game; Coach McCornack (front row, fourth from left); and Jimmy Johnson (back row, in white shirt). Johnson was an All-American at Carlisle and was later named to the College Football Hall of Fame. After beating NU with Carlisle in 1903, Johnson said, "Northwestern was not as hard a proposition as I expected. We would have made a larger score if the field had not been so slippery." Johnson played for Northwestern in his very next game.

Two

The Purple Returns and NU Rebuilds

1908–1925

While substantial changes were being made to the rules of football (NCAA rules, the end of mass-formation plays, the start of the forward pass), students at Northwestern continued to play using the old football rules and tactics, teaming up by classes to play intramural football games. The students and alumni were furious that the school had discontinued the varsity program, and by the fall of 1907 90 percent of the students enrolled at the school signed a petition to reinstate the football team.

Other schools, including the members of the Western Conference, were incorporating the new approaches into their tactics and strategy and were continuing to build their teams and recruit. With the changes and formalization of the sport's rules in 1906 also came changes to the recruitment process. Northwestern now had no program and no faculty, staff or students experienced with the new game nor with the strategies of recruiting capable student athletes. In just one year the damage done to Northwestern's potential ability to compete again at intercollegiate football was so great that it took the school two decades and numerous futile attempts to undo it.

By the beginning of 1908 the faculty made a compromise deal with the sports supporters: it would allow a varsity team for the 1908 season, but the team could only play 2 "warm up" games and 2 conference games, a far cry from the 13 and 14 game schedules it played during its earlier incarnation. The Trustees also required that the University's alumni create a $1,000 fund to guarantee against any possible financial losses from the new program. The school enlisted its former star, All-American Alton Johnson, as its new head coach.

Johnson was faced with one of the most daunting tasks ever to befall a Northwestern coach. Other schools had been playing by the new football rules for two seasons and had improved their recruitment techniques. Support for a Northwestern football team, while still evident, had waned from the heady 1905 season and its 10,000-spectator games. And, most urgently, there was no team; unfortunately, nearly all of the talented veterans from the 1905 team were gone. Johnson made do with what he could, using some of the players from the school's intramural class teams.

The first game Northwestern played in its return to varsity football was held at Northwestern Field on October 10, 1908, against a team composed of alumni from some of the earlier Purple squads. Coach Johnson enlisted Harry "Dixie" Fleager to coach and captain the alumni team. Fleager was a key member of the champion 1903 team and one of the greatest fullbacks in NU history. He brought back several of Northwestern's biggest stars for the game, including Harry Allen and Jesse Van Doozer. Rounding out Fleager's starting lineup for the alumni was Alton Johnson himself. For the second time in its history, NU's varsity was coached by a person who

was simultaneously playing on the opposing team!

Alumni Coach Fleager also served as the game's referee, and the teams played for three "halves," lasting 20, 15, and 10 minutes. These odd throwback rules and personnel decisions only demonstrated that, while college football elsewhere had continued to advance, Northwestern was still playing the game as it was enjoyed at the end of the 19th century. There were still no forward passes, and success relied on the brute force of the line. The varsity team eventually edged their predecessors in the third "half," 10-6.

Two weeks later the team held its first intercollegiate game in nearly three years, hosting an inferior Beloit squad and crushing them, 44-4. After several unsuccessful tries, Northwestern finally recorded the first forward passing play in the team's history when John Culbertson, the left tackle, caught a pass from quarterback Charles Kittleman. Although undefeated midway through its test season, Northwestern's success was illusory; the alumni team played by the old rules of the game and was no real challenge, and Beloit won only one game in 1908. NU's two conference opponents, Purdue and Illinois, were far tougher. The Purple nearly beat the Boilermakers, but fell 16-10. Illinois, however, was still vying for the conference title. The experienced and talented Illini showed the new Purple squad no mercy, routing them 64-8.

For Coach Johnson, the challenge was just too great. He left Northwestern after just the four games in 1908, and he was replaced by M. Frank "Bill" Horr. Horr's 1909 team also started off seemingly well. After a scoreless tie with Illinois Wesleyan, the Purple scored its first major victory in four years with a win over Purdue. Unfortunately, that was the high point for the squad, and it dropped its final three games. Horr, like Johnson, lasted only one season. In 1910, Horr jumped ship to coach the only team he had beaten, taking over at Purdue.

By 1910, Northwestern was faced not only with the same problems it had when it resumed varsity football in 1908, it also was saddled with the unacceptably frequent turnover of its head coaching job. Northwestern's third coach in as many seasons, Charles Hammett, improved the turnover rate somewhat, staying for three years. Hammett's attempt to rebuild Northwestern football was just as futile as the previous two coaches'; regrettably, his teams finished 1-3 (with one tie), 3-4, and 2-3 (with one tie, a scoreless mess with Lake Forest), respectively.

The 1911 season was notable only for the game against Chicago, which was Northwestern's first homecoming game. The University of Illinois had staged the nation's very first homecoming just one year before. Northwestern had hosted alumni reunions at football games before 1911; the first was in 1897, at the varsity vs. alumni game at Sheppard Field. Northwestern's 1911 homecoming featured a parade and the marching band. Downtown Evanston businesses decorated their store fronts, and 7,500 fans turned out for the game despite steady rain. The weather wasn't the only unfortunate part of the day: Chicago edged NU, 9-3.

Coach Hammett's final season, 1912, would have been a total disaster had it not been for two players, Ray Lamke and newcomer Wilbur Hightower—and for the artistic creation of a cornet player in the marching band. Lamke ran wild at Indiana and single-handedly beat the Hoosiers by punching in three touchdowns. Hightower powered NU to a win over Illinois, and Theodore Van Etten, a member of the band, wrote "Go U Northwestern," inspired by the Indiana game.

Northwestern's effort to rebuild its football program continued in 1913. Its new leader, Dennis Grady, was yet another one-season coach for the Purple. Northwestern and Lake Forest had agreed the previous year to recommence their series by holding season-opening games every year through 1917. By this point Lake Forest was no longer truly competitive with the large schools of the Western Conference, and NU defeated Lake Forest 10-0. The rest of the 1913 season was a catastrophe. Purdue, Illinois, Chicago, and Ohio State (in the Purple's first meeting with the Buckeyes) all won easily, and Iowa beat Northwestern 78-6—to this day the most points scored against Northwestern in a single game.

With Grady's quick departure, Fred Murphy took over. The team had not yet managed a winning season since returning to football, and was becoming less, rather than more, competitive. His first season, just like Hammett's last year and Grady's only season, relied on Wilber Hightower for what few bright spots there were. And, like Grady's, Murphy's first season began with a win

against hapless Lake Forest, followed by a string of losses. The Purple managed to score six against Purdue, but suffered shutouts to Chicago, Indiana, Illinois, Iowa, and Ohio State.

The 1915 season was little better: Northwestern managed its annual win against Lake Forest and beat Missouri (where Murphy had coached at the turn of the century), losing the rest of its games and placing last in the conference. It didn't seem that the Purple were improving at all, but the team was about to turn the corner suddenly, thanks mostly to one player.

John "Paddy" Driscoll had distinguished himself in the 1915 Iowa game when he returned a kickoff 85 yards. Driscoll was a genuine triple threat: a combination running back and quarterback who could throw reasonably well, run spectacularly, and drop kick with power and precision. Powered by Driscoll's three offensive engines, the 1916 team beat Lake Forest, then traveled to Marshall Field to play Chicago, a team Northwestern had not beaten since 1901. The Purple dominated Chicago, blanking them, 10-0. Driscoll scored a touchdown and a 43-yard field goal.

After victories over Drake College and Indiana, the Purple hosted a powerful Iowa team. NU was undefeated, but Driscoll had been injured in the Indiana game and sat out the Hawkeye game. There were doubts that the team could hold without its star, and Northwestern entered the game a decisive underdog. Even so, for the first time since the return of football to Northwestern eight years before, football had become a mania on campus. The team was undefeated, it had a true star that was beginning to make national news, and the Iowa game was now critical in determining which school had a shot at the conference title. It was also NU's homecoming game. Twelve thousand fans and alumni packed Northwestern Field for the showdown.

Northwestern led the Hawkeyes, 13-10, early in the fourth quarter. However Iowa quickly marched down the field and kicked a field goal to tie. On the succeeding possession NU benefited from a 20-yard pass by quarterback Robert Koehler to Marshall Underhill—a very long passing play at the time. Several plays later Koehler carried the ball across Iowa's goal, and NU held on to beat Iowa 20-13, sparking celebrations across campus and dancing on the field by the students.

When it faced Purdue a week later, Northwestern was 5-0 for the first time since 1905. Driscoll had returned to the squad, and Northwestern routed Purdue 38-6. The team now had a shot at not only the conference title, but at an undefeated season and a national championship as well. All that stood in its way was Ohio State.

Northwestern had played Ohio State the three previous years, and had been soundly defeated in all three games. The team traveled to Columbus, hoping to avenge their earlier losses and to secure a perfect season. Unfortunately, 1916 was Ohio State's year. The Buckeyes were also undefeated and were enjoying the play of Chic Harley, one of the greatest players in Ohio State history.

The game, played November 25, was for the conference championship between two undefeated heavyweights, one expected in its position, the other a stunning surprise. Evanston was in a state of near hysteria. Northwestern had chartered a special train to take students and fans to Columbus for the game. Two hundred students boarded, as did several high-profile alumni, including James Patten and former Evanston Mayor William Dyche.

The game was so big that the thousands of NU fans left behind in Evanston staged a live simulation of the game inside old Patten Gymnasium. Walter Eckersall, the former college football great who was the lead football columnist for the *Chicago Tribune*, described the ersatz Northwestern-Ohio State game in the *Tribune* on the day before the game: "The big indoor field of Patten Gymnasium will be used as a demonstration field. Two teams, one representing the Purple and the other Ohio State, will line up at the call of time, and as telegraphic reports come in the imitation elevens will carry out the game. In the event of victory, the Evanston fans polled have not yet decided whether to join in tearing up the town or to make an effort to save the Athens of the west from total destruction."[1]

For better or worse, the NU faithful would not have to make that decision. Over 15,000 people showed up for the real game, and expected a slugfest between Driscoll and Harley. They weren't disappointed. Harley scored first, drop kicking a field goal from the 33-yard line. The

score remained 3-0 for much of the remainder of the game. Driscoll had been held in check by Ohio State's big and experienced defensive line. Late in the fourth quarter, however, Driscoll saw a break and drop kicked a goal from the 40-yard line, tying the game. Soon after the score NU punted, and Harley ran back the punt 67 yards for a touchdown; things quickly unraveled for the Purple after that. Ohio eventually put the game away, 23-3, and was the only team that prevented Driscoll from scoring a touchdown during the season.

Despite the loss, the game marked a resurgence, however brief, for Northwestern football. For the first time in over a decade the team had played a national marquee match, and for the first time since 1905 the team finished with a winning record and a very close second place finish in the conference.

The night after the Ohio State game the team elected Driscoll to be captain of the 1917 squad. However, as America neared its entry in the First World War, Driscoll left Northwestern and joined the Navy and was stationed at Great Lakes. When Driscoll left Northwestern in 1917 the team was without its greatest star, but it was still loaded with veteran talent. It was Coach Murphy's fourth year, and many of his recruits had now matured and were carrying the team. The season started off badly, though; after its victory over Lake Forest, NU suffered a blowout loss to Ohio State. Returning home, the team lost narrowly to Chicago, and fans began to wonder if Northwestern could keep up in the conference without Driscoll.

The doubters were answered the following Saturday, when Northwestern traveled to Purdue and beat the Boilers, 12-6. Northwestern then hosted, and beat, Michigan State and Iowa, securing its second straight winning year. The season finale was against Michigan, a team that had won eight games and was a favorite to win. The game was one of the best the Purple ever played at Northwestern Field. NU beat the Wolverines, 21-12.

The 1918 season began with a tie against Driscoll's Great Lakes team, but the Purple had worse luck the following week, when it hosted Municipal Pier. With the United States at the height of its involvement in World War I, many of the nation's best football players were enlisted in military service, and the academy and base teams such as Great Lakes and Municipal Pier swelled with talent. Municipal Pier swamped NU, 25-0.

Northwestern regrouped with an easy win against tiny Knox College, and then faced its toughest test of the season: a homecoming game with rival Chicago. On a muddy field the Purple overpowered Chicago, winning 21-6. Sam Peyton scored two of the team's touchdowns, including a 55-yard interception return. According to one viewer, "The Purple attack was aggressive, and the passing was excellent considering the conditions of the field."[2] A loss to Iowa concluded the season. After two strong, winning years Northwestern split the 1918 season, but the program still looked like it would continue to ride the success it found with Driscoll and Murphy.

Murphy, however, resigned after the season. He later became coach at the University of Kentucky. NU picked Charles Bachman as Murphy's successor. Bachman was one of Halas and Driscoll's teammates on the Great Lakes team NU had just played. Paddy Driscoll briefly joined Bachman as an assistant coach at NU.

Bachman's era at Northwestern was a brief one. The team managed wins over little DePauw and a struggling Indiana team, but lost four straight in the conference, and closed with a loss in New Jersey on Thanksgiving Day to Rutgers. Bachman left after his 2-5 campaign, but his stint with Northwestern was the beginning of a long coaching career. He was hired the next year by Kansas State, and while at Kansas State he gave his new team a brand new nickname: *Wildcats*. He also became the second former NU coach to write a widely-read football tactics book: *The Z Formation*, based on his own (now very obscure) creation. Bachman went on to coach at Florida, then at Michigan State.

Northwestern hired Elmer McDevitt, a Minnesota lawyer, as an interim coach. McDevitt's team won a warm up game with Knox College before hosting Minnesota and opening the Big Nine season. It was the first time the team had played Minnesota since the 1905 disaster. Northwestern stunned the Gophers, 17-0.

The Purple hosted Notre Dame, a team it had not faced in 17 years, for the 1920 season finale. The game is notable because it marked the final appearance of the Irish's legendary player, George Gipp. Gipp suffered a shoulder injury the week before, had a cold, and was not in the lineup for the game in Evanston. Both Notre Dame and NU fans began chanting for the Gipper to be put into the game (Notre Dame won easily, 33-7). Finally, late in the fourth quarter, Coach Knute Rockne put in Gipp. Though weak and unable to run, Gipp did manage one play. That play was a 55-yard pass that the receiver ran another 15 yards with after catching. The 70-yard play was one of the longest passing plays up to that time. As Gipp threw the ball, the Northwestern defenders, rather than tackle the clearly ill and injured star, carried him slowly to the turf. After the game Gipp contracted strep throat, and then pneumonia, and died on December 14.

McDevitt's second season was a failure. The team beat one Chicago team—meager DePaul— but lost to the Chicago rival that really mattered. The Maroons bludgeoned Northwestern, 41-0. After tallying a 3-10 record over his two years, McDevitt left Evanston. The Purple was again without a coach, and another attempt to rebuild the program had not ended well. The situation was so bad that the university convened a committee to investigate the problem with Northwestern's football program. Walter Paulison's *The Tale of the Wildcats* summarizes the committee's conclusions:

> The questions are these: 'What is the matter with Northwestern athletics? Is it not possible to do something to improve the situation?' In making this study of athletics at Northwestern, we have had in mind chiefly the situation with reference to football, since it is the sport in which the greatest interest naturally centers. . . . Six major reasons for Purple shortcomings on the athletic field:
>
> 1. The abolition of football at Northwestern in 1906 and 1907.
> 2. The absence of a common understanding on the part of the faculty, alumni, and students as to the importance of intercollegiate athletics.
> 3. Inadequate administrative organization with undefined relationships.
> 4. Frequent coaching changes & lack of continuity in coaching systems.
> 5. Difficulty utilizing the professional schools on the Chicago campus.
> 6. Lack of real University spirit.[3]

The committee recommended that the school make an organized effort to promote "University spirit" at Northwestern and that the alumni make every reasonable attempt to persuade students to come to NU and to join the team. They also took the unprecedented step of hiring a year-round, full-time head coach for football. Prior to 1922 Northwestern's coaches had been faculty members or seasonal, part-time employees.

The school could not have made a better choice for its new coach. Northwestern hired a local high school coach, Glen Thistlethwaite, who took over in early 1922. Thistlethwaite brought an entirely new approach to the program, grim-faced, serious and disciplined. He demanded that Northwestern's recent misfortune on the field, its relatively small size, and its increasingly restricting admissions standards would not deny the team the ability to improve and to build and sustain athletic excellence to match its growing academic reputation.

He started his rebuilding plan by implementing spring practice for the first time in the school's history. Recruiting for the team picked up, and the school spirit around football, which had peaked in 1916, began to return. The results began to show, slowly at first. The 1922 team was the first since 1918 to avoid a losing season, winning against Monmouth College and Beloit and whipping Purdue, 24-13. Although the Purple lost again to Chicago, the game was a closely-fought one.

Most impressively, Northwestern held Minnesota, a veteran team with far more power, to a 7-7 tie in 1922. Walter Paulison described NU's tying score:

The Gophers scored early and seemed to be on their way to a second touchdown, with only three yards separating them from it. Otis McCreery hit the Purple line, broke through, and charged over the goal, but somewhere en route he lost the ball. The erratic leather popped out of the pile and straight into the hands of Chuck Palmer, who was standing two yards in the end zone. Palmer swung to his right and started down the west sideline toward the Minnesota goal 102 yards away. Earl Martineau, fleet Gopher back, cut diagonally across the field in furious and desperate pursuit, and as they crossed midfield he had closed the gap dangerously. . . Palmer turned and flattened him with a perfect straight arm. The impact caused Chuck to stagger, too, but he regained his stride and sped on to a touchdown.[4]

The 1923 season might have been seen as a small step backwards. Northwestern only managed two wins that year, the second coming against Lake Forest—the final time that Northwestern met its first-ever intercollegiate rival in a game. But as one tradition came to an end, another was born. The Lake Forest game, held at Northwestern Field, marked the first "Dad's Day," which would be an annual tradition at Northwestern for over 60 years.

NU was now facing a demand for seating that Northwestern Field could not accommodate. By 1923, football's popularity had returned to campus, and the 10,000 seats of the wooden bleachers had been increased with additional stands and standing room only games. Twenty thousand spectators had jammed into the stadium in 1920 to see the game with Gipp and Notre Dame. The 1923 game with Illinois also had a featured star. Red Grange was becoming a huge ticket draw for the Illini. Northwestern decided to move the Illinois game off campus, to the Chicago Cubs' home at Wrigley Field. In front of a school record 32,000 fans Northwestern fell to the Illini. In one memorable play Grange picked off what would have been a Northwestern scoring pass and returned it 91 yards for a touchdown.

The team had suffered a losing season, but its attitude was changing, and the level of discipline and the team's depth and overall quality was gradually increasing. Thistlethwaite was instilling pride and an eagerness to fight. The following season that persistent, relentless will to fight helped to earn Thistlethwaite's team its nickname, the title the team uses to this day.

Among Red Grange's Illini teammates who took on Northwestern at Wrigley Field was a backup halfback from Rockford, Illinois, named Ralph "Moon" Baker. Before the 1924 season Baker transferred to Northwestern and joined the Purple squad. Along with NU's captain, Bob Wienecke, and its veteran center, Tim Lowry, Moon Baker helped form the core of a team that redefined Northwestern Football.

The team played its first five games of the 1924 season at Northwestern Field and began by demolishing South Dakota and the Cincinnati Bearcats. Northwestern dropped a close game to Purdue and then edged out Michigan State and Indiana to secure a 4-1 record. This was little comfort, since the team's last three games were against three of the best teams in the nation.

On November 8, the Purple played Michigan at Ann Arbor and lost 27-0. NU returned to Evanston and began to prepare for Chicago. Stagg's team was challenging Illinois for the conference championship; in fact, Chicago had played Grange and the Illini to a 21-all tie the week before. Northwestern was expected to lose at Chicago by a worse margin than it suffered at Michigan.

Thistlethwaite, however, had his team ready. Northwestern stunned the Chicago crowd by playing the Maroons to what looked to be a scoreless tie until the last few minutes, when Chicago was able to kick a single field goal to squeak by Northwestern, 3-0. Even though the Purple lost, the honors went to Northwestern. Wallace Abbey, a recent Northwestern graduate who was a *Chicago Tribune* sports reporter, gave an account of the game the following day that is now legendary:

Something more than ordinary wildcats are required to subdue wildcats gone completely vicious, entirely aroused, by the temptation of a great prize, a big, juicy

piece of "meat." Let us call that "meat" the Big Ten football championship and consider the following situation at Stagg Field yesterday afternoon, to which 32,000 hoarse fans will attest today: It was the fourth quarter of the annual Chicago-Northwestern grid battle. Football players had not come down from Evanston: wildcats would be a name better suited to Thistlethwaite's boys. Baker was there, and he was the chief wildcat giving his supreme effort. Stagg's boys, his pride, the eleven that had tied Illinois a week ago, were unable to score. Once they had been on the 9 yard line and had been stopped stone dead by a Purple wall of wildcats.[5]

Abbey's description of the team was adopted by Northwestern almost immediately. It was the perfect metaphor for the "never quit, no matter the odds" approach the team had taken. The *Tribune* writers as well as Northwestern's students continued to use the nickname from that week on. The Purple became the Wildcats.

Northwestern's new name was cemented the following week, when the team hosted Notre Dame. Because of the limitations of Northwestern Field, NU held the Notre Dame game at the recently- finished Soldier Field. On November 22, 1924 Northwestern and Notre Dame played the first football game ever staged at Soldier Field. As with the Michigan and Chicago games, Northwestern was a heavy underdog. Notre Dame was nearly through an undefeated season, which would end with a victory in the Rose Bowl and a national championship, and boasted its best team ever. Coach Rockne was at the height of his career, and the Irish squad featured the legendary Four Horsemen backfield. The Wildcats, however, were not intimidated and shut down the Irish offense completely. Moon Baker kicked two goals in the first half, and Northwestern led 6-0 at halftime. In the second half Notre Dame finally scored a touchdown to edge NU by one point. A couple of plays from the end of the game, the Irish intercepted a pass and returned it for another score. Notre Dame won, 13-6, but Northwestern's showing had again shocked the crowd.

For Northwestern fans who came later (especially those who weathered the team's suffering during the 1970s and 1980s), the idea of a "moral victory" might not sit well, but Northwestern's 1924 stands against Chicago and Notre Dame were the epitome of the Moral Victory. They were signs that the school's program had finally arrived and was ready to compete with anyone. Northwestern's team captain, Bob Wienecke, years later referred to the 1924 Wildcats as "a very average team which developed a spirit that carried it to superb heights in the Chicago and Notre Dame games." Competing and holding one's own on the field was one level; the next was actually winning, and Thistlethwaite's team was ready to advance to that level the following year.

There was tremendous excitement around the 1925 season, and the football program appeared to be in great shape. Tim Lowry and Moon Baker both returned to the team were joined by Leland "Tiny" Lewis. At the end of 1924, Northwestern approved the construction of a new stadium, to be built after the '25 season. Fans and alumni were overjoyed that the school would soon have a state of the art football stadium. However, for the 1925 season the school still had to contend with Northwestern Field. Northwestern decided to play two of its smaller preseason games and only one conference game on campus; the other home games were moved to Chicago.

The Wildcats, winning both of their preseason games, again traveled to Chicago and again lost, 6-0. NU then hosted Tulane. The game, originally scheduled to be played at Chicago's Marshall Field, was moved to Soldier Field and was another loss for NU. Northwestern hosted Indiana on Halloween. The team needed a win—it was losing momentum and had an even record for the year. In a thriller, Northwestern beat the Hoosiers in the last game ever played at Northwestern Field. Crews began dismantling the old wooden stands within days.

The following week Northwestern played host to Michigan at Soldier Field. Just like the previous year NU was a heavy underdog. Prior to its match with the Wildcats, Michigan had defeated Michigan State (39-0), Indiana (63-0), Wisconsin (21-0), Illinois (3-0), and Navy (54-0). Michigan's coach, Fielding "Hurry Up" Yost, later called the team the best he had ever coached.

At least 45,000 (some sources putting the number as high as 75,000) fans had bought tickets for the game, which was shaping up to be one of the biggest of the season in the Midwest. But only 20,000 made it to Soldier Field for the game. On Saturday, November 7, 1925, the Chicago area was hit by a terrific thunderstorm and monsoon-like rain. Many fans chose not to endure the storm outside. The Soldier Field turf was wrecked and driving wind and rain hampered the entire game.

Immediately it was clear that both teams' passing games were useless due to the weather. Thistlethwaite had also decided that if Northwestern had the ball too deep in its own territory, the team might quick kick, even on first down. In fact, Northwestern chose to punt on the very first play of the game. Tiny Lewis kicked, and Wolverine quarterback Benny Friedman attempted to return it and fumbled. The ball was recovered by Wildcat senior Frank Mathews, who raced through the mud toward the Michigan goal.

Unfortunately, the field was so muddy that when Mathews recovered the Michigan fumble, he rose caked in mud and unrecognizable. Wildcat captain Tim Lowry, unable to see Mathews' purple jersey, tackled him at the Michigan 2-yard line. After three unsuccessful tries for the touchdown, Lewis kicked a field goal from the Michigan 18-yard line. When the ball barely cleared the crossbar, NU had accomplished what no other team had or would against Michigan in 1925: it had scored.

NU and Michigan's defenses, bolstered by the mud and water, tightened. By the third quarter, the Wildcats had the ball, but had been backed up to their own 1-yard line. Punting from the back of the end zone would have been potentially disastrous. Lowry came up with a bold plan. Football rules at the time stated that a team suffering a safety lost two points, but recovered the ball on its own 30-yard line. Lowry instructed Lewis to take the snap and down the ball in the end zone. With the score three to two in favor of NU, the Wildcats regained the ball and eventually punted it well into Michigan territory.

The rest of the game was a series of punts by the teams, followed by stalwart defense. Northwestern put all 11 of its players on the defensive line, reverting to a strategy used in the 1890s. The defenses held, neither team came close again to scoring, and Northwestern pulled off one of the biggest upsets in its history. Yost was furious and played a major role later in getting the rules of football changed, so that a team that has suffered a safety must free kick the ball to its opponent.

Northwestern concluded the 1925 season on the road, beating Purdue, 13-9, and losing another close game to Notre Dame. The Wildcats' three Big Ten wins matched Michigan's conference record; however, Michigan had the better overall record—except for its disaster at Soldier Field, it finished the year unscored upon. The Big Ten awarded its title to the Wolverines, even thought Northwestern had won the head-to-head match.

Its second-place finish was still a major triumph for NU. In its four years under Thistlethwaite the team had gone from a disorganized program locked in a series of futile attempts to rebuild to a legitimate championship contender. In 1922, the program had finally received the needed support from the university's administration. In 1924, the team had turned a corner and began to build the fan base and momentum necessary for a rising program. The 1925 season brought the culmination of the school's efforts. The Wildcats had been reborn, and they were about to play their greatest seasons yet.

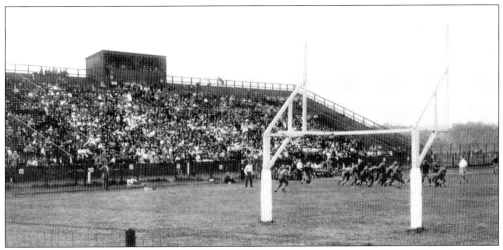

Northwestern plays a game in the 1910s at Northwestern Field on Central Street. Northwestern Field's wooden stands, originally built to hold 10,000 fans, were eventually increased to accommodate nearly 20,000. The original Northwestern Field stands cost $25,000 to build in 1905. The team played here until 1925.

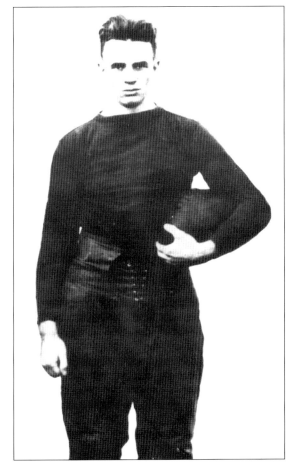

Paddy Driscoll was one of NU's earliest NFL stars. After leaving NU, Driscoll played amateur football for Great Lakes (with future Bears owner George Halas), baseball with the Chicago Cubs, and pro football in Hammond, Indiana. In 1918, Great Lakes played host to Northwestern. Driscoll took on his former team on a muddy, almost unplayable field. The game ended in a scoreless tie. Driscoll's team remained undefeated throughout the season, and he and Halas led their team to the 1919 Rose Bowl. Driscoll later joined the Chicago Cardinals before switching to the Bears in 1926. Paddy Driscoll was named to the NFL Hall of Fame in 1965.

Paddy Driscoll throws a pass against Lake Forest College at Northwestern Field, 1915. The game was the beginning of Coach Murphy's second season at NU. Murphy stayed on for five seasons, the longest tenure for a Northwestern coach to that time.

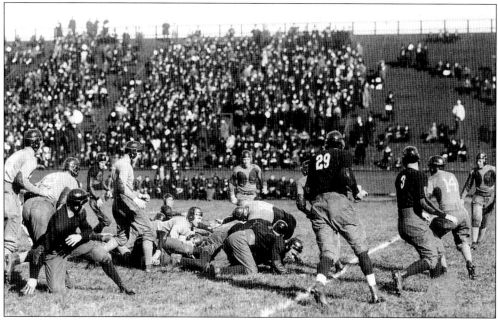

Northwestern also opened with a win against Lake Forest in 1916. During the 1916 season fans first heard Donald Robinson's fight song, "Rise Northwestern." Robinson had written it in 1913, but he didn't want his song to compete with the popularity of "Go U Northwestern." Van Etten wrote "Go U Northwestern" after watching NU beat Indiana and hearing the Hoosier fight song. The song debuted on November 23, 1912, during the Illinois game. It was such a hit the band played it twice. "Go U Northwestern" was not the team's original fight song, however. The band first played "Northwestern Battle Cry" at Sheppard Field in 1904, but the song soon slipped into obscurity.

Wilbur Hightower was the hero of the "Go U Northwestern" game. After the band played NU's new fight song at halftime, the celebration continued into the second half, when Northwestern beat Illinois and notched its second win of the season. Wilbur Hightower scored the only points in the game, and gave Northwestern a six to nothing win. Hightower's powerful running would help Northwestern through a difficult period in the seasons just before World War I.

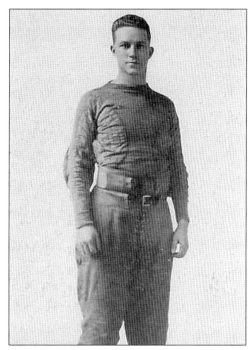

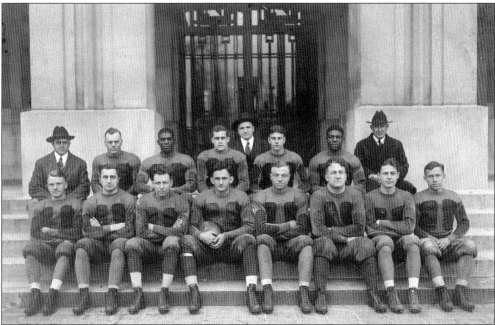

The 1918 team was young; few starters had returned from 1917. However, the team did have some new players that showed considerable promise. Among them was Sam Peyton (second row, second from right), a halfback who won a starting position that fall and played for the Purple for two years. Black students had played on NU's football team as early as 1893, and by 1910 players such as Roy Young (a star player for the Illini who transferred to Northwestern in 1909) were making substantial contributions on Northwestern's field. However, before Coach Murphy's teams no black athlete had enjoyed such a prominent place on the team's lineup.

(*left*) Just one year before they became the Wildcats, the Northwestern players were known as . . . the Northwestern Bears. The Chicago Bears had taken their new name just a couple of years before, and NU considered following suit. For the 1923 season the team had a live bear mascot. One of the NU cheerleaders is seen here with the bear cub and a group of amused students on the Northwestern campus.

(*below*) Pictured is the muddy triumph over Michigan at Soldier Field, 1925. After the game the Wildcat fans waged riots across Chicago, Evanston and on campus. Ecstatic students returned from Soldier Field and doused an abandoned fraternity house with oil, setting the wooden building on fire. By the time firemen arrived, students had thronged the fire and were chanting and singing wildly. The firemen turned their hoses on the rioters in an effort to calm them. The students overpowered the stunned firemen, took their axes, and destroyed the fire hoses. Students also attempted to burn down what remained of Northwestern Field, but were turned back by waves of police. The mob moved into downtown Evanston and built a bonfire so large that the heat melted the overhead wires for the city's trolley system, sending the trolley supports crashing. The Evanston chief of police had to send in men armed with tear gas to disperse the fans.

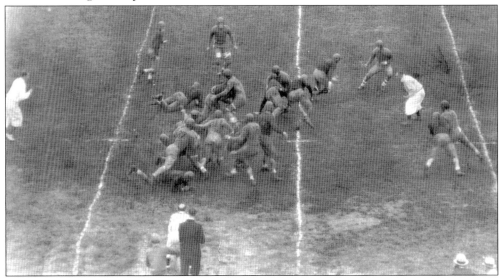

THREE

The Golden Age

1926–1936

Northwestern's successful 1925 season, particularly the tremendous upset of Michigan, added to the growing popularity of the football program, both on campus and throughout the Chicago area. The University's plan to build a remarkable new football facility was perfectly timed.

Crews began to dismantle parts of Northwestern Field immediately after the Wildcats played their 1925 game with Indiana. Construction continued on the new grounds, tentatively called Northwestern Stadium, throughout the following year. William Dyche organized fundraising for the facility, just as he had led the drive for Northwestern Field in 1904 and 1905. By the summer of 1926, however, construction was behind schedule and over budget, with costs approaching two million dollars. The school decided to unveil the new stadium in stages, with the first stage, the east and west stands, ready by the start of the season. The west side press box and the west side towers would be completed before the 1927 season.

Thistlewaite's team had lost some great players, including its All-American, Tim Lowry. Another NU star, Tiny Lewis, had agreed to sit out the 1926 season for academic reasons. Northwestern, which had always been an academically demanding school, was tightening its scholastic requirements even more. The Wildcats, however, were still stocked with talent. The veterans on the team included player number 22, Moon Baker, who returned for his senior season and was named captain.

While workmen frantically continued to build the new stadium, the Wildcats practiced at old Roycemore Field for the start of the season. On October 2, 1926, a crowd of over 18,000 entered the unfinished Northwestern Stadium and sat beneath cranes and scaffolding to watch Northwestern beat South Dakota for the third straight year. Moon Baker needed to play only in the first half and showed that he was in prime form.

Northwestern's president, Walter Dill Scott, who had been a key member of the football team in the 1890s, raised critics' eyebrows when he announced that Tiny Lewis had fulfilled the requirements for returning to the team. Scott served during one of the greatest periods in the University's history, overseeing unparalleled expansion on both the Evanston and Chicago campuses, as well as a rise in the school's reputation as an academic powerhouse. Scott was also a fervent football fan and made every move ethically possible to ensure that Northwestern maintained its competitiveness on the field. Perhaps his greatest critic was Chicago's Coach Stagg. By 1926, Stagg faced withering support from the University of Chicago's administration, which was beginning its effort to de-emphasize athletics. Stagg decried the support Northwestern's administration gave its team, and he leveled baseless charges against the school of improper recruiting. As Northwestern's new stadium neared completion, rumors grew that Chicago might break its ties with Northwestern and refuse to play the team at all. While Stagg insisted such a decision would be based on his allegations that Northwestern recruited unfairly, the reality was that Stagg could see support in the city of Chicago shifting dramatically from the Maroons to the Wildcats, and he wanted no part of being Northwestern's local warm-up game.

With the exception of a heartbreaking loss to Notre Dame (the third straight close loss to the Irish), Northwestern plowed through its October 1926 games, swarming its opponents with

a balanced run and pass attack and winning by multiple touchdowns. By the time the Wildcats reached their November 6 showdown with Purdue, Northwestern's offense, specifically Moon Baker's triple attack, was the talk of the Big Ten. Purdue also entered the contest undefeated in the conference, and the winner would have a clear shot at the Big Ten title. Coach Thistlethwaite led the 'Cats through two-hour secret night practices under floodlights to prepare for Purdue, and the campus had been whipped into a frenzy. The game was homecoming and Dad's Day, and students built one of the largest bonfires ever seen in Evanston. Homecoming banners predicted "Victory by the light of our Moon," referring to the Wildcat captain.

Northwestern had a 14-pound average weight advantage over the Boilermakers, and this edge in size, combined with the Wildcats' expert passing attack, doomed Purdue. Baker was nearly uncontested on the field, running and throwing at will; he also kicked a field goal during the Wildcats' 22-point shutout victory. The *Chicago Tribune's* Walter Eckersall marveled at the coordination between Northwestern's line and its backfield. The dominance the Wildcats showed over a very strong Purdue team led Eckersall to declare that the 1926 Northwestern team was "the best Purple eleven in its football history."[1]

Even before the homecoming festivities ended, Northwestern fans were looking forward to the following Saturday, on which Evanston would host the University of Chicago, possibly for the final time. One word was used by the media, the team, alumni, and fans to describe the game: revenge. The game was a chance for payback, not only for blowout losses the Maroons had handed Northwestern in years past, but for the three very close shutout defeats the teams' seniors had endured from Chicago. Baker in particular looked forward to scoring against the team that had so far thwarted him from breaching the end zone. For his part, Coach Amos Alonzo Stagg had prepared his team all year for this game, knowing what was at stake.

The Chicago game had been picked at the beginning of the season as the dedication game for Northwestern's new stadium. Several weeks before the game the trustees of the University voted to name the new facility Dyche Stadium, after William Dyche, Northwestern's business manager who had been so instrumental in planning and raising funds for the school's football fields for a quarter century. As it had with the dedication of Sheppard and Northwestern Fields, the University hosted a variety of pre-game dedication events, including a special marching band performance and speeches by the mayor of Evanston and the president of the University. William Dyche also spoke, thanking Northwestern for the honor and officially dedicating the stadium. The crowd of 47,000 on hand for Dyche Stadium's inauguration was by far the largest to have seen a football game in Evanston.

The outcome of the game was decided at kickoff. Chicago's quarterback kicked deep, the ball coming near the NU 12-yard line. Gus Gustafson, the Wildcat's versatile and quick halfback, caught it and slashed his way up-field, racing 88 yards for a touchdown. Less than 10 seconds into the game, NU had scored. As the crowd began a deafening roar the Wildcat band began to play and hundreds of purple balloons were released. On the ensuing drive Chicago fumbled, and Northwestern recovered on the Chicago 24-yard line. The turnover resulted in a field goal by Baker.

The Wildcat defense held Chicago, and when Northwestern got the ball, Baker took to the air, first with a pass to Waldo Fisher, then with a touchdown strike to Gustafson. On NU's next possession Baker launched a 50-yard bomb to Fisher. As the Maroons reeled back again toward their own goal, the Wildcats snapped the ball directly to Gustafson. Gustafson completed the trick play by rifling a pass to Baker for a touchdown. By the end of the first quarter, the Wildcats had outscored Chicago, 24 to nothing.

Northwestern began the second quarter by punting; however, Chicago fumbled the return. Gustafson recovered and streaked past the goal for another touchdown. Later in the game Chicago managed one touchdown, and Tiny Lewis capped the scoring for the Wildcats. The final score, 38-7, featured as much scoring by Northwestern as the team had managed against Chicago in the previous 10 years, combined. Baker and the team had tallied 200 passing yards.

Coach Stagg, having been served up as the sacrifice for Northwestern's grand dedication event, made good on his threat and announced that he would never again play the Wildcats. That decision immediately took Chicago out of the city's football spotlight, and the Maroons began their 13-year football decline. By the mid-1930s Stagg could no longer tolerate the Chicago administration's handling of his athletic department and left the program he created. The university disbanded its football program in 1939 and left the Big Ten in 1946.

For Northwestern, however, the game was a monument to the program's turnaround. In one week the Wildcats became the headliners of Chicago-area football, a position they held until the mid-1950s, when the popularity and attendance for Chicago Bears games finally overtook them. The 'Cats were in a tie with Michigan for the lead in the Big Ten. In 1925, despite beating the Wolverines, Northwestern finished a close second to Michigan in the conference. Now Northwestern and Michigan were both undefeated in the Big Ten and were not scheduled to play each other. Both teams had one game left: Northwestern traveled to Iowa, and Michigan played Minnesota.

Over 1,000 Northwestern fans took a Northwestern Alumni Association special train to Iowa for the season finale. As they had for most games in 1926, the Wildcats struck early and took a seven-point lead. Iowa rallied, held Baker and the rest of NU's offense in check for much of the afternoon, and scored as well—missing the crucial extra point, however. Northwestern held on and beat Iowa, 13-6, securing a share of its second Big Ten title. (Michigan also won its finale, forcing the 'Cats to share the championship.) Immediately after the game, the jubilant Wildcats celebrated with a dinner and named Gus Gustafson their captain for the 1927 season. For his heroics during the 1926 season Moon Baker was named an All-American, as was Wildcat tackle Bob Johnson.

Gustafson returned to lead the team in 1927, but Coach Thistlethwaite did not. Thistlethwaite opted to leave Northwestern for Madison and the Badger head coaching job. At Wisconsin Thistlethwaite never found the same level of success he attained at Northwestern, and in 1934 left the conference, spending the rest of his career at Richmond College, Virginia.

Northwestern tapped Dick Hanley, a former Marine coach, as its leader. As a player Hanley was a star halfback for Washington State. At the time NU approached him he was the head coach at the Haskell Indian Institute and had coached alongside Pop Warner, the former Carlisle Indian coach. Hanley brought to Northwestern the offense that Warner had perfected, an off-balance formation that placed the halfback to the rear and outside of the ends, in a new position Warner nicknamed the wingback.

Facing its first coaching change in five years and having lost Moon Baker, the team faltered somewhat in 1927. However, it was a testament to how far the program had improved under the direction of Thistlethwaite (and with the support of President Scott) that Hanley's first season was a "reloading" year, and not another rebuilding effort. In addition to Gustafson, Waldo Fisher and Tiny Lewis also returned and formed a solid offense. The team started the season well, taking its first two home games and claiming a rare win in Columbus, beating the Buckeyes, 19-13. They finished the season, however, with four wins and four losses, and couldn't repeat their title performance.

The Wildcats enjoyed a winning season in 1928, primarily because of the weakness of its non-conference opposition. NU shut out Butler and Kentucky, and throttled Dartmouth, 27-6. However, it lost its only two road games of the season, narrow defeats to Illinois and Indiana, and finished 2-3 in the Big Ten.

The following year the team continued its mastery of Hanley and Warner's offensive system, and the depth and talent of the players had risen to the level Glen Thistlethwaite had achieved by his final year at Northwestern. Red Woodworth, Hank Bruder, and Dallas Marvil all gained the experience that would allow them to help keep the team at the top of the conference.

The 1929 season started with one of the strangest events to be held at Dyche Stadium. Before World War II, major college teams occasionally held double-header games, with the varsity team playing another college in the morning, followed by the reserves playing a different

college later in the afternoon. NU had practiced this as well. On October 5, 1929, Northwestern's varsity was slated to play Indiana's Butler University, and after that game the Wildcats' scrubs were to face Iowa's Cornell College. The varsity team easily beat Butler, 13-0. However, after the first couple of plays it became obvious that the reserve team was outmanned against Cornell's varsity. As dusk settled over Evanston, Coach Hanley decided to switch teams, returning his varsity squad to the field. The Wildcats, though exhausted from their earlier match against the Bulldogs, managed to beat Cornell, 27-18, providing Northwestern with the only true varsity double-header in its history.

The Wildcats played to another winning season, highlighted by another strong win in Columbus and a shutout against the Illini. However, as it had the two previous seasons, Indiana proved an unexpected obstacle and upset Northwestern again. The 'Cats still reveled, however, in a successful year and another All-American honor—this one for guard Henry Anderson.

Northwestern entered the 1930 season as the favorites in the Big Ten, and the team was now stocked with talent. Hank Bruder, a spectacular half back who had broken his leg at the beginning of the '29 season, had returned to captain the team. One of the newcomers to the team, Ernest "Pug" Rentner, was an explosive fullback and was expected to contribute immediately. Another newcomer, Fayette "Reb" Russell, was a transfer from the University of Nebraska. By age seven Russell broke horses and worked on his family's Oklahoma ranch. He enrolled at Nebraska in 1927 and by the 1928 season had earned a spot as Nebraska's quarterback. Russell wanted to attend Northwestern, however, and after transferring was given a starting spot on Hanley's team.

The season began with one of its greatest challenges when Northwestern hosted Tulane at Dyche Stadium. Tulane had come to Soldier Field in 1925, NU's breakout year, and had handed the Wildcats their only home loss. The Green Wave were the 1929 Southern Conference champions and were favored to repeat. They were coached by Bernie Bierman, who later became Minnesota's head coach and led the Gophers to multiple national championships. After a scoreless first quarter, Northwestern's line began to dominate, harassing Tulane's backfield. Under pressure, Tulane's quarterback threw a bad pass, which was intercepted by Hank Bruder and returned 54 yards for a touchdown. Pug Rentner, in his debut, dove for Northwestern's second touchdown. Reb Russell, powered by Dallas Marvil's blocking, menaced Tulane all day. The Wildcats' 14-point shutout set the tone and raised the expectations for the season, and some fans began talking about the possibility of a national championship.

The conference held its opening games the following week. Ohio State, also predicted to do well in 1930, visited Evanston to begin the title run. Just before the game began, though, Hank Bruder's bad luck struck again. This time, however, it wasn't another broken leg that sidelined Bruder, but smallpox. Bruder was immediately quarantined, and the rest of NU's team received supplemental vaccinations. Shaken, and without their captain, the Wildcats took the field with Bruder's backup, senior Lee Hanley, at halfback. Hanley took the opportunity to run wild, scoring a touchdown. Rentner also scored on the Buckeyes, throwing a bomb to Frank Baker. NU ended Ohio State's title hopes with a 19-2 win.

From that game on, Northwestern seemed unstoppable. The Wildcats traveled to Champaign the weekend after the big victory against Ohio State and dismantled Illinois, 32-0. They returned to Dyche and snuffed Centre College, 45-7. By the time the team prepared to travel to Minneapolis for their showdown with Minnesota, NU was considered one of the best teams in the country and was a heavy favorite over Minnesota, itself a very talented team. Anticipating one of the most important football games in the Midwest in years, scalpers began charging up to $25 for a pair of tickets to the Northwestern-Minnesota game, an unheard of amount at the time.

The game was Minnesota's homecoming, and the Gophers anticipated an upset. Fortunately for Northwestern, Captain Bruder was well enough to return to the team, and the rest of the Wildcats were at the top of their form. NU started slowly, but at the beginning of the second quarter the team exploded. Pug Rentner began the assault with a 40-yard touchdown strike to Frank Baker. Later in the quarter the Wildcats stunned the Gophers and the crowd when

Rentner again passed to Baker, this time laterally. Baker took the ball and heaved it to Lee Hanley for a 72-yard score. Reb Russell continued to tear at the Minnesota line and drove methodically to the Gopher four-yard line. There the 'Cats pulled out another surprise, snapping the ball to guard Red Woodworth. Woodworth, known as "Red" because he refused to wear a helmet, leaving his bright red hair exposed during games, took the ball and pounded it across the goal. NU's 27-6 win increased the speculation that Northwestern was on the cusp of a national title.

On November 8, the team visited Indiana and ruined another Big Ten homecoming. The Hoosiers feared Northwestern's aerial assault but were startled when NU instead began running the ball, and running it at will. Indiana was forced to play eight men on its line, but to no avail. Northwestern ground out 12 first downs in the first half alone and coasted to a 25-0 rout.

The Wildcats hosted their final conference opponent, Wisconsin, in heavy fog. With the visibility at Dyche Stadium so poor that it was impossible for spectators to see who had the ball, the Badgers scored first, and led at halftime, seven to nothing. Among the spectators trying to sort out the action was Notre Dame coach Knute Rockne. Rockne's Irish were in South Bend playing Drake at the time and were scheduled to play Northwestern the following week. Rather than coach his team, Rockne chose to turn over his duties to his assistants and travel to Evanston to scout his most dangerous opponent of the season. By the second half the fog had lifted (from the stadium and from the team) and the Wildcats cranked out 20 unanswered points, defeated Wisconsin, and secured their third Big Ten title. They had done so by outscoring their opponents, 182-22.

Parties erupted throughout Chicago. Students built a massive bonfire in Evanston, and the school announced that classes for Monday afternoon were canceled. Northwestern held an all-school dance Monday night in celebration of the championship, and speeches were given, both in praise of the team and previewing the team's finale with Notre Dame the next Saturday at Dyche Stadium.

Pep rallies were held throughout the week in anticipation of the Notre Dame game, and scalpers who had charged $25 for a pair of tickets to the Minnesota game were now charging $25 for *single* tickets for the Northwestern-Notre Dame game, with 50-yard seats commanding up to $110 each. Notre Dame was also undefeated in 1930, and Knute Rockne enjoyed his most powerful Irish squad ever. The game was now clearly for the national championship, the only time in history that such a game was played at Dyche Stadium. The school even obtained a live wildcat that it displayed on the sidelines during the game. 48,000 spectators, another Dyche Stadium record, came to watch history.

Unfortunately, history proved to favor the Irish in 1930. The Wildcats twice got to the Notre Dame 5-yard line, only to go away without points. Northwestern also kept Notre Dame scoreless until midway through the fourth quarter. With 7 minutes to go a Notre Dame 27-yard touchdown run ended Northwestern's national title hopes. A Wildcat desperation play led to a turnover and one more Irish score, and Notre Dame took a 14-0 win and the national championship.

Coach Dick Hanley was near tears after the game. He told reporters, "I'll have to admit that we tossed one out the window after showing the way until the last stages of the game. . . . The outcome has sort of bowled me over."[2]

Although the season was over for Northwestern's varsity, NU football fans had one more game to enjoy in 1930. By the beginning of the season the Big Ten and other conferences had begun staging games, both regular and exhibition, to benefit charities and Great Depression relief efforts. The Shriners' annual game was made into a charity event in 1930, to be held Thanksgiving Day at Soldier Field. For an opening attraction, an alumni team from Notre Dame challenged Northwestern alumni to form a team and play it prior to the Shriners' game. Even though the NU Alumni team included Tim Lowry and Moon Baker, the Irish squad, loaded with members from Notre Dame's national champion teams, was the favorite. At 10:00 Thanksgiving morning, the Alumni 'Cats faced the Notre Dame All-Stars on snow-covered

Soldier Field and held the Irish to a scoreless tie.

After the disappointment of the close loss to Notre Dame faded, the team enjoyed its conference championship and the announcement that the Wildcats had three new All-Americans, a team record for one season. Reb Russell, Frank Baker, and Red Woodworth were honored, but Pug Rentner was overlooked. The Wildcat captain, Hank Bruder, had missed four weeks from smallpox, and so missed the chance to become a Northwestern All-American. Bruder's football career was not over, however, as he starred for the Green Bay Packers throughout the 1930s.

After the season rumors began that Dick Hanley might be named head coach for the University of California. Hanley denied the rumors, but it was revealed that Hanley was not under contract with Northwestern. He had only a verbal agreement with the school.

Irv Kupcinet was a quarterback on the 1931 team, but got into a fistfight with Coach Hanley's brother, and soon transferred. Kupcinet played for the Eagles and gained fame as a Chicago newspaper columnist.

The 'Cats were favorites to win the Big Ten in 1931. And just like 1930, the possibility of a national title would be raised, only to end in disappointment. The disappointment in 1931, however, would come from an unlikely source: college football's charity efforts for Depression relief.

The Wildcats began 1931 by hosting the University of Nebraska, a team they had not played since 1902. Although Reb Russell was motivated by playing against his former teammates, it was Pug Rentner who defeated the Cornhuskers. Within the first ten minutes of the game Northwestern scored three touchdowns, including 35-yard and 65-yard touchdown runs by Rentner. Nebraska eventually managed one score, but Northwestern coasted to a 19-7 victory.

However, it was not the Wildcat offense that caught the attention of most Dyche Stadium spectators that Saturday. Sitting among the fans was Chicago gangster Al Capone, who was facing tax evasion charges and whose career was nearing its end. To take his mind off his impending legal problems, Capone headed to Evanston to watch the season opener. The crowd, most of whom had lived for years under Capone's shadow, did not try to hide their contemptuous stares, and cheered when the gangster ducked out of the stadium during the third quarter. The next Monday the *Daily Northwestern*, mustering up a Hollywood gangster swagger, announced, "Get this, Capone, you are not wanted at Dyche Stadium nor at Soldier Field when Northwestern is host. You are not getting away with anything and you are only impressing a moronic few who don't matter anyway." Later that afternoon a grand jury convened and indicted Capone.

The next Saturday Northwestern had originally been scheduled to face the Irish in South Bend again. However, as part of college football's Depression relief work, Notre Dame moved its home game to Soldier Field, and Northwestern entered the Chicago stadium as the *visitor* for the only time in its history. Notre Dame was a university in mourning—the previous winter, weeks after the end of the 1930 season and the Irish being crowned national champs, Coach Knute Rockne was killed in a plane crash. The Irish, though without their legendary coach, were still heavy favorites to repeat as the nation's best, and Northwestern—while still the best in the Big Ten—was an underdog against Notre Dame.

Despite driving rain, 65,000 showed up for the rematch with Notre Dame. Soldier Field was decked out with pageantry; red, white, and blue bunting decorated the sidelines, along with blue and purple banners. Northwestern offered to conduct a tribute to Rockne, and Notre Dame accepted, and decided not to bring its band to Chicago. The Northwestern band faced the Notre Dame fans (who, naturally, took the east stands, while NU's fans took the west) and spelling out "HELLO," "NOTRE," "DAME," then played the Star Spangled Banner. The band then spelled out Rockne's name, and two buglers played taps.

The Irish and Northwestern spent the rest of the afternoon slugging in the mud and came away with a scoreless tie. The stalemate was an upset, favoring the Wildcats. NU avoided a loss to Notre Dame for the first time since its scoreless tie with the Irish in 1903. The game also ended Notre Dame's 20-game winning streak.

Though Northwestern could no longer claim a perfect record, its tie with Notre Dame gave the team the confidence and momentum to tear through the 1931 season. The team's next victim was UCLA, making its first trip ever east of the Mississippi. The Wildcats were so confident in their ability they started their reserves against the Bruins, substituting in their star players only briefly. Northwestern cruised to a 19-0 win.

The Northwestern defense notched its third straight shutout the next Saturday when the 'Cats blanked Ohio State in Columbus, 10-0. It was Northwestern's fourth win over the Buckeyes in five years, the team's best stretch ever against OSU. The Buckeyes sought revenge for the embarrassment it suffered in 1930, when Pug Rentner hammered the Buckeyes all afternoon. Ohio State coach Sam Willaman focused his team's effort toward shutting down Rentner, and at first it appeared to have been a good strategy; the Buckeyes held NU scoreless at halftime. However, after some adjustments and a fiery speech by Coach Hanley, the Wildcats overwhelmed Ohio State. Rentner was on the field for 59 minutes of the game, and he scored the game-winner in the third quarter, when he ran 50 yards for the touchdown.

Pug Renter next brought havoc on the Illini. Just one minute into the game, he raced 66 yards for the score. By the tenth minute Northwestern had piled up 25 points, and Coach Hanley pulled Rentner from the game. NU began substituting at will, but still managed another score when quarterback George Potter returned a kickoff 83 yards for the touchdown. Illinois fell, 32-6, and Northwestern was back on track for another conference championship.

Minnesota was also looking for the Big Ten title. Though an underdog when it traveled to Dyche, Minnesota had recently routed Wisconsin and Iowa. The Gophers had an offense almost as explosive as the Wildcats'. Minnesota showed just how explosive when it scored early in the first quarter against Northwestern, jarring the team and the fans. Shaken from the early and seemingly effortless Gopher touchdown, Northwestern fumbled in its own territory. The Minnesota offense, smelling blood, quickly tore 25 yards through NU's stunned defense and took a 14-0 lead.

Although Northwestern was able to make up one of the touchdowns with a score late in the second quarter, the team's seven point deficit at the end of the first half incensed fans. The homecoming crowd of 42,000 booed the Wildcats as they left the field, angering Hanley and the players. Hanley built on that anger at halftime by launching into one of the most dramatic, furious halftime speeches in the team's history. When the 'Cats returned to the field, they played as though their uniforms were on fire. The Gophers kicked off to start the half. Rentner took the kickoff and burned 95 yards across the field for a touchdown. However, the extra point sailed wide, and Northwestern still trailed by one point.

The Wildcats took the lead for good minutes later with a 47-yard ground drive for a touchdown, followed by Oli Olson intercepting a Gopher pass and returning it 50 yards for another touchdown. The scoring ended in the final minutes of the game when Rentner returned a Minnesota punt 70 yards for Northwestern's fifth touchdown. The crowd exploded and celebrated throughout Evanston well into the night.

After a scare against Indiana (NU edged the Hoosiers 7-6), NU began to prepare for the team's final scheduled game, against Iowa. However, as the team practiced for the Hawkeyes Northwestern announced that it had agreed to play an extra game on the Saturday after Thanksgiving for charity. As part of the ongoing Depression relief, Northwestern would play another Big Ten team at Soldier Field. The obvious opponent was Michigan, since the teams had not played in 1930 (and had split the conference title that year), nor would they play in 1931. However, Michigan coach Yost argued that Michigan should play a team in Ann Arbor while NU played another team at Soldier Field. With two large stadia filled, there would be larger gate receipts for the charity drive. The Big Ten agreed and arranged Purdue as Northwestern's opponent for the charity game.

Northwestern quickly disposed of its last regular season foe. The Wildcats marched into Iowa City and returned to their quick strike offense, notching a touchdown within three minutes and blanking Iowa, 19-0. After the rest of the Big Ten games had been played that Saturday, it

became obvious that, even if NU should lose the next week to Purdue, the Wildcats were guaranteed at least a share of the Big Ten championship. If Northwestern won the game, it would be in position to argue for a share of the national title, even with its tie against Notre Dame. The Big Ten proposed that Northwestern should play Southern California in the 1932 Rose Bowl. (The conference did not yet have a contract with the bowl.)

The Wildcats entered Soldier Field for the Purdue game shaken and injured—and not just from the regular season. The night before the game the team stayed in downtown Chicago, sleeping at the Chicago Beach Hotel. That evening ten players, including starting quarterback George Potter, boarded an elevator on the sixth floor for the lobby. The elevator's cable snapped, plunging the car six stories and smashing it into the hotel's basement. Luckily each floor had an emergency brake, but the brakes only slowed the car slightly through its descent. The result at the bottom of the elevator shaft was chaos; eight of the Northwestern players lay in a twisted heap on what remained of the elevator floor. Miraculously, the eight who fell escaped injury, except for some very large bruises. The two who stayed standing, however (including Potter), both received serious ankle injuries. Coach Hanley was beside himself, and noted that the team seemed to be dogged by bad luck.

Even with his injury, Potter played Saturday. The Wildcats and Boilermakers slugged all afternoon, but neither side could come close to scoring. As the fourth quarter drew to a close, it looked like Northwestern would claim its second scoreless tie during an otherwise perfect season and would take the Big Ten title uncontested. However, an errant pass by Potter was intercepted, and Purdue returned the ball to the Northwestern 15-yard line. Two plays later the Boilermakers scored the only touchdown of the game and pulled the upset.

The loss in the charity game was Northwestern's first conference defeat since 1929, and it forced NU to share the 1931 Big Ten championship with Purdue and Michigan. Still, the campus celebrated the team's first ever back-to-back titles with bonfires and dances. The team also celebrated three new All-Americans (tying the 1930 squad for the most in a season). Pug Rentner was recognized at last, along with Dallas Marvil and tackle Jack Riley.

Although it seemed like the Wildcats were on the verge of becoming a conference dynasty, the team lost a significant amount of its talent after 1931. Although Pug Rentner would be back in 1932, twelve seniors, including Marvil and Riley, graduated, as did Reb Russell, the 1930 All-American.

Russell played briefly with the Philadelphia Eagles. Then, like so many other Northwestern alumni, he took up acting. Reb became a star of early western pictures, appearing in over a dozen movies during the 1930s. Hanley and Rentner, however, beat Russell to the movie business. In 1932, Felix Feist directed a short film called "Football Footwork," featuring Hanley and Rentner. Hanley received directing credit for another training film called "Block and Tackle" later in 1932.

The Wildcats were depleted, and it would take them three seasons to reload fully. 1932 was Northwestern's first losing season in nine years, but there were a couple of games in which the 'Cats excelled. NU spoiled Illinois' homecoming when Rentner and Oli Olson ran wild and pounded the Illini, 26-0. And the 'Cats romped over Iowa, 44-6, at Dyche Stadium to close out the season.

The 1933 season, though a disappointment, did produce another Northwestern All-American. Edgar "Eggs" Manske, NU's powerful end, became the eleventh Wildcat to win the honor. Manske was one of the last Wildcats in history to play without a helmet.

By the end of the 1934 season Northwestern fans, who had become accustomed to winning, were growing impatient with Hanley's effort to restock the team and return it to champion status. His Wildcats had one more moment of glory, when on November 24, 1934, they invaded Ann Arbor and beat the Wolverines, 13-6. Michigan's starting center in the game, and eventual 1934 team MVP, was Gerald Ford. NU had recruited Ford, but the future president chose to stay in his home state.

The relationship between Hanley and the university's administration was never warm, and

by the end of 1934 it was becoming hostile. Hanley left Northwestern soon afterward, taking with him the best Wildcat coaching record since Walter McCornack in 1905. Hanley eventually returned to coaching. During World War II he rejoined the Marines, took over the El Toro Marine football squad, and coached it to a 16th place finish nationally in 1944. He also served briefly as head coach of the AAFC League Chicago Rockets in 1946.

Coach Lynn Waldorf began his tenure at Northwestern with a small base of senior talent that had played through several tough years: starting guard Paul Tangora; Henry Wadsworth Longfellow; and captains Walter Cruice and Albert Lind. The Wildcats began the 1935 season with a win in a warm up game against DePaul. On October 5, the team hosted Purdue at Dyche Stadium in the first night game in Dyche Stadium history. It was also the first conference night game in Big Ten history. Northwestern and Purdue battled in yet another low-scoring game in the series, and NU appeared on the verge of scoring first when the team methodically drove 76 yards to the Purdue two-yard line, only to fumble the ball over to the Boilers. Purdue returned a Wildcat punt 55 yards for a touchdown and the game's only score. Road losses to Ohio State and Minnesota seemed to consign Waldorf's first season at Northwestern to another rebuilding and readjustment period.

However, the players were energized by the new coach, and Waldorf was a master at game preparation and strategy. He had assessed the talent his team possessed and was adapting his tactics to work with the team's strengths, particularly with the passing game and defense. By November his team had adjusted to the new system, and Waldorf's system had been recalibrated to work with the players. When the Wildcats returned to Dyche, they hosted Illinois for homecoming and beat the Illini for the first time in three years. Sophomore Don Heap raced 60 yards for the game's only touchdown.

While Northwestern was holding off the Illini in Evanston, undefeated Notre Dame and Ohio State were battling in Columbus. NBC radio carried the game nationally, and Notre Dame beat the Buckeyes, 18-13, in the first game to be called "the game of the century." The media immediately tagged the Irish as the frontrunners for the national title. Notre Dame returned to South Bend in triumph and began preparations to host the Wildcats the following Saturday.

Waldorf had circled the Notre Dame game at the beginning of the season and had prepared his team for it for much of the year. His focus was rewarded. Notre Dame scored first, and the Irish fans roared with celebration, confident that the Irish would keep the lead. The 'Cats, however, were equally confident, and in the second quarter they began their attack. The team drove to the Notre Dame red zone, and Wally Cruice threw a touchdown pass to Henry Longfellow. Waldorf's new defensive scheme, which was among the first in the nation to feature changing defensive formations based on the offense's position before the snap, stymied the Irish. The teams remained deadlocked until late in the fourth quarter. Notre Dame, driving from its own 35-yard line, fumbled. Paul Tangora recovered for Northwestern, and the 'Cats drove to beat Notre Dame, 14-7.

The team followed the triumph over Notre Dame by beating Wisconsin and later holding Iowa to a scoreless tie. The winning season proved that Northwestern had returned to form and was ready to make another run at the Big Ten crown. The success of the 1935 season, capped by the win over the Irish, led Coach Waldorf to win the first ever national coach of the year award. "Pappy" Waldorf, as his Wildcat assistants had started to call him, also appeared on the Wheaties cereal box that fall. Paul Tangora was named an All-American, primarily for his game-turning plays against Notre Dame. In the spring of 1936, the NFL held its first real draft of incoming players, and Tangora became the first Northwestern player drafted by the NFL when the Washington Redskins selected him in the fourth round. Wally Cruice was also drafted from NU, going to the Green Bay Packers in the eighth round.

Northwestern would have been a clear preseason favorite to win the Big Ten in 1936, but Minnesota entered the season with a 24-game undefeated streak and was the defending national champion. The 'Cats had never before been blessed with such depth and overall talent. Northwestern named senior guard Steve Reid captain. The 'Cats also had new players poised to

make a breakout in 1936, including Bernie Jefferson at halfback and Bob Voigts at tackle.

The Wildcats hosted Iowa in the season opener, and beat the Hawkeyes, 18-7, capped by a 56-yard touchdown run by Ollie Adelman. North Dakota State was the next team served up at Dyche Stadium, and the Wildcats and their strong, well-conditioned line pounded them, 40-7.

NU next edged Ohio State, 14-13. Ohio State enjoyed a 13-7 lead for much of the game. In the third quarter Coach Waldorf began deploying what was essentially the first slot formation in college football, and gave Don Heap the option of throwing to one of four possible receivers or to have Bernie Jefferson, the other halfback, throw to him. Midway through the fourth quarter, Jefferson, one of the first black halfbacks to start in the Big Ten, threw a bomb to Heap for the winning touchdown. The last time NU had beaten the Buckeyes was during its 1931 title run. And, as it had then, the Wildcat win stoked talk of another championship. Title expectations continued to rise when the team traveled to Champaign for its first road trip of the season. The 'Cats staged another fourth quarter burst to beat Illinois, 13-2.

The following Saturday was Halloween, and it brought Big Ten titan Minnesota into Dyche Stadium. Minnesota's undefeated streak had now grown to 28 games; with NU poised undefeated, the game snowballed into the event of the season. Arrangements were made to broadcast the game by radio nationally, one of the first NU games to be heard by a national audience.

The audiences, both via radio and the 49,000 in person at Dyche Stadium, were not let down. In one of the greatest defensive games ever played by Northwestern, the Wildcats became the immovable object that overcame the irresistible force—the (up until then) high-scoring Gopher backfield. The teams slugged at each other relentlessly in the rain and held the other side scoreless through the middle of the third quarter. Deep in their own territory, the Gophers fumbled. An ensuing penalty gave the Wildcats the ball at the Minnesota one-yard line. The capacity crowd at Dyche shot to their feet, and then exploded into deafening celebration as Ollie Adelman broke into the end zone for a touchdown and the only points scored in the game. Steve Toth, who had conducted a Wildcat punting clinic throughout the game, missed the extra point. Neither team had another chance to score. As the game ended wild celebrations spilled out of Dyche Stadium and streamed into Evanston and onto Chicago's Loop. Thousands of students and fans, along with the Northwestern marching band, gathered at Fountain Square in Evanston Monday morning to enjoy a pep rally and celebration.

Northwestern's 6-0 triumph over Minnesota appeared to shatter the Gophers' hopes of repeating as national champions, and it propelled NU into a number one ranking in the Associated Press weekly poll. The 1936 season was the first to see the AP ranking system, and Northwestern had been ranked fourth in the country in the first-ever weekly poll. Just three weeks after the AP's debut, the Northwestern Wildcats perched alone atop it and were positioned to take their first true national title.

The last two Big Ten teams on Northwestern's schedule put up little resistance. NU hosted Wisconsin and beat the Badgers, 26-18, in a game that was not as close as the score would suggest. The Badgers staged a furious comeback attempt and launched a wild passing attack, but were later overwhelmed by the NU line. Even with its game against Michigan still to be played, Northwestern had guaranteed itself at least a share of the 1936 Big Ten title with the win over Wisconsin. When the Wildcats traveled to Ann Arbor and stung Michigan, winning nine to nothing, it marked Northwestern's first-ever unshared Big Ten championship. It was Northwestern's second win in a row in Ann Arbor, and it marked the team's third straight week at number 1 in the AP poll.

Northwestern, however, had one game to go before it could claim the national title. And, as it had in 1930 and in 1931, NU saw its title hopes slip away in the finale. The Wildcats traveled to Notre Dame to face the Irish, who with two losses were out of the national title hunt, but were eager to exact revenge on Northwestern for the 1935 disaster. Notre Dame got its revenge, upsetting Northwestern, 26-6. In one of the strangest decisions in sports history, the AP voters put Minnesota back into the number1 spot at the season's end. The Gophers claimed the 1936 national championship, even though they had suffered a loss to Northwestern, and wound up

in second place to Northwestern in the Big Ten!

The Wildcats celebrated their successful conference run nonetheless, with bonfires, dances and parades. On a team loaded with playmakers, Captain Steve Reid was named the team's MVP and an All-American[3]. With 15 seniors graduating, it was clear that the team would need to rebuild a little. What was not yet clear to Northwestern's fans or alumni was that 1936 was the end of an era. In just over a decade the Wildcats had won four Big Ten championships. Fans thought they might have to wait two or three years for the next. However, it never came—for that generation of fans nor the next. Sixty years would pass before Northwestern fans again saw a Big Ten football trophy in Evanston.

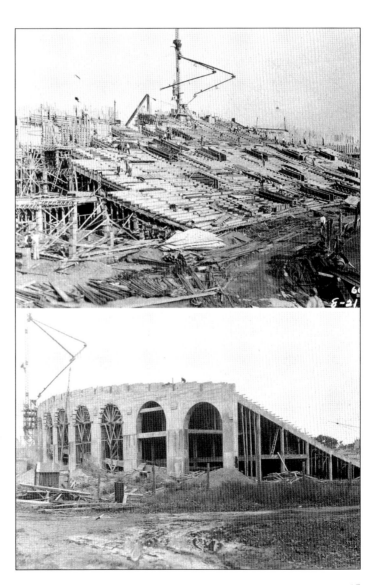

These two photographs show Dyche Stadium at different stages of construction. Concrete was first poured on May 5, 1926. By October 2, 1926, enough of the stands were completed to hold 19,000 for the very first game, against South Dakota. The site of the field is 75 feet east of where Northwestern Field stood, and was elevated two feet higher. The stadium was built with two elevators, a press box that could hold 146 "writers and telegraph operators." Engineers thought that the stadium could last 500 to 1,000 years. They arranged the seats on a crescent so that every fan faced the center of the field.

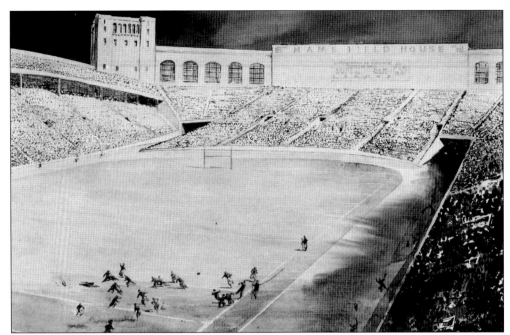

This is the early plan for Dyche Stadium. While the northwest tower and the west stands look similar to what was actually built, architect James G. Rogers' initial plans called for a much grander end zone area. Note the dramatic tunnels entering onto the field and the enormous score board.

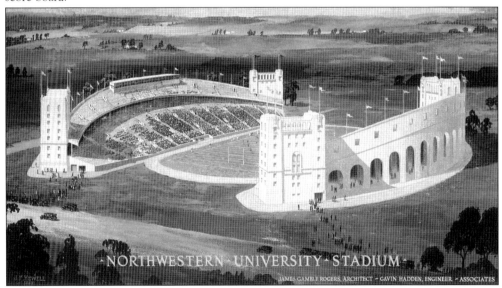

Here is a later plan for Dyche Stadium, which was still under consideration even after the stadium's dedication. The construction ran behind its schedule and over budget, and the plan to build towers and the upper deck on the east side was eventually abandoned. If it had been fully implemented, the plan called for the stadium to be built in stages over several seasons. The next stage would have added not only east side towers, but *triple* decks on the east and west stands, the only triple-deck stadium in the United States. The final stage called for double decks in the end zones, bringing Dyche Stadium's capacity to over 80,000.

Dyche Stadium
Northwestern University

DEDICATION
November 13, 1926

Chicago vs Northwestern

PROGRAM

Pictured is the program from the Dyche Stadium dedication game with Chicago. During the dedication Robert Campbell, speaking for the Trustees, said that they named the stadium after Dyche because, "No man living has done more than he to conserve and to develop the resources of Northwestern University. An alumnus of the institution, he has been unsparing in his personal and sacrificial service for his Alma Mater."

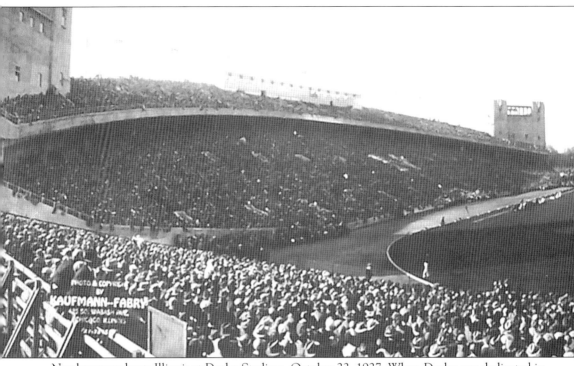

Northwestern hosts Illinois at Dyche Stadium, October 22, 1927. When Dyche was dedicated in 1926 it did not yet have its distinctive west stand towers. The stadium finally took the form fans know today just before the 1927 season. The south end zone stands were not yet joined to the east

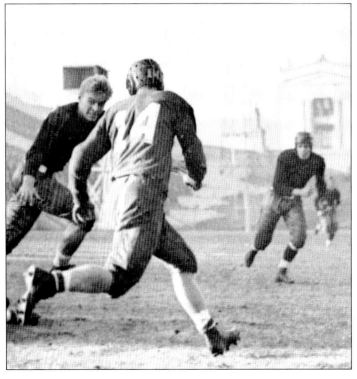

The city of Chicago began hosting its Century of Progress Exhibition in 1933. It was the third World's Fair to feature Northwestern Football. NU Coach Dick Hanley moved the team's first two home games to Soldier Field to take part in the festivities. In the opener, Iowa got revenge for the pounding it received in the previous game by edging NU, 7-0. The Wildcats followed that game by hosting Stanford at Soldier Field (shown here) and wound up with a scoreless tie.

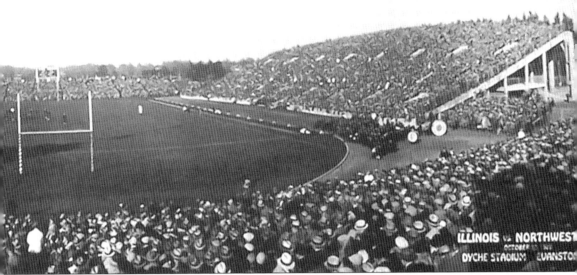

section; Dyche Stadium would not become a horseshoe stadium until 1949. Just visible in the west stands is the "Block N" student section.

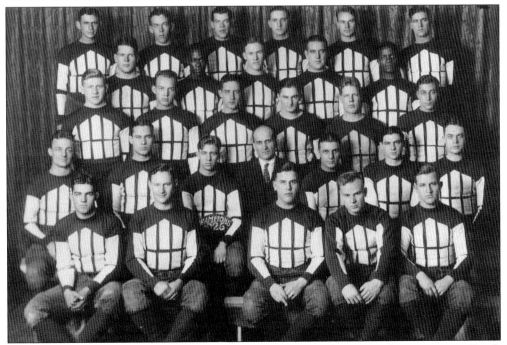

The 1926 team was Northwestern's first recognized Big Ten champions. Sitting next to Coach Glen Thistlethwaite (looking as gloomy as ever), and holding the championship game ball is Northwestern star and All-American Ralph "Moon" Baker, the hero of the 1924 "Wildcat" game.

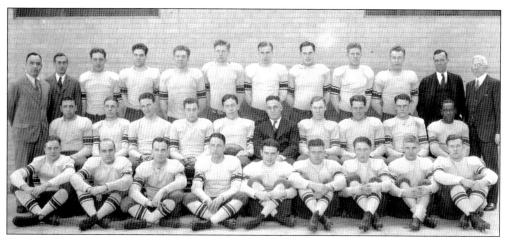

The 1928 team poses for its preseason photo, wearing new uniforms. It was the first time the team had ever worn white jerseys. But the most important change was the stripe design of the white jersey. NU removed the big chest stripes and instead added a new sleeve stripe pattern: three purple stripes, with the center stripe wider than the two thin outer stripes.[4] The 1928 Northwestern jersey was the first truly modern football uniform, and the distinctive sleeve stripes would become a fixture of the team—so much so that they are known as "northwestern striping" to this day. Within just a few years football teams across the country adopted the narrow-wide-narrow stripes for their jerseys as well.

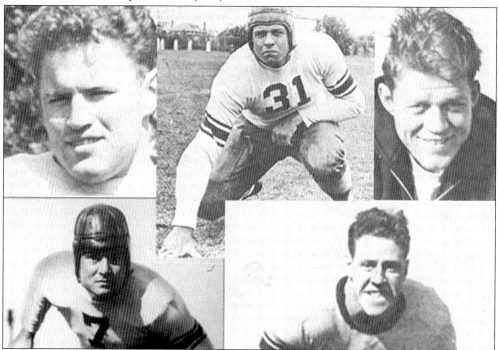

This composite features of some of Northwestern's All-Americans from the 1930s. Pictured, clockwise from top left, are lineman Jack Riley (All-American, 1931—Played NFL football with the Redskins), tackle Dal Marvil (All-American, 1931), Pug Rentner (All-American, 1931, and NU's MVP in 1932—Played for the Redskins and the Bears), Steve Reid (All-American and NU's MVP, 1936), and Reb Russell (All-American, 1930—Played for the Eagles).

Wildcat end Vern Anderson poses in a publicity still prior to the 1933 season. Anderson was part of a line that was among the best in the country. Wildcat captain Jack Heuss, Al Lind, Chuck Hajek, Paul Tangora, and Irwin Kopecky all contributed to the solid NU line. The backfield slumped after the 1932 season, however, and NU would have to wait until 1935 to continue its winning ways.

The 1932 Wildcat squad takes a breather and tends to an injured player during a 1932 game at Dyche Stadium. Number 38, guard Clif Kinder, chats with number 29, quarterback Al Kawal. Number 51, center Harold Weldin, looks on.

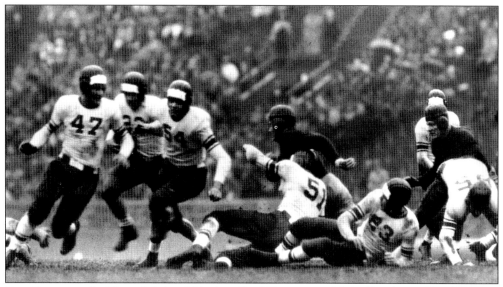

Don Heap runs for 28 yards behind blockers Paul Tangora and Babe Bender, as Northwestern upends Notre Dame, November 9, 1935, at Notre Dame Stadium. Heap later broke from the line and rushed for the winning touchdown. It was Northwestern's first outright victory over Notre Dame since 1901, and it sparked one of the largest celebrations in Evanston history. As it had when the Wildcats won the 1930 and 1931 Big Ten titles, the school canceled classes the following Monday. NU staged a giant pep rally and dance at midnight Sunday, attended by hundreds of students wearing pajamas.

Coach Lynn "Pappy" Waldorf started his head coaching career at Oklahoma State, then moved in 1934 to Kansas State. In 1935, Northwestern was still very much a Methodist university, and Rev. Ernest Waldorf, an NU trustee and a Methodist bishop, had considerable influence. Rev. Waldorf suggested to athletic director Tug Wilson that Waldorf's son, Lynn, should be considered for the NU coaching job. Wilson agreed, and Lynn Waldorf went on to win more games at NU than any other coach.

FOUR

Spread Far the Fame

1937–1949

Coming off the 1936 title season, Waldorf still had a few standouts on the roster for 1937, including Bernie Jefferson, Bob Voigts, and Don Heap. Heap captained the squad to three straight wins, including a 7-0 victory over Michigan, the Wildcats' third win in a row against Harry Kipke's Wolverines. NU had an 11-game home winning streak dating to 1935, and fans thought perhaps the Wildcats had filled all their open spots without missing a beat. The team was ranked as high as seventh early in the season. However, Northwestern lost in Columbus on October 23 and went on to drop three of its next four.

The team rebounded in 1938. A stellar defensive team, led by Voigts at tackle, notched five shutouts during the season, including a 13-point win over the Illini and a scoreless tie with Michigan. For his efforts Voigts was named an All-American. The following year center John Haman became Northwestern's 15th All-American during a campaign that relegated the Wildcats to the middle of the pack in the Big Ten.

The Wildcats began 1940 ranked fourth in the nation. Senior captain Dick Richards, junior tackle Alf Bauman, and senior center Paul Hiemanz formed the core of an explosive, high-scoring offense. The Wildcats charged into 1940 by beating Syracuse (40-0), Ohio State (6-3), Wisconsin in Madison (27-7), and stunning a very powerful Indiana Hoosier team, 20-7, by rallying in the fourth quarter. In four weeks NU had put itself in position to challenge for the Big Ten title. But it lost a heartbreaker to Minnesota at Dyche Stadium, missing an extra point that would have brought a tie. Throughout the 1930s the Northwestern-Minnesota series had shaped into the greatest, most entertaining rivalry in the Big Ten, and NU's loss in 1940 was its fourth to the Gophers since 1930. Northwestern had beaten Minnesota five times during this period.

The team regrouped from the Minnesota setback by handily beating Illinois, but then dropped a close match to Michigan in Ann Arbor. Bill DeCorrevont passed for a 60-yard touchdown, but the 'Cats came up short of the Michigan goal at the end of the second half, and NU suffered its first loss to the Wolverines since 1933. The Wildcats brought their 5-2 record to Dyche for another season finale with Notre Dame. This one, however, resulted in a 20-0 Wildcat victory and a spectacular celebration across the Evanston campus.

Coach Waldorf, during his six years so far at Northwestern, had produced five successful seasons and had set several players on course for promising professional careers. In the spring of 1941 Waldorf's advice and decisions would help guide the careers of two more men, men who eventually made profound contributions to football.

The first was an up-and-coming coach named Eddie Robinson. Robinson had just accepted the head coaching job at Grambling State and had come to Evanston to take part in Northwestern's spring coaching clinic. Robinson, however, was unsure he had made the right decision and was not certain he was ready to coach. After a long discussion with Robinson, Waldorf assured him that he was ready to coach, and suggested that he begin his term at Grambling by using Waldorf's football playbook. Robinson agreed and brought to Grambling a new confidence and a knowledge of Northwestern's plays. Eventually Robinson evolved Grambling's system into one that was uniquely his, and over the course of a remarkable 57-year

career at Grambling, Robinson won over 400 games. In his autobiography, Robinson called Waldorf "a coaching role model," and said, "this clinic was Pappy's school, and he set the tone. He'd always take the time to talk. [Years later] he smiled when he saw films of our team using his plays because that showed him respect."[1]

The second man whose career Waldorf influenced that spring was a freshman at Northwestern on a basketball scholarship who might have become a professional musician. While Waldorf's team was carving its way through the national rankings, Otto Everett Graham was leading his fraternity intramural football team to a campus championship. Waldorf invited Graham to practice with the team that spring, and Graham startled the coaching staff with his running and throwing ability. Pappy convinced Graham to find time to join the football team.

Graham, who would go on to earn letters in baseball and All-American honors in basketball, made his debut as a varsity football player on October 4, 1941, in the Wildcats' season opener against Kansas State. Fans knew that they were watching something special when Graham took a Kansas State punt and returned it 94 yards for a touchdown. He scored two more touchdowns that afternoon, and NU routed Kansas State, 51-3, and rose to number five in the polls. The next week Northwestern hosted Wisconsin in the Big Ten opener, and Graham continued to overwhelm opponents and fans, rolling up two touchdowns en route to a 41-14 win. DeCorrevont also helped in the festival of touchdowns against Wisconsin, returning a Badger punt 51 yards for a score. The 'Cats traveled to Columbus and beat the Buckeyes for the second straight year. This time Graham took to the air, throwing two touchdown passes and bringing the Wildcats back into the top ten. The defeat was Ohio State's only loss in 1941 and spoiled the Paul Brown and the Buckeyes' national title hopes. NU finished 1941 ranked 11th in the country. Otto Graham played a key role in Northwestern's success in '41, but a strong team that included DeCorrevont, Bauman and Charles Clawson made the difference.

Graham and Pappy Waldorf wouldn't have the advantage of a strong team in 1942. In addition to the heavy toll graduation took on the team, most of Northwestern's most talented players had enlisted in the military. Graham enrolled in the Navy but remained at Northwestern for the next two years. Few other players were left, and the Wildcats staggered through the season and claimed only one win.

That one win, however, was significant. NU hosted Texas on October 2. The Longhorns were undefeated and had just dismantled Kansas State, 64-0. The 'Horns drove to NU's 7-yard line, then threw for an apparent touchdown. However, the receiver was ruled out of bounds. Eight seconds later, Texas threw again. Again the pass was caught for an apparent touchdown, but once more the receiver had caught the ball just outside the end zone. With the game still scoreless in the fourth quarter, senior Alan Pick kicked a 22-yard field goal, and NU held on to win, 3-0. Although the 'Cats struggled through the remaining games, Graham set a Big Ten season passing record with 89 completions. Years later Waldorf said of his '42 Wildcat team, "the winning team has a great incentive, but I believe a losing season demands more moral stamina and genuine courage from the gang. Never once did they quit, and perhaps the most notable quality of those boys was their resiliency."[2]

A staggering 30 players from the 1942 team did not return the next season, as the war effort had swung into full force and many students had left. However, the Navy had a training unit stationed at NU, which allowed Graham to stay. It also brought many college football players from across the country to Evanston, and they enrolled at NU. This bunch included former stars from Minnesota and Nebraska. Northwestern began the 1943 season with the second night game in Dyche Stadium history, hosting Indiana. Indiana, like NU, consisted almost entirely of Marine trainees and Navy V-12 enlistees. The Wildcats handled Indiana, 14-6. A week later NU dropped a game to Michigan, a loss that would eventually cost the 'Cats the Big Ten title. Graham and Northwestern rebounded by shutting out the Great Lakes service team and then ran through the rest of the conference, outscoring their remaining Big Ten opponents 149 to 12.

The Wildcats' first victim was Ohio State, the defending national champs. Graham launched

a passing attack in the first quarter that netted 56 yards, then ran in for the score. Early in the fourth quarter Graham rushed 21 yards and Don Buffmire ran for 27 yards, setting NU at the OSU 9-yard line. Graham faked an end sweep and stealthily handed the ball off to Lynch McNutt, who raced in for the Wildcats' second score. NU won, 13-0, and Buckeye coach Paul Brown noted Graham's performance. Brown's first loss as Ohio State's coach was due to Graham in 1941, and now in his third and final season as the Buckeye leader, Brown had been stung by Graham again.

The next week Northwestern hosted Minnesota in a game the *Daily Northwestern* called, "Minnesota versus former Minnesota," due to the number of Navy V-12 transfers from Minnesota's team that were now Wildcats. One of these former Gophers was Herb Hein, who caught a 50-yard pass from Graham to begin the NU scoring attack. The 'Cats blistered Minnesota, 42-6. A week later NU traveled to Madison. Prior to the game Wisconsin students, celebrating homecoming, hanged Graham in effigy, swinging a dummy dressed in an NU uniform and wearing Graham's number 48 by a noose over a sorority balcony. The gesture didn't intimidate Automatic Otto; indeed, the game was Otto Graham's magnum opus as a Wildcat, one of the strongest performances by an NU player ever. Just under two minutes into the game, Graham raced in for his first touchdown. By the end of the first quarter Graham had rushed for three touchdowns and had kicked all of the extra points himself. Graham later passed for another touchdown, scoring 27 of the Wildcats' 41 points that Saturday.

The Wildcats didn't have enough power to stop Notre Dame at Dyche Stadium the next Saturday. The Irish, with their explosive backfield, were on their way to a national championship. But Northwestern ended 1943 with a victory, destroying Illinois, 53-6. Graham again ran wild and scored twice. The 'Cats finished the season ranked number nine. Graham broke his own Big Ten passing record by nearly doubling it, completing 158 passes. He came closer than any player in NU history to winning the Heisman trophy, taking third place in the voting. Graham was named Big Ten MVP, given All-American honors (along with Herb Hein), and would eventually become the first player from NU to be a first-round NFL draft pick. (He was selected by the Detroit Lions, but later snatched up by Paul Brown and the new Cleveland Browns as the team's first-ever selection).

Graham and the other Navy air students left after 1943. Pappy Waldorf's 1944 squad wasn't competitive, winning just one game. The 1945 team also looked like it might be a lost cause: with so many skilled players now fighting, the team was almost entirely made of freshmen. 1945 offered a few surprises, however. After beating Iowa State, 18-6, NU hosted Indiana. The Hoosiers fielded the best team in their history, one that had legitimate expectations of a national title. Wildcat Stan Gorski returned a blocked Indiana punt for a touchdown, and NU held on to tie Indiana, 7-7. The tie was the only blemish on the Hoosiers' record in 1945. The 'Cats hosted Illinois for the last game of the season, and they needed a win to finish the year with an even record. James Murphey ran for 153 yards against the Illini and scored a touchdown in the fourth quarter to lead the 'Cats to a 13-7 win. Lineman Max Morris became the second Wildcat, after Otto Graham, to win All-American honors in both basketball and football.

The game marked the debut of the "Sweet Sioux" rivalry with Illinois. Northwestern had attempted trophy series with teams before 1945. In 1930 Notre Dame began its first trophy rivalry when Knute Rockne proposed a series with NU for a shillelagh that the president of the Irish Free State had personally presented to Rockne. The shillelagh series was eventually discontinued. NU and Illinois had previously played for an old firehouse bell. In 1945, the schools decided to revive a trophy game and used a wooden Indian statue which students first nicknamed Sweet Sioux. The former cigar store statue had been carved in 1833 and was found in an Evanston antique store. In September 1946 the statue was stolen from its trophy case in Evanston.

In 1946, the Wildcats welcomed back several stars from the early forties who returned from service. The team was stocked with returning veteran talent, including Ed Hirsh and Vince DiFrancesca. Pappy Waldorf's 12th and final Wildcat team opened the season in an offensive blaze, smoking Iowa State, 41-9, and routing Wisconsin, 28-0. Frank Aschenbrenner took the

ball during the first play against Minnesota and ran for a touchdown, then scored again later in the game to beat Minnesota, 14-7. A week later NU tied Michigan in Ann Arbor. NU rose to sixth-ranked in the polls. It seemed that the 'Cats had taken command for the first time since the Otto Graham heydays three years before. However, the bottom fell out of the team the next week. The Buckeyes outgunned Northwestern, 39-27. The spiral continued with losses to Indiana, Notre Dame and Illinois, and Northwestern ended up with an even record for the second straight season.

Pappy Waldorf had a contract with the university that ran through 1948, but in January 1947 he was offered the University of California coaching job. The California Bears had not enjoyed a winning season since 1938, but Waldorf saw promise in the challenge, and he headed to Berkeley. For Coach Waldorf's replacement, Northwestern chose 31-year old former All-American Bob Voigts. He was the first Wildcat alumnus to coach the team since Dennis Grady in 1913. Voigts had coached at Yale, then joined the Navy in 1942. He was an assistant coach at Great Lakes, and after the war he served as an assistant coach for the Cleveland Browns.

Voigts' first year as NU's coach was a learning period for the new coach, and the team only won three games. The first win for NU under Voigts was against UCLA. Frank Aschenbrenner, who had provided such fireworks in the Minnesota game in 1946, returned a Bruin kickoff 93 yards for a touchdown, and the teams engaged in a shootout that ended with a 27-26 Northwestern victory. The 'Cats also edged Indiana by a point, beating the Hoosiers, 7-6, for NU's homecoming. Before the game NU students first dressed up as Willie the Wildcat. Four members of Alpha Delta Fraternity dressed up as Willie for their homecoming float. Another tradition was reborn when NU and Illinois brought back their trophy rivalry game at the end of 1947. Having skipped 1946 due to the theft of Sweet Sioux, the schools decided to play instead for a tomahawk. The Wildcats took the Tomahawk Trophy in its first game when they whipped the defending Rose Bowl champions, 28-13.

The 1947 season, while disappointing, showed the team's potential. The *Daily Northwestern* pointed out that ". . . despite the evident handicaps facing a new coach, Voigts has organized a well-balanced squad of which we may be justly proud. Noteworthy, too, is the predominance of sophomore material which he has developed this year [which] will return next fall to form the nucleus of a stronger, more experienced team. Next year, let the conference beware of Northwestern and the 'Bob-Cats.'"[3]

Alex Sarkisian was picked to serve as the captain of the 1948 Wildcats, indeed a "stronger, more experienced team." Aschenbrenner returned, as did the other starting halfback, Ed Tunnicliff. The team headed west for the return game with UCLA and had a much easier time with the Bruins than they had at Dyche, pounding them, 19-0. The 'Cats faced Purdue in the Big Ten opener and upset the conference favorites, 21-0. Quarterback Don Burson scored, as did Tunnicliff and halfback Tom Worthington. The following week Minnesota came to Dyche Stadium and jumped to a 16-0 lead by the end of the first quarter. In a dramatic comeback, the 'Cats scored three times in the second quarter. Aschenbrenner plunged into the end zone first, a fumble recovery set up a Burnson touchdown pass to Chuck Hagmann, and Burnson notched another touchdown pass when Worthington made the catch in the end zone. The 19-16 Wildcat lead at halftime proved to be the final score.

The Wildcats were ranked third in the nation, their highest spot in the polls since 1936. Unfortunately, they next faced Michigan, the defending national champions, in Ann Arbor. The Wolverines were simply unstoppable in 1947 and 1948, and they rolled over NU, 28-0. Bob Voigts' team remained ranked in the top ten, regrouped, and pounded Syracuse the next week, 48-0. For homecoming in 1948 NU hosted Ohio State, and over 47,000 fans saw the Wildcats beat OSU, 21-7. One of those fans, a homecoming guest of honor, was Alvin Culver, the man who single-handedly rebuilt NU's team in 1894. Wisconsin next fell to NU, 16-7. However, the Wildcats were stopped once again by Notre Dame in South Bend. Northwestern, now 6-2, was in second place in the Big Ten. Michigan, which was coasting to another Big Ten title, had won the Rose Bowl that January and was not eligible to return. At the time the Big

Ten had a "no repeat" rule for Rose Bowl eligibility, forbidding any team to return within three years of its last appearance. If the Wildcats won their finale with Illinois, they would finish second in the conference, and would therefore become the Big Ten's Rose Bowl team.

The 'Cats mauled the Illini, 20-7, at Dyche Stadium, to clinch their bowl berth. In front of 48,000 fans Aschenbrenner again ran decisively for a score, and Burson lobbed a 23-yard pass for another. As time expired the team lifted Voigts onto their shoulders and carried him to the lockers. As they had done when Northwestern won Big Ten championships in the 1930s, fans poured out of Dyche Stadium following the Illinois game and began to celebrate wildly.

Just moments after the Big Ten confirmed Northwestern's spot in the Rose Bowl, the Pacific Coast Conference announced its representative: undefeated, top-ranked California. In his two years at Cal, Pappy Waldorf had wrought a wonder, taking the hapless Bears and leading them to nine wins in 1947 and ten in 1948. In what would have been his final year in Evanston under his old NU contract, Waldorf was indeed going to the Rose Bowl—coaching against NU, not for it. And Waldorf would face his All-American, Bob Voigts, the coach he recommended to NU as his replacement.

After the pre-game ceremonies and festivities over 92,000 fans watched Wildcat George Maddock kick off to Cal under a gloomy, overcast sky. Cal and NU traded punts, and Cal returned NU's punt to the Bear 21. On third down, Jackie Jensen took the ball, swept right, and fired a pass. Junior Loran "Pee Wee" Day, the Wildcat halfback and safety intercepted Jensen's throw at the NU 25-yard line, sending the Rose Bowl crowd to its feet. On the very next play NU's rushing leader, Frank Aschenbrenner, ran 16 yards and then fumbled, giving the ball right back to Cal, on the NU 41-yard line. However, the 'Cat defense stymied the high-powered Bear attack, forcing a punt. NU got the ball on its own 27-yard line. The 'Cats gave the ball again to Aschenbrenner. This time he held onto it, and sprinted 73 yards for a touchdown. The run was the longest in Rose Bowl history. Jim Farrar made the extra point, and NU had stunned the Bears, scoring first. On the next play from scrimmage Jackie Jensen responded for Cal, running 67 yards virtually untouched and tying the game.

Northwestern could not match with another touchdown, and punted. On Cal's first down Bob Celeri tried another pass, which was intercepted by Tom Worthington. Aschenbrenner, Ed Tunnicliff, and Art Murakowski orchestrated a methodical drive from their 13-yard line to the Cal 12. The drive stalled there, however, and the game remained tied. Several series later Art Murakowski capped a Wildcat drive by scoring and giving NU a 13-7 lead. For the rest of the second quarter neither team had another clear opportunity to score, although Worthington did manage to intercept another pass.

The third quarter started as a defensive battle between NU and Cal, but midway through NU quarterback Don Burson fumbled. Cal recovered at midfield and began an 11-play drive that culminated with Jack Swaner punching in the touchdown. When Jim Cullom's PAT sailed through the uprights, Cal took the lead for the first time. With Cal leading by one point in the fourth quarter, the teams again traded punts, and NU's offense appeared to have stalled. The 'Cats faced second down and long from their own 12-yard line, and less than five minutes left in the game. Aschenbrenner took the snap and swept right, then fired off NU's only completed pass of the game, to Don Stonestifer for 17 yards. Aschenbrenner and Gasper Perricone took turns running the ball, bringing the 'Cats to the Cal 43-yard line. From there Ed Tunnicliff raced 45 yards to score and give NU a 20-13 lead. The Bears began their final drive with less than two minutes left. Suddenly, it looked like Cal could survive. A 17-yard run was immediately followed by a 17-yard pass, and the Bears were near midfield. With 43 seconds left Bob Celeri lofted a pass toward the goal. Pee Wee Day intercepted, bookending the interception Day had in the game's opening quarter, and sealing the win for Northwestern.

Most fans and alumni at the time considered the Rose Bowl win the greatest moment ever in NU sports. It eventually provided the climax to a period in the program's history that, while lacking conference championships, gave the school its greatest stars, a string of All-Americans, consistent top-ten rankings, and national respect.

Bernie Jefferson scores the winning touchdown against Minnesota at Dyche Stadium, October 29, 1938. Northwestern had tried unsuccessfully to kick four field goals. Late in the fourth quarter, with the Gophers leading, 3-0, Jefferson ran from the Minnesota 8-yard line and sealed the win.

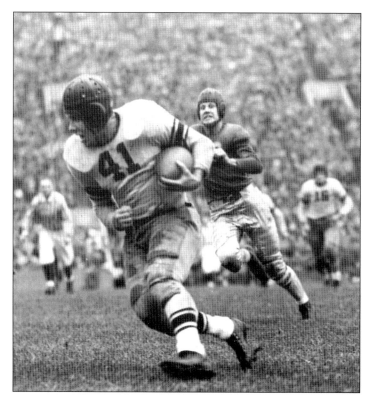

Jack Ryan carries the ball for a gain, but no score during the Wildcats' 1938 game with Ohio State at Dyche Stadium. In fact, neither team was able to cross the goal, and the game ended in a scoreless tie, NU's only tie ever with the Buckeyes.

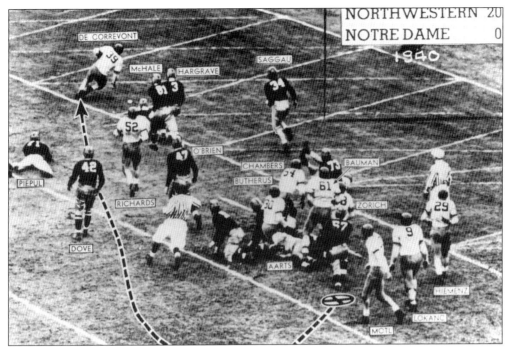

The Irish came into Evanston in 1940 with a 6-1 record and were expected to win. The Wildcats instead handed Notre Dame their worst loss in four years, routing the Irish, 20-0. In the first quarter Bill DeCorrevont passed to fullback Don Clawson, who ran 45 yards to score. This diagram shows DeCorrevont's touchdown run in the third quarter. Clawson had another scoring run in the fourth quarter. Clawson and DeCorrevont ran virtually unchecked, and Alf Bauman was a terror on both offense and defense.

Northwestern students parade through campus after the 1940 Wildcat win over Notre Dame. Fans formed snake dances and paraded through Evanston and downtown Chicago. The victory restored Northwestern to a number eight ranking nationally and helped Bauman become an All-American.

The great Bill DeCorrevont (who changed his jersey number from 39 to 49 in 1941) collides with a Michigan player at Dyche Stadium, October 18, 1941. A scoring sensation at Chicago's Austin High School, DeCorrevont's final high school football game, for the 1937 city championship, was held at Soldier Field. When 120,000 people watched DeCorrevont score three touchdowns and throw for a fourth, they became the largest crowd to watch a football game in Chicago history. DeCorrevont was the hottest recruiting prospect in the nation, and when he agreed to attend Northwestern and play for Waldorf, DeCorrevont became the university's highest-ranked recruit of all time.

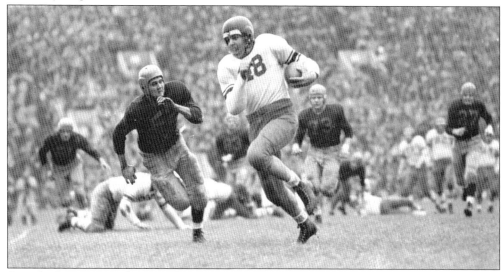

Otto Graham runs as the 'Cats beat Illinois, 27-0, on November 22, 1941. The son of music teachers, Graham learned to play the French horn, piano, violin and cornet. When NU played at home, Graham not only commanded the action on the field, he played in the band. When the first half ended, rather than recuperate in the locker room, Otto tore off his uniform, put on his band outfit, played the fight songs, then put on his football clothes and raced back to the field. Graham was also academically gifted. He graduated from high school early and received a scholarship from Northwestern to play basketball.

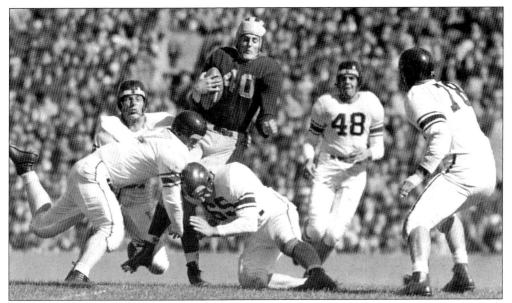

Graham, number 48, playing defense against Michigan at Dyche Stadium in 1943. Graham graduated early from Northwestern and was transferred east by the Navy. He played basketball for Colgate, then returned to college football, playing for the Carolina Pre-Flight team. After the war Paul Brown, the former Buckeye coach whom Graham had so impressed at Ohio Stadium, signed Graham to play with the Browns. Graham starred with the Browns from 1946 through 1955, becoming one of the great pro quarterbacks. He took the Browns to the championship game every season he was there, winning seven of ten championships. Graham threw for an astounding 23,584 yards, notching 174 touchdowns. While he wore the Cleveland uniform, he never missed a game.

Graham scores NU's only touchdown against Michigan in 1943. Graham later became the second former Wildcat to be enshrined in the NFL Hall of Fame, joining Paddy Driscoll. Graham coached the Coast Guard Academy football team, he coached the College All-Star team more years than anyone else, and he served as the Washington Redskins' head coach from 1966 to 1968.

The Wildcats celebrate a touchdown against Purdue at Dyche Stadium in 1945. NU went on to win, 26-14. Freshman Bob McKinley, making his first start at Northwestern, was the difference, scoring two touchdowns.

College of the Pacific runs the ball, and quarterback Jerry Carle (#28) closes in. Amos Alonzo Stagg took the coaching job at Pacific after leaving the University of Chicago in 1933. In 1946, at the age of 84, and after having served as a coach since 1890, Stagg was in his final season as a head coach. On October 26, 1946, Stagg did what no one ever thought he again would do—he entered Dyche to coach a game against Northwestern, 20 years after his vow never to do so. His friendship with Waldorf had thawed his feelings toward NU, but his luck at Dyche was as poor as it was when he coached at the stadium's dedication. NU won 26-13.

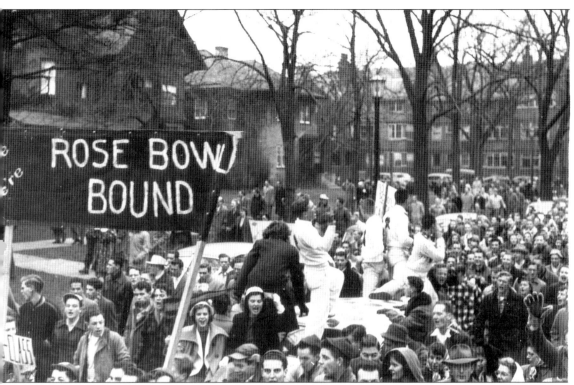

Students celebrate the announcement that Northwestern was invited to the 1949 Rose Bowl. The win over Illinois on November 20, 1948 gave the Wildcats a number seven ranking in the final AP poll. All weekend students partied at dances and pep rallies and waited for the official announcement that NU was going to California. Students stayed away from classes Monday, continuing their parties and waiting for the invitation. It finally came later that morning, and it was greeted by an even bigger explosion of celebrations. During a "Rose Bowl Dance" at Patten Gym Monday evening, NU president Franklyn Snyder introduced Captain Sarkisian, who informed the 4,000 students at the dance that NU was, indeed, going to Pasadena. The *Daily Northwestern* printed a special edition and splashed the headline, "ROSES!" across its front page. In an unprecedented move, the school canceled classes for a *full week* for the ongoing parties and pep rallies. Northwestern's academic rival, the University of Chicago, had dropped football nearly a decade before, and their unused football stadium was the site of the first experiments with atomic fission. The bookish Chicago undergrads looked with disdain at the Evanston students' freewheeling Rose Bowl celebrations. The Chicago students published a parody of the *Daily Northwestern's* "ROSES!" front page. The *Daily Country Club* instead had the headline, "ONIONS!"—perhaps an eerie precursor of today's *Onion* parody newspaper? Earlier the *Chicago Maroon*, the University of Chicago's real student paper, sniffed, "yes, Northwestern students are on the ball. They are busy learning the new dance steps and fathoming the intricacies of the T-formation. The atom bomb? Pooh, what's that? Hail to thee, O Wildcats, and may you have bigger and better football teams."[4] The *Daily Northwestern* shot back, "What Chicago doesn't seem to realize is that you must compromise to become a well-balanced, normal individual. Yes, we like dancing, we like football games; and we think this is better than being hailed as a social and athletic graveyard." Just 20 years later such a statement was to take on a heavy dose of irony.

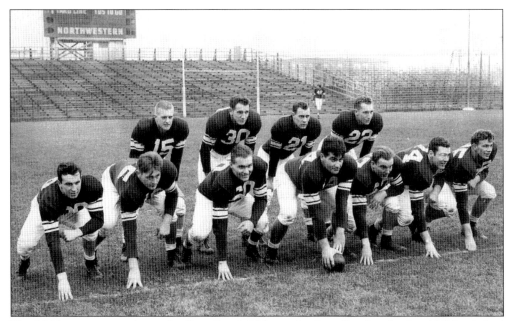

The 1948 team poses prior to the Rose Bowl. NU was the Rose Bowl underdog. California had taken a blow torch to its opponents in 1948. Its vicious ground attack averaged 28 points per game, and its line was talented and deep. Northwestern had little depth, but its starters (nearly all of whom had been recruited by Cal Coach Waldorf) were resourceful and experienced. The Pacific Coast Conference wasn't exactly impressed that its co-champ, likely on its way to a national crown, was going to face the Big Ten runner-up. Voigts made sure his players saw all of the newspaper articles that dressed down Northwestern.

Willie the Wildcat, as he looked on the 1949 Rose Bowl float. Northwestern students and alumni converged on Pasadena. Three rail lines hastily created special train service to California to accommodate Chicago-area fans. NU's band made the trip as well, and put on a memorable halftime performance. Its formations included a moving football player kicking a ball over a goalpost. NU director of bands Glenn Bainum had brought over 140 band members to Pasadena aboard one of the special trains from Chicago. His assistant, John Paynter, had also made the trip. Paynter would later serve as band director for 43 years.

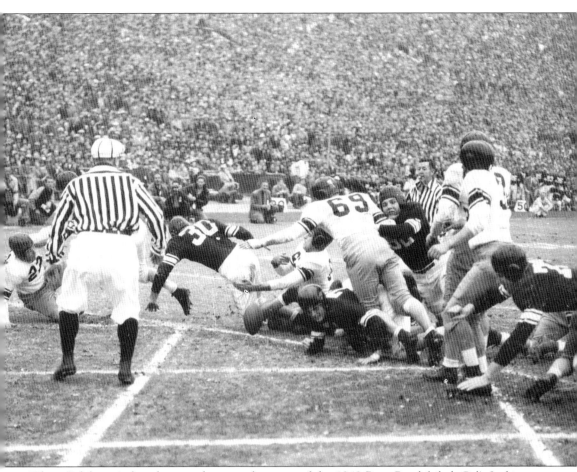

When California's first drive in the second quarter of the 1949 Rose Bowl failed, Cal's Jackie Jensen punted to Johnny Miller. Miller began to return the punt, then handed the ball to Tom Worthington, who raced to the Cal 22. Rushes by Art Murakowski (#30 above), and Miller advanced the ball to the California 1-yard line. On first and goal Murakowski took the ball and lunged for the end zone. Just as he crossed the goal, however Murakowski lost the ball which fell into the end zone and was recovered by Will Lotter for the Bears. Jay Berwanger, the very first Heisman Trophy winner, was the head linesman (pictured left of Murakowski). Berwanger ruled that the ball had broken the plane before the fumble, and that NU had scored. Murakowski later said that he was confident that he had made it across the goal line, and that he had been pulled back by a Cal player, and then fumbled. Northwestern took a 13-7 lead.

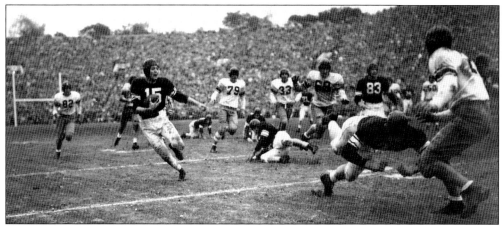

NU trailed Cal in the '49 Rose Bowl, 13-14, with just over two minutes to go. On second down center Alex Sarkisian, rather than snapping the ball to quarterback Don Burson, snapped it directly to halfback Ed Tunnicliff. Burson faked a pass to Frank Aschenbrenner, and Tunnicliff slashed his way though the perplexed Bear defense and streaked to the end zone, aided near the goal with some key blocking by sophomore Richard Anderson. The trick play sent the Wildcat fans into a frenzy. Jim Farrar made the extra point, and the Wildcats were in position to upset California, 20-14.

Coach Voigts and Alex Sarkisian celebrate in the locker after the Rose Bowl win. As the game ended, the team lifted Voigts and carried him to the locker room, but only after Voigts and Coach Pappy Waldorf shared words of congratulations. Meanwhile thousands of Northwestern fans stormed the Rose Bowl field and tore down the goal posts. Northwestern administrators, having canceled a week of classes prior to the game, refused to cancel any more after the victory, but students continued to party for days afterward. Art Murakowski and Sarkisian earned All-American status, and Voigts was seen as one of the rising stars among college coaches.

FIVE

Transition and the Era of Ara

1949–1963

Northwestern's Rose Bowl Champs only lost eight men to graduation in 1949; however, the graduated players included Alex Sarkisian and Frank Aschenbrenner. The personnel had shifted enough that the dynamic of the team had as well. Nowhere was this change noted as starkly as in the Wildcats' defensive play.

The 1949 season started promisingly enough: Northwestern hosted Purdue and easily beat the Boilermakers, 20-6. Art Murakowski was in top form, as was veteran quarterback Don Burson. NU then absorbed beatings from Pittsburgh and Minnesota, but seemed to turn things around when it hosted Michigan on October 15. A record crowd of 54,821 was on hand at Dyche Stadium for the Michigan game. NU trailed the Wolverines by seven when, toward the end of the first half, Burson threw a bomb to Ed Tunnicliff. The Rose Bowl hero caught the ball near the 50-yard line and dashed in for the score. In the third quarter Burson put NU ahead for good when he threw a touchdown strike to Don Stonesifer, and Northwestern hung on to upset Michigan 21-20. It was NU's first win over Big Blue since 1937, and it was Michigan's first Big Ten loss since 1946.

The 'Cats couldn't capitalize on the win, however, and dropped their next three games. They rebounded by whipping Colgate, and then traveled to Champaign for the traditional season closer with Illinois. The Illini seemed poised take their first game against Northwestern in three years, leading 7-6 with seconds to go. The 'Cats stormed into field goal range. Burson, the team's senior quarterback, kicked his first field goal and won the game for NU. The season, however, was a terrific disappointment coming off the Rose Bowl triumph in January, and it was Coach Voigts' second losing season in three tries. Still, the previous year had brought the greatest acclaim the program had known, and fans were quick to give Voigts credit for what he had accomplished.

After 1949 the team lost nearly all of the talented players remaining from the Rose Bowl team. The influx of experienced athletes coming back to Northwestern via the GI Bill had come to an end, and those veteran players were graduating.

The shift in personnel wasn't the only major change the Wildcats encountered during the next couple of seasons. Television was rapidly increasing the number of people who could watch their favorite football teams, and NU's proximity to Chicago initially brought a huge benefit to the Wildcats. Northwestern's first "official" televised game was in 1951, but the Wildcats' games had been televised long before that. Experimental television stations had shown NU football with mechanical TV sets in the early 1930s. During World War II Chicago's WBKB began broadcasting live TV feeds from Dyche Stadium. The station set up cameras and transmitters in the stadium's south tower. Only a few viewers with experimental

sets got to see these first live televised Wildcat games. By 1947, however, the number of households in Chicago with TV sets had increased dramatically, and the WBKB live telecasts of NU football were being featured in area bars. One sports reporter at the time noted that "patrons of downtown Chicago bars who never got closer to Evanston than Howard Street now stagger blindly to the defense of the Purple each Saturday."[1] The biggest jump happened when WGN-TV put NU football on its 1948 schedule of live broadcasts. Millions of Chicago-area residents saw NU football for the first time, and many who had never before followed the Wildcats became fans.

Northwestern regained much of its success during the next two years. Senior lineman Don Stonesifer captained the 1950 team, a capable but underestimated squad. They opened the season by knocking off Iowa State, then traveled to Maryland to play Navy, beating the Midshipmen, 22-0. Minnesota and Northwestern had traded wins and losses since 1942, and 1950 was no exception: the 'Cats got revenge for their loss the previous season by beating the Gophers, 13-6, in Minneapolis. Dick Flowers revived NU's passing attack, becoming the first Wildcat since Otto Graham to throw for more than 1,000 yards. Flowers' aerial assault led to the winning touchdown against Minnesota. The Wildcats also avenged their previous loss to Pittsburgh when they hosted the Panthers and edged them, 28-23.

Northwestern was undefeated and ranked in the top ten. However, as they did in 1946, injuries depleted Northwestern's already-limited depth. The Wildcats dropped a game to Wisconsin and a week later suffered a 32-0 drubbing by Ohio State, Northwestern's worst conference loss since 1922. Reeling from these setbacks, the Wildcats traveled to West Lafayette needing a win. They got one thanks to Stonesifer, who broke the Big Ten receiving record for one game by catching 24 passes. After falling to Michigan, NU played Illinois, a team on the verge of clinching a Rose Bowl bid. Northwestern instead ensured Michigan a trip to Pasadena by shocking the Illini, 14-7. Don Stonesifer capped the season by taking All-American honors.

Northwestern celebrated its centennial in 1951, and interest in the school and the football team was high. The program sold 15,855 season tickets. The pattern for the 1951 season was the same as the previous year—four straight wins and a strong ranking to open the season, and a dive in November. Voigts' fifth team went 5-4, and two of the victories were standouts. On October 6, NU hosted Red Blaik's Army team. The West Point players seemed to be on their way to victory, until Don Burson fired off a 33-yard touchdown pass to Dick Crawford with one minute to go and took the game, 20-14. Vince Lombardi, the defensive line coach for Army, was heartbroken and wept in the locker room afterwards. On November 17, the Wildcats traveled to Ann Arbor and upset the team that they helped put into last season's Rose Bowl. The 6-0 loss to Northwestern consigned Michigan to a rare losing season.

Bob Voigt's period of success at Northwestern came to an end with the win at Michigan. In 1952 the team won two games, although lineman Joe Collier did distinguish himself and became an All-American. The 1953 team fared little better, dropping all its conference games. It did, however, win its non-conference games, including another match with Army. The Cadets were much improved since 1951, but two key fumbles doomed West Point, and Northwestern handed Army its only loss of 1953.

For the first time Coach Voigts was under substantial pressure to turn around NU's program. Two straight losing seasons had put more distance on Voigts' Rose Bowl triumph. The N-Men's group and other alumni were becoming impatient for a rebound. Unfortunately, NU underachieved in 1954. The team started out well enough. The 'Cats, sporting new white shell helmets with northwestern striping, hosted Iowa State in the opener. The teams were tied at seven until the third quarter. John Rearden plunged across the goal to give Northwestern the lead. Iowa State returned the kickoff 92 yards for a tying touchdown. Minutes later Rearden threw a 28-yard touchdown pass, and a late fourth quarter score gave Northwestern the 27-14 win. The win was NU's last until the season finale. Northwestern dropped seven straight games, including one to Pitt in which the 'Cats were heavily favored. Finally NU met Illinois in

Champaign. The Illini scored a touchdown in the first three minutes, and it looked like the 'Cats had completely packed in the season. However, NU stormed back with three unanswered scores and won, 20-7. Halfback Frank Jeske ran for 75 yards to help power Northwestern to the win. Voigts echoed his mentor Pappy Waldorf's sentiments when he said after the Illinois game, "This year's was the finest football team that I've ever been associated with. If any team had a reason to throw in the towel, they did. But they went into every game wanting and expecting a victory."[2]

For the alumni, however, expecting a victory was not the same as securing it, and their patience was gone. Northwestern's Rose Bowl coach, its All-American star, its favorite son, was forced to resign. Bob Voigts left in February 1955. The school immediately went to work to find Voigts' successor, and it wanted to find another alumnus. It narrowed its search to four alumni: Otto Graham, Don Stonesifer, Don Burson, and Ed Tunnicliff. Graham had just completed his record-shattering career with the Cleveland Browns and was available, but he declined NU's offer within hours.

Northwestern did not wind up picking an alumnus. Instead it tapped 33-year old Lou Saban, a former Indiana University star and Otto Graham's teammate with the Cleveland Browns, who was serving as one of Voigts' assistant coaches. Like Voigts, Saban was the youngest coach in the Big Ten. Saban began to try to invigorate the program immediately. He scrapped Voigts' split T formation in favor of a straight T, and he emphasized speed and the passing attack. Sadly the team continued its decline of the last two seasons. The line never came together, handicapping the 'Cats in the trenches. NU's backfield suffered a string of devastating injuries throughout 1955, depleting its starters and stressing its reserves.

Saban's debut was on September 24 at Dyche Stadium. The Wildcats played Miami of Ohio for the first time ever. It was the beginning of Northwestern's strange intertwining with the Oxford, Ohio school. That interaction was usually a painful one for NU, as it was in 1955—The Redskins dumped Northwestern, 25-14. Miami's coach, Ara Parseghian, had enjoyed four brilliant seasons with the team. He started his fifth year, and what would be an undefeated campaign, by pulling off a convincing road win against a Big Ten team. For the 'Cats, however, the game signaled utter collapse. NU stumbled through its next seven games without a win. Since the Big Ten had been created in 1896, no conference team had ever lost every game in a season. Northwestern was on the cusp of becoming the first, and only the season finale against Illinois could prevent it. For the first time that year NU's line held, and the teams tied with seven points apiece. Saban's team finished with just that tie to show for the season. Afterward Saban said, "This was our best game of the season. Now we have to look ahead."

Saban would have to look ahead elsewhere. NU's long-serving athletic director, Ted Payseur, left at the end of the 1955 season, and NU brought in Purdue head coach—and former Miami coach—Stu Holcombe to replace him. Holcombe had beaten the Wildcats the week before the Illinois game, and one of his first acts as athletic director was to fire Saban and his entire staff. For Saban, the one-year stint began an epic string of coaching jobs throughout college divisions and the NFL, most notably with the Buffalo Bills. Saban continued to coach into the 21st century, finally retiring at age 81.

Holcombe naturally looked to Miami and Ara Parseghian for Saban's replacement. Parseghian was another Cleveland Browns veteran. He had been an assistant to Woody Hayes at Miami and had taken over as head coach when Hayes left for Ohio State. Parseghian came to Evanston and inherited a team that had weathered four straight losing seasons (and only one win in the last 17 games) and had its third coach in as many years. A remaining Miami assistant, John Pont, replaced Parseghian as the Redskins' coach.

Northwestern played its first game under Parseghian on September 29, 1956. The 'Cats again hosted Iowa State for the opener. The Cyclones' head coach was former Wildcat captain Vince Di Francesca. Di Francesca's return to Dyche Stadium resulted in Iowa State's seventh straight loss to the 'Cats. Running back Bob McKeiver found the end zone twice in the first half, and NU held on to win 14-13. Parseghian's first win at Northwestern was the team's final game with

Iowa State.

The Wildcats finished the '56 season with four wins, four losses and a tie, the first time in four years that the team had avoided a losing record. But the team lost all nine of its games in 1957, the first season in NU's history that the team lost every game.[4] The disastrous season reached its low point on November 2, when Ohio State dismantled the 'Cats, 47-6, in Columbus.

To casual observers Northwestern seemed to be a team continuing a downward spiral, no longer competitive at the major college level. For the first time since 1921, there were calls for Northwestern to consider leaving the Big Ten. However, the team's winless record and blowout losses diverted attention from what Parseghian was accomplishing in Evanston. He was struggling to restructure the program fundamentally, with a new system and many new players. And the players were struggling with injuries: at one point in 1957 nearly half of the team was on the injured list. As the team suffered through the '57 schedule, a host of future stars such as Fred Williamson, Ron Burton, Gene Gossage, Andy Cvercko, James Andreotti, and John Talley were undergoing a trial by fire in the Big Ten, building experience and improving under Parseghian. Other inexperienced 'Cats such as Irv Cross, Dick Thornton and Mike Stock were playing on the freshman team or were learning the ropes, preparing to take starting positions. Northwestern was loaded with more talented and disciplined players than it had enjoyed in a decade, and it was closer to greatness than anyone outside the program could have guessed.

The Wildcats, with only two seniors in the starting lineup, upset Washington State, 29-28, to begin 1958, snapping their nine-game losing streak. A week later they torched Stanford, 28-0, and followed that victory by traveling to Minneapolis and beating the Gophers, 7-3. NU's first win over Minnesota in seven years gave the 'Cats enough momentum to earn a national ranking for the first time since October 1953. NU next played Michigan, another team the Wildcats had not beaten in seven years. On October 18, 1958, Northwestern hosted the Wolverines and handed the storied team from Ann Arbor the worst beating in Michigan's history, a 55-24 rout. NU's line, including Irv Cross, Andy Cvercko, and Gene Gossage, dominated Michigan. Ron Burton scored his seventh touchdown of the season and quarterback Dick Thornton led the ferocious Wildcat offense in a balanced attack that rolled up a 43-0 score—at halftime. According to the *Chicago Tribune's* Bill Jauss, "When [the bulletin of the NU-Michigan halftime score] hit the wires, sports desks called the wire services and asked them to fix the 'typo'. It was no typo. The Era of Ara was going full steam."[5] Fans tore down one of the goalposts. Immediately after the game Parseghian called the team "the finest I have ever fielded on a given day." The win propelled NU—winless just one season before—to eighth place in the AP poll.

The team then lost its first game, when it stumbled against Iowa, 26-20. The Hawkeyes were undefeated and on their way to a Rose Bowl championship, but the loss was a bitter one for the 'Cats. During this period of the team's history Iowa was a Big Ten team that Northwestern rarely played, and the last Wildcat win over the Hawkeyes was back in 1936. Northwestern next played Ohio State. Since Woody Hayes took control of the Buckeyes in 1951, Ohio State had beaten NU every year. Hayes' Buckeyes had a 14-game unbeaten streak and were ranked third in the AP poll when they came to Evanston. It was NU's homecoming, and 85 percent of the entire student body attended the game. 51,102 fans packed Dyche Stadium to see what promised to be a war. For the first half at least, that's exactly what the fans witnessed. NU and Ohio State slugged through two scoreless quarters. The second half, however, was all NU. The Wildcats shut out Ohio State, 21-0, OSU's only loss that fall.

The fans stormed the Dyche Stadium field for the second time in 1958 and tore down the south goal post. The players carried Parseghian off the field and into the locker room. Once in the locker room, guard Joe Abbatiello screamed, "does anyone know the score of this game?" The team shouted back, "21 to nothing!" and began to celebrate. Ron Burton was so overcome with emotion from beating Ohio State that, after he greeted his elated family, he walked to the lakefront and wept. "The team was so keyed up for the Ohio State game, that they refused to bend an inch," Parseghian said later. NU's revenge against Woody Hayes sent NU to fourth

place in the national rankings.

Injuries had finally taken too great a toll on the team's depth, and NU dropped its last three games, finishing 5-4. But the Wildcats' winning season had shaken the conference and had instilled confidence in the team and in Ara Parseghian. Burton finished the year with a team-record 76 points. Andy Cvercko was recognized as a first-team All-American. Fred Williamson went on to play for the Pittsburgh Steelers, Oakland Raiders, and Kansas City Chiefs. While with the Chiefs, Williamson played in Super Bowl I, and he earned the nickname "The Hammer" for his Karate-like offensive move. Fred "The Hammer" Williamson later gained fame from starring in a string of 1970s "blaxploitation" films and appearing in movies such as "M*A*S*H" (a movie that, ironically, featured a scene that parodies Jimmy Johnson's "hidden ball" play).

Nearly all of the Wildcats' stars returned for the 1959 season, and NU started the year ranked in the top ten. The season opened against Oklahoma, the top team in the country and the most dominant team of the last decade—the Sooners had won 107 of their last 117 games. When Bud Wilkinson's team came into Dyche Stadium rain had turned the field to mud. NU blocked a punt for a touchdown, and scored again when Ron Burton exploded for 62 yards. The Sooners fumbled the ball 11 times, and by the third quarter Northwestern was beating Oklahoma so badly that the 'Cats brought in their reserves. The Wildcats cruised to a 45-13 rout, Oklahoma's worst defeat in over 14 years.

The blowout victory over Oklahoma made national headlines, and it gave Northwestern the number two spot in the nation, a ranking the Wildcats held for over a month. Next, the Wildcats traveled to Iowa and relied on their defense for a win, finally beating the Hawkeyes, 14-10. With just over seven minutes to go, Iowa began what might have been a game-winning drive. However, Dutch Purdin intercepted Iowa, ending the Hawkeyes' hopes. NU line coach Alex Agase began jumping wildly on the sidelines, screaming "I knew we'd get a break! I knew it!" The following week NU hosted Minnesota and shut out the Gophers, 6-0. The 'Cats then upended Michigan for the second straight year, winning 20-7 in Ann Arbor. They beat the Wolverines without the help of their star running back—Ron Burton had sprained his ankle in the Minnesota game.

Notre Dame was next. From 1929 to 1948 NU had played Notre Dame every year, but the traditional rivals had not played each other since. Notre Dame had won the last eight against the 'Cats, and was scheduled to play Northwestern each of the next four years. This first game of the new series was held in South Bend, and Notre Dame came into the match the underdog, having lost two of its four games in 1959. In drizzling rain NU's John Talley threw three touchdown strikes, including a 78-yard bomb to Irv Cross. The pass to Cross was the longest in NU history, breaking Talley's own record set against Michigan in 1958. Cross was actually running a blocking route, but broke away and took a longer pass from Talley than was planned. Talley also scrambled 61 yards for a fourth touchdown, and Northwestern beat the Irish, 30-24. *Life* magazine ran a feature story about the Wildcats, their preparation for the Notre Dame game, and the game itself. Northwestern remained in second place, behind Louisiana State.

Burton returned to the team in time for the next game, homecoming against Indiana. The Wildcats trounced Indy, 30-13, but suffered still more injuries, and dropped their last three games of the season. As they had during the previous season, the 'Cats were positioned to make a run for the conference title, but lack of depth eventually took its toll. Still, the 6-3 season was a great success for the program. Center James Andreotti and Ron Burton were named All-Americans.

The 1960 season began on the road. NU whipped Oklahoma again, this time 19-3. However, the Wildcats proceeded to lose three straight games, including a close defeat to Michigan. The 'Cats, reeling from the skid, hosted Notre Dame on October 22, 1960. The crowd of 55,582 set another Dyche Stadium record, a bar that had been lifted several times during Parseghian's tenure. Northwestern also set a record for season ticket holders in 1960, with 16,087. Millions more saw the game live on TV, the first time ever that a Northwestern game was televised nationally. NU held on to edge the Irish, 7-6, for its first back-to-back wins over Notre Dame

ever. The 'Cats followed that big win by routing Indiana and Wisconsin on the road, but they were stopped by a very powerful Michigan State team. NU went into its finale with Illinois even for the year and needing a victory to have a winning season. Illinois obliged by folding, 14-7. Several players who left after the 1960 season had successful pro careers, including Irv Cross, who played for the Eagles and Rams. Cross later co-hosted CBS's *NFL Today* show alongside fellow NU alumnus Brent Musburger.

The '61 season broke the other way, however, and NU finished 4-5. The year started promisingly: Northwestern hammered Boston College, 45-0. The team next played Illinois (the first time since 1942 that the Illini game was not at the end of the season) and whipped its downstate rival, 28-7. After two disappointing losses, the 'Cats faced Notre Dame for the third game of the series. Junior halfback Larry Benz threw two touchdown passes against the Irish at Notre Dame Stadium, but both extra points after were no good. Notre Dame, down by two, drove in the fourth quarter and seemed poised to move into field goal range and win the game. However, Larry Onesti and Fate Echols turned back the Irish and caused a fumble that sealed NU's third straight victory over Notre Dame. Onesti took All-American honors at the end of the season.

Ara Parseghian's Wildcat program had become a success; it was winning consistently, and even during "down" years such as 1961 the team was competitive. Parseghian and his staff shrewdly worked with Northwestern's recruiting challenges, making the most they possibly could from the restrictive admissions and a limited budget, and played to the school's strengths. They recruited bright, easily adaptable players who, because they might have been overlooked by the bigger schools, had something to prove and came to Northwestern with fierce motivation. Parseghian himself had become a key recruitment advantage. By beating Notre Dame three years running and having his team continuously in the AP poll (even if the 'Cats didn't finish the seasons ranked), Parseghian had become one of the hottest coaches in the country.

Parseghian's—and the Wildcats'—strengths reached their peak during the 1962 season. The team was stocked with veteran talent. Centers Jay Robertson, Gerald Goshgarian and Jack Cvercko; guards Kent Pike and Burt Petkus; tackle George Thomas; halfbacks Larry Benz and Willie Stinson; and receiver Paul Flatley were all juniors or seniors, and all would make significant contributions. But the star of 1962 was a 19 year-old sophomore from Troy, Ohio. Quarterback Tom Myers was making his first start for NU.

Myers and Flatley began the Wildcats' aerial circus by hosting South Carolina and bombing the Gamecocks, 37-20. They routed Illinois, 45-0. Minnesota, the defending Rose Bowl champion in '62, possessed one of the best defenses in the country. On October 13, Minnesota hosted the red-hot 'Cats and lost, 34-22, giving up more points to Northwestern than they would to all their other 1962 opponents combined. In their first three games, the Wildcats had compiled 116 points and had skyrocketed to eighth place in the nation.

NU traveled to Columbus. Woody Hayes' team was coming off an undefeated season and was looking to repeat as Big Ten champions. When the game started, it seemed that the Buckeyes would have no problem doing just that—OSU took the opening kickoff and ran it 90 yards back for a touchdown. The Ohio Stadium record crowd of 84,376 went into a frenzy. However, Myers and Flatley continued their air campaign. Myers racked up 177 passing yards, and Flatley had 10 receptions. The pair teamed up for an 8-yard touchdown that brought NU back. Ohio State, meanwhile, repeatedly gave the ball to the 'Cats: NU recovered two Buckeye fumbles and intercepted once. Most shocking, however, were the four Buckeye turnovers on downs. Hayes refused to surrender the ball to NU on fourth down, and Ohio State paid. In the most spectacular series of the game, Ohio State had the ball and a first down at the Wildcat five. Hayes decided to pound the ball down NU's throat. The NU line held for three rushes. On fourth down and a yard to go, Ohio State's quarterback, about to attempt another plunge, surged forward too soon and drew a false start. OSU faced fourth down and six and finally tried a pass. The receiver, however, was an ineligible lineman. The penalty included a loss of down, and the NU defense had rendered the Buckeye drive scoreless. Late in the fourth quarter the

'Cats drove desperately into Ohio State territory and made it to the Buckeye one-yard line. Steve Murphy leapt past Buckeye defender Gary Moeller (the future Illinois and Michigan head coach), and scored the game-winning touchdown.

As the game ended Northwestern fans came out of the Ohio Stadium stands and helped carry Ara Parseghian, Woody Hayes' former assistant, off the field. Parseghian called the game "one of Northwestern's greatest victories." Hayes was in tears as he strode toward the lockers. He said simply, "it was a great ball game. I guess Northwestern deserved to win."[6] In Evanston, 2,000 celebrating fans clogged Deering Meadow. That evening nearly 2,000 students packed the United Airlines terminal at O'Hare Airport to cheer the team when it returned from Columbus. That night a crowd of more than 8,000 watched as Parseghian climbed onto a flatbed truck at Dyche Stadium to address the fans. Surrounded by the team, Parseghian shouted, "I've been here seven years and have never seen the likes of this demonstration. This is the most spirited student body I've ever seen."[7]

Remarkably, 55,752 fans packed themselves into Dyche Stadium for a showdown with Notre Dame, setting the all-time record for the stadium, to this day the largest crowd to see a Northwestern home game played on-campus. The game was also NU's homecoming, the only time in the school's history that its homecoming opponent was not a Big Ten team. The game was never close. NU dismantled Notre Dame, 35-6. The victory was the most lopsided game in the Notre Dame-Northwestern series up to that time, and it gave Northwestern the Shillelagh trophy for the fourth straight year. Only Michigan State had ever before beaten the Irish four times in a row. A day later, the AP gave Northwestern the number one ranking for the first time since 1936. For the first and only time in the team's history, the 'Cats were also at the top of the UPI rankings.

The 'Cats stayed at number one when they beat a determined Indiana team in Bloomington. Indiana's strategy, to contain Flatley at all costs and deny Meyers his primary weapon, was initially successful. The Hoosiers consistently double-teamed Flatley. The cost of containing Flatley, however, was springing loose NU running backs Willie Stinson and Bill Swingle, who contributed to 243 rushing yards for the 'Cats. NU won, 26-21, but it paid a tremendous price. The Wildcats were riddled with injuries suffered during the last two games. Jack Cvercko and Burt Petkus both sustained season-ending knee injuries, leaving gaping holes in the line. Willie Stinson had injured his back, and halfback Larry Benz and linebacker Jerry Goshgarian were also banged up.

Wisconsin had little trouble whipping NU in Madison, 37-6, and NU fell to Michigan State the following Saturday. However, by the time the team traveled to Miami to play the Hurricanes in the season closer, it had recovered enough to compete. The 'Cats mauled Miami, 29-7, to win its seventh game of the year, but its two losses late in the season cost it the Big Ten title and a shot at a national crown. Cvercko and Myers were named first-team All-Americans.

Parseghian lost much of his talent after the '62 season, but still managed to lead the team to a successful record in 1963. One of the victories that year was a 37-6 win against Parseghian's old team, Miami of Ohio, the only win the Wildcats would ever manage against Miami. The season ended in Columbus, Northwestern's second straight road game in its series with Ohio State. The Wildcats had a 4-4 record, and Ara Parseghian, in his eight seasons at Northwestern, had compiled 35 wins, 35 losses, and one tie. The 'Cats again frustrated Hayes, beating the Buckeyes, 17-8. Parseghian left Ohio Stadium the owner of a one-game winning margin in his record at NU. He is the last Wildcat coach to leave NU with a winning record.

And that is exactly what Parseghian did, just two weeks after the '63 season ended. Notre Dame was looking for a new head coach. Parseghian, when asked about possibly stepping away from Northwestern simply replied, "I'm restive." The Irish hired Parseghian on December 3, 1963, and immediately turned their fortunes around. Parsheghian would take his place alongside Rockne and Frank Leahy as one of the great Irish coaches. For Northwestern, however, Ara Parseghian's departure was a tremendous blow. The "Era of Ara" had ended just as the spectacle of modern college football was building.

Coach Lou Saban (far left) poses with his staff in 1955, before their only season at NU. One of Saban's assistants was a young coach named George Steinbrenner (far right). Steinbrenner was a native of Columbus, Ohio, and had been an assistant football coach at Ohio State. When Stu Holcombe fired Saban and his staff, Steinbrenner was incensed. Many years later after he bought the New York Yankees he reminded Holcombe (who was by that time with the Chicago White Sox) of the mass firings. Steinbrenner immediately followed the reminder by voting down Holcombe's television deal for the Sox.[3]

Wildcat star halfback Bob McKeiver charges across Michigan Stadium, October 20, 1956. McKeiver could skillfully run, punt, and placekick. His extra point kick against Illinois at the end of the '56 season made the difference; NU kept the Tomahawk Trophy with a 14-13 win. McKeiver earned All-Big ten honors in 1956 and co-captained the Wildcats in 1957.

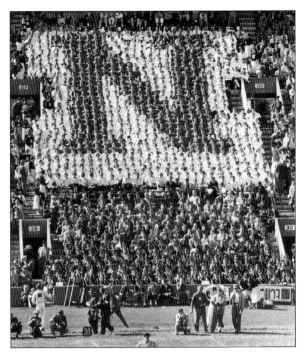

Northwestern's Block N section, in a photograph from the mid-1950s. A select group of 1,000 students formed the Block N, wearing purple and white ponchos to form the "N," and holding up colored cardboard cards to spell out messages to the east stands. Block N was a Northwestern tradition that dated back to the first season at Dyche Stadium in 1926, and it continued until 1958. During the third quarter of the Wildcat win over Ohio State some Block N members sent their cards sailing downward and caused several injuries, causing the group to disband.

Rising stars of 1958, seen here from left to right, are Dick Thornton, Ron Burton, Raymond Purdin, and Mike Stock. Thornton's finest moment may have been the 1958 Ohio State game (flying Block N cards notwithstanding). In the third quarter Thornton took the snap from the NU 34-yard line and fired a touchdown pass to Burton. Several possessions later Thornton engineered a drive that brought the 'Cats to the Buckeye 1-yard line. Thornton kept the ball and punched in NU's second score. Late in the fourth quarter Thornton intercepted a Buckeye pass and returned it to the OSU 20. He then threw a touchdown to Elbert Kimbrough and followed up by connecting with Burton for the two-point conversion.

Coach Ara Parseghian (center) is pictured with his NU assistants. When Parseghian left Miami of Ohio for NU, he took with him most of his assistant coaches. He also brought along a Miami alumnus, Bo Schembechler (far left), who was to serve as the Wildcats' freshman coach. Schembechler is probably better remembered for later coaching Michigan than he is for his work with the NU freshmen. Future NU coach Alex Agase is on the far right in the photo.

Wildcat great Ron Burton. Burton ran for 21 touchdowns during his time with NU, a school rushing record that stood for 37 years. He was Northwestern's MVP in 1958, All-American in 1959, and All-Big Ten in 1958 and '59. He was later named to the College Football Hall of Fame. Burton was drafted by the Philadelphia Eagles, but was promptly traded to a new team, the Boston Patriots, becoming the very first pick by the Patriots organization.

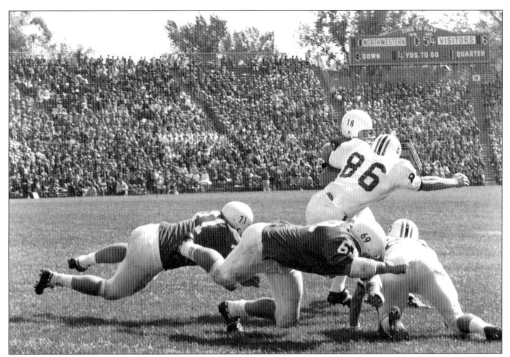

Quarterback Tom Myers (#18) tries to get a few extra yards against South Carolina at Dyche Stadium in the 1962 opener. NU won 37-20. All-American Jack Cvercko (#71) and Burt Petkus (#69) provide the blocking. Cvercko would appear on the cover of Sports Illustrated in November 1963, with the rest of the Wildcat line.

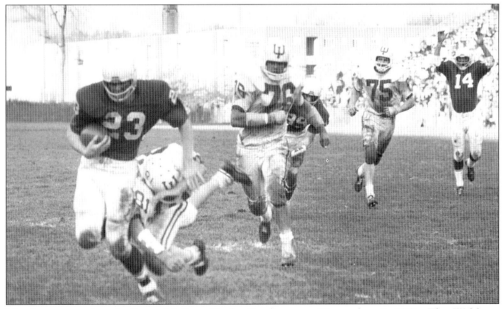

Northwestern edges Indiana, 14-8, at Dyche Stadium, on November 4, 1961. The Wildcats beat the Hoosiers in seven straight games during Parseghian and Agase's tenures, from 1959 to 1965. The series with Indiana is the only Big Ten rivalry in which Northwestern has an all-time winning record.

Tom Myers pauses during the 1962 Notre Dame game. On the very first play from scrimmage the Irish fumbled, and Larry Benz recovered for the 'Cats. NU drove methodically and scored. Several minutes later Jim Benda intercepted a Notre Dame pass. The resulting Wildcat drive also ended in a touchdown when Myers connected with Paul Flatley in the end zone on a 23-yard pass. Flatley had faked a short route, then sprinted into the end zone, where he caught the long pass. Ara Parsheghian commented later, "[Notre Dame] bit the bait, and we got the long one."

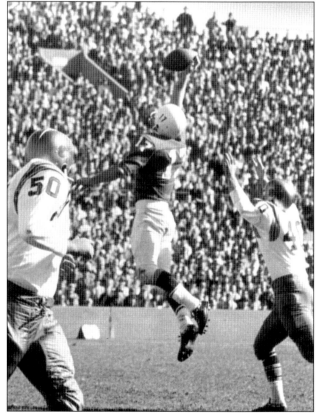

Paul Flatley makes a circus catch against Notre Dame in the 1962 classic. Near the end of the first half Jay Robertson blocked an Irish punt, and NU scored on its next drive. In the second half Myers and Flatley continued to play havoc with Notre Dame. Even with the passing display, Wildcat rusher Willie Stinson managed to run for 75 yards. NU put together a 75-yard touchdown drive, followed by an 80-yard scoring march, and beat the Irish 35-6.

SIX

Agase and Big-Time Football

1964–1972

Northwestern replaced Ara Parseghian with Alex Agase, Parseghian's line coach. Agase's first Wildcat team had been gutted by the graduation of 27 seniors the previous June. The 1964 squad was particularly hard-hit on defense, just when teams were returning to two-platoon football. College teams began to field separate squads for offense and defense during World War II. The practice continued until 1952. Wildcat Coach Pappy Waldorf didn't like to divide his teams into platoons, and Bob Voigts briefly experimented with it. By 1964, Northwestern and other schools returned to the system, and two-platoon football became the norm the following year.

Agase's first defense, coached by James Shea and Jack Ellis, played like pros in the '64 season opener. The 'Cats hosted Oregon State and edged the Beavers seven to three. NU defensive end Pat Riley terrorized the Oregon State backfield all day, while fullback Steve Murphy broke into the end zone for the game's only touchdown. Oregon State salvaged its season, however, and went on to face Michigan in the Rose Bowl.

Unfortunately, the Wildcats weren't so lucky, and the win over Oregon State was the defense's best game of the year. After surviving Indiana with a one-point win, Northwestern lost its next five games, including a heartbreaker to Miami of Ohio. On November 7, the Wildcats hosted Wisconsin and finally beat the team that had cost NU so much in 1962. The homecoming triumph against the Badgers gave fans hope, but it was the team's third and final win in 1964.

Players were still adjusting to Agase's system, and Agase was increasingly constrained by the school's academic restrictions on his recruiting efforts. The Big Ten began to consider limiting the number of football scholarships each school could provide per year, but the numbers in place in 1965 still gave substantial advantages to large state schools, which often had teams that dwarfed Northwestern.

The Wildcats improved gradually in 1965, winning four games out of a brutally tough schedule. The team began a new series with Notre Dame, and Ara Parseghian's Irish trounced NU, 38-7, in South Bend and reclaimed the Shillelagh for good.

The high point of the 1965 season was the upset victory over Michigan, the last win over the Wolverines for 30 years. It was Michigan's first visit to Dyche Stadium since the 1958 Wildcat blowout win. Michigan was the defending Big Ten champion, and they were ten-point favorites. The Wolverines led seven to nothing in the second quarter when Bob Hampton blocked a Michigan punt in the end zone. The ball was downed on the one, where sophomore quarterback Denny Boothe drove in and scored for NU. With just 28 seconds left in the first half, Boothe lobbed a 45-yard pass to Dick Smith for NU's second score. Bob McKelvey ran for a total of 136 yards and two touchdowns, the second of which gave the 'Cats a 34-16 lead.

Northwestern coasted from there and held on to upend the Wolverines, 34-22.

Agase's 'Cats couldn't drum up momentum from the win over Michigan, however, and fell to Illinois a week later. The 1966 team managed just three wins, despite a team rife with seniors. The Wildcat interior offensive and defensive lines were lacking depth, and by the end of the season the problem had become catastrophic. Depth remained a problem in 1967, compounded by the loss of 15 senior starters from '66.

The 1967 season opened with the Miami Hurricanes making their first trip to Dyche Stadium. Miami was ranked number one in the nation in some of the preseason polls; Northwestern was a 14-point underdog. The game was televised live, regionally on ABC and in color, unusual at the time. The Wildcats stunned the Hurricanes with spectacular defense (especially Roger Ward, Mark Proskine, Bill Galler, and John Brandt on the line), inspired efforts on special teams, and a couple of trademark trick plays. The teams went to the lockers at halftime still scoreless, thanks in part to a 65-yard quick kick by halfback Chico Kurzawski that penned Miami deep. Agase had occasionally used quick kicks throughout the last three seasons. The 'Canes spent most of the first half locked well within their own territory.

Late in the third quarter Kurzawski took the ball and shocked the crowd by again quick kicking, this time for 68 yards. The ball rolled to the Miami four. On the third play of Miami's resulting drive, Northwestern linebacker Ron Mied intercepted. A 14-yard pass by Wildcat quarterback Bill Melzer to Jeff Buckner on the very next play put Northwestern on the Miami two-yard line and set the NU fans wild. Kurzawski drove for one yard. Melzer kept the ball on the next down and punched it in. The point after try hit the upright, and NU held a six to nothing lead. With just over nine minutes left, Miami scored and made its kick, taking a seven to six lead. Miami eventually got the ball back, but was forced to punt. The 'Cats came with a full punt rush, forcing the punter to fumble, and NU recovered the ball at the 'Cane nine-yard line. The time was at hand for NU's last trick of the day. Melzer took the snap, handed off to Kurzawski, then rolled left. Kurzawski, about to roll right, instead fired the ball to Melzer, who jumped into the end zone. NU's two-point conversion failed, but the 'Cats didn't need it, winning 12-7.

As with the '65 Michigan game, the tremendous upset over Miami could not jumpstart Northwestern's fortunes, and the 'Cats finished 1967 with three wins. The bottom fell out of the Agase Era in 1968, when Northwestern mustered just one win, over hapless—and winless—Wisconsin. All of the losses were blowouts, and the team's defensive backfield just didn't have the depth to keep up with the toughest schedule in the nation and the likes of Notre Dame, the Miami Hurricanes, Michigan, Ohio State, and USC. Ohio State was on its way to a national championship, and O.J. Simpson powered USC to the Rose Bowl. When Simpson and the Trojans faced NU at Dyche Stadium, Simpson ran in all three of USC's touchdowns.

The Wildcats began to improve in 1969. NU's powerful linebacker corps featured senior Don Ross. Junior fullback Mike Adamle and sophomore quarterback Maurie Daigneau powered the offense and led the team to three Big Ten wins, their best conference finish in four years. NU narrowly beat Illinois and Indiana, and it waxed Wisconsin, 27-7. Adamle went wild against Wisconsin and ran for 316 yards, which broke the Big Ten record for an individual rushing performance in a game, and is still the Northwestern rushing record.

Before the start of classes in 1970, Dr. Roscoe Miller resigned as Northwestern's president, but stayed on at NU as University Chancellor. Miller had served as president since 1949. The school replaced him with Arts and Sciences Dean Bob Strotz, despite enraged protests by the student body against his appointment. The Associated Student Government criticized Strotz for "inability in dealing with students." At the time, and for the next decade, students accused Strotz of being unresponsive to their needs, including downplaying requests for increased campus safety, better social programs, and support for athletics. The period when the university's upper administration actively supported its marquee varsity athletic programs, which had peaked when former NU football player Walter Dill Scott was president, had come to an end.

The 1970 season started just as rough as the last several for NU. The 'Cats again opened with Notre Dame, and were again upended by Parseghian's Irish juggernaut at Dyche Stadium, 35-14. The next game played at Dyche did not involve the Wildcats. On September 27, 1970, the Chicago Bears hosted the Philadelphia Eagles in Evanston, selling out the stadium. It was the first time since the Bears moved to Chicago that they started their home schedule outside of Wrigley Field. The Cubs were still playing at Wrigley, so the Bears requested to move their game. The city of Evanston was furious at the idea, and twice during the summer of 1970 the Evanston city council attempted to block the game. Northwestern reluctantly sided with the city and tried to withdraw its offer to the Bears. The Bears, however, wanted to play at Dyche at all costs, and they sued Evanston and Northwestern. The courts ruled for the Bears. Ironically, over a decade earlier the Chicago Cardinals had requested to play all their home games at Dyche Stadium, but were rejected—by the Bears. Bears owner George Halas had the rights to NFL home sites played on the north side of Chicago and all the north suburbs, and he refused to waive those rights to the hated Cardinals.

While the Bears took over Dyche, Northwestern was suffering in California, losing a close game to UCLA. The Wildcats returned to Evanston and lost their third non-conference game, a 21-20 heartbreaker to Southern Methodist. NU sported a three game winless skid to start the season, and the press turned ugly. One Chicago reporter described the team as noncompetitive, claiming it didn't know how to win. The team posted the articles in the locker room.

Northwestern played its 1970 Big Ten opener against Illinois, and the 'Cats had become nearly rabid during the week leading up to the game. They were convinced that they were a better team than what fans had witnessed so far, and they had become hell-bent to prove the media wrong. Illinois came into Dyche with the tenth-best defense in the country. The Illini left in disarray. Northwestern's offense obliterated Illinois, 48-0, the biggest blowout by Northwestern since 1958. Agase deployed a three-back backfield and turned Adamle and halfback Al Robinson loose. Daigneau threw for two touchdowns, and the 'Cats notched 210 total yards and 21 points just in the first half. The Wildcat defense, which had struggled during the non-conference games, tightened. Wildcat safety Eric Hutchinson recovered an Illini fumble and had an interception. By the start of the second half Northwestern had withdrawn many of its starters. The Wildcat reserves continued to pound Illinois. Sophomore quarterback Todd Somers threw two more touchdown passes in the fourth quarter.

The Wildcats, boosted by their thrashing of the Illini, traveled to Camp Randall and beat Wisconsin, 24-14. A week later Northwestern hosted Purdue for homecoming, and the stakes were considerably higher than they were three weeks before. If NU won it would be in position to compete for a conference championship. The team was also remarkably uninjured, especially compared to how they had fared by late October in recent years. Adamle and Daigneau again had a field day: Daigneau threw for 185 yards and two touchdowns, including a spectacular pass to Jim Lash for a score, while Adamle ran for 154 yards. Adamle also threw two passes during the game—the first was a 26-yard touchdown pass to Jerry Brown. The NU defense kept up its determined play. Jack Dustin intercepted the Boilers three times, and Eric Hutchinson picked off a fourth Purdue pass. Northwestern trounced Purdue, 38-14.

Northwestern football was generating more buzz than at any time since 1962. NU was in a three-way tie for the Big Ten lead with Michigan and Ohio State. NU played Ohio State the very next week, on Halloween in Columbus. The buildup to the Ohio State game was also unlike anything the campus had seen in nearly a decade. Over 500 students traveled to Columbus to see the game in person. Those remaining in Evanston piled into McGaw Hall to watch the game live on closed-circuit TV, in an event similar in spirit to the 1916 "simulation" game played in Patten Gym during the big Northwestern-Ohio State game. 2,700 fans filled McGaw and "took part" in the game—standing and singing during the National Anthem, and cheering on the Wildcats from their basketball seats. The fans at Ohio Stadium were part of another Ohio State record crowd: 86,673 were on hand to see a game that would decide the Big Ten title.

When Mike Adamle leaped over the Ohio State defenders and landed in the end zone for NU's first score, the McGaw Hall crowd exploded. Northwestern led at halftime, thanks to Bill Planisek's field goal, and the fans back in Evanston began Rose Bowl chants. Adamle ran for 102 yards in the first half. However, Woody Hayes' defense made critical adjustments at the half, and it shut Adamle down. Hayes also went back to playing the brand of football with which he was most comfortable. Ohio State began to grind it out. The Buckeyes only attempted two passes during the entire second half, and they eventually wore down the 'Cats and prevailed, 24-10.

Even though its shot at the Rose Bowl had ended, the team was still bolstered by its relentless performance in Columbus, and it went on to beat Minnesota, Indiana, and Michigan State. Just before the game, Coach Agase had drawn a large number 6 on the blackboard in visitors' locker room at Spartan Stadium. After the 'Cats beat Michigan State, 23-20, Agase circled the number. It represented the number of Big Ten wins his team could claim for the year—the most for Northwestern since 1936 and good enough for second place in the Big Ten. The *Daily Northwestern* commented on the finish, "not bad for a team playing in a conference with professionals. Not bad for a school with reasonable admissions requirements."[1]

The Wildcats' had so improved their efforts over the last two seasons that Coach Agase earned the national coach of the year award, becoming the first Northwestern head coach to be so honored since Pappy Waldorf in 1935. Mike Adamle became Northwestern's first All-American since Tom Myers in 1962. Adamle was also named the Big Ten's MVP, the first Wildcat to take that honor since Art Murakowski in 1948.

Mike Adamle was also the very last Wildcat to be named to the Chicago College All-Star team. The *Chicago Tribune* sponsored the College All-Star game from 1934 until the game's end in 1976. Fans from around the country chose each year's All-Star team by voting for their favorite players and sending in their ballots to local newspapers. The All-Star team then played the defending NFL champion team in a pre-season match. Early in the series the games were actually very competitive, and the scores between the college players and the pros were close. By the 1960s, though, the talent gap with the NFL was just too great, and the game slipped out of reach for most of the College All-Star squads.

From Eggs Manske, Northwestern's first All-Star who played on the 1934 squad (which tied the Chicago Bears, 0-0), to Adamle in 1971, Northwestern players earned 61 spots on the All-Star teams. Only Notre Dame and Ohio State had more All-Star honors. Otto Graham had played in the College All-Star game in 1943. He intercepted the Washington Redskins' Sammy Baugh and returned the ball 97 yards for a touchdown, helping the All-Stars upend the Redskins, 27-7. That game was played, fittingly enough, at Dyche Stadium in front of over 48,000 fans[2]. Graham went on to coach the College All-Star team a record eight times.

Adamle had graduated, but Agase's 1971 team still had a core of experienced and very talented players, including Daigneau, Hutchinson, offensive guard Tom McCreight, receiver Barry Pearson, and linebacker John Voorhees. The team's schedule was as tough as ever and opened with the first game against Michigan in three years. The Wildcats lost, and they lost badly the next Saturday when they played Notre Dame in South Bend. Just as they had in 1970, the 'Cats had started off outmatched, but hit their stride a few weeks into the season.

The '71 Wildcats found their stride in a win against Syracuse, when the NU defense held the Orangemen to six points, after giving up 21 to Michigan and 50 to Notre Dame. Northwestern then beat Wisconsin for the fifth straight time. NU went on to beat Iowa, Indiana and Minnesota, but lost to Purdue and Illinois. The team had compiled a 5-4 record before heading to Columbus for the second straight year.

As it was in 1970, the Ohio State game had become the Big Game in the Big Ten schedule. For many Northwestern players it was a bizarre sort of homecoming. Twenty-four Wildcats on the 1971 squad were from Ohio, and Woody Hayes had recruited many of them. NU halfback Al Robinson recounted, "I was heavily recruited by Ohio State, and when I told Hayes I was going to Northwestern, he said, 'If you go there, we'll kill you every year.' He stressed the fact

that more people would know about me if I went to Ohio State. But I've gotten more publicity coming out here to a cultural center like Chicago than I would have had at Ohio State."[3]

The Ohio State game was a wild, sloppy mess from the start. Somehow Northwestern managed to turn the ball over to the Buckeyes five times in the first half alone and still survive. NU's very first pass in the game was intercepted. The Wildcats suffered two more picks, and lost two fumbles before halftime. Ohio State capitalized on two of those mistakes, including the first, driving down the field and eventually scoring on a seven-yard run to take a 7-0 lead over NU. On the ensuing Ohio State kickoff, though, Greg Strunk took the ball and sprinted 93 yards in the other direction, working his way through stunningly expert Wildcat blocking and slashing past flummoxed Buckeye players and into the end zone to tie the game and silence the Ohio Stadium crowd.

Ohio State managed only a field goal after that, and led 10-7 at halftime. The Wildcat defense continued to contain Hayes' relentless fullback attacks. Early in the fourth quarter the 'Cats began their most commanding drive of the game. Daigneau fired a 17-yard rocket to Ohio native Steve Craig that put NU near midfield. Al Robinson and Randy Anderson then bulled their way systematically down the field to mere feet away from the Ohio State goal. Anderson plunged over the line, and the 'Cats surged ahead, 14-10. Ohio State had enough time left to mount a potentially game-winning drive. The Buckeyes moved the ball 67 yards and were nearing the Wildcat goal when Mike Coughlin intercepted a Buckeye pass—Agase called it "a big, sweet play!"—and sealed the NU victory. Coach Agase called the win over Ohio State "the biggest victory I've ever been associated with as a head coach."[4] All of the Wildcat players were ecstatic, particularly the Ohio natives. Jerry Brown said later, "you could feel it all week, especially Friday. When we worked out there was this feeling that we knew we were going to win. Even the dudes from Illinois helped the dudes from Ohio like they were beating their home state, too. It was the best game I've been in."[5]

The Wildcats finished the season by demolishing ranked Michigan State, 28-7. Eric Hutchinson and Jerry Brown denied the Spartans any opportunity to establish a passing game. In fact, Michigan State avoided passing to Brown's side of the field for most of the afternoon, afraid of being intercepted. It didn't matter. On their final drive the Spartans threw and were picked off by Jack Derning, who ran the ball back for NU's last touchdown. Northwestern had won its seventh game of 1971, and players and fans were jubilant. This team had truly played like Wildcats—after losing to Notre Dame, 50-7, it could have easily folded the season. Instead it fought its way to the upper tier of the Big Ten. Agase said, "one of the most satisfying things in life is when people you believe in come through and do what you believed they could. This team did exactly that."[6] After his final game at Dyche Stadium, Maurie Daigneau declared that his decision to come to Northwestern "was the best thing I ever did."

Eric Hutchinson was named a first-team All-American. Two weeks after the Michigan State game, the 'Cats were ranked 19th in the country for one week. That one week was the last time the Wildcats would crack the polls for 24 years. And 1971 would be the Wildcats' last winning season until 1995.

Alex Agase's Wildcat stockpiles were emptied by graduation in 1972. The team lost 27 seniors—15 of them starters. The team had few veterans, among them receiver Jim Lash and defensive tackle Jim Anderson, and did have some promising newcomers, including quarterback Mitch Anderson and running back Greg Boykin. But the young team had too many holes to fill, and only managed two wins in '72, beating Pittsburgh and Indiana. Fans were disappointed, but the young players had shown promise, and expectations rose for the 1973 season.

The Wildcats celebrate the end of the 1964 spring practice, the first under Coach Alex Agase (foreground). Agase, who was born in Evanston, earned All-American status at two different schools. As a star at the University of Illinois, Agase was named All-American in 1942. He enlisted in the Marines at the outbreak of war and was transferred to Purdue to complete his Marine training, where he made All-American in 1943. Agase then served overseas, earning a Bronze Star and a Purple Heart on Okinawa. When he returned from service he re-enrolled at Illinois and was named All-American in 1946.

Campbell (#35) runs against the University of Florida in the 1966 season opener. The 'Cats fell to the Gators, 43-7, and began a three-game slide. Agase's 1960s teams struggled through a series of losing seasons, but remained competitive in the Big Ten.

This picture of Willie the Wildcat, taken in 1967 at Dyche Stadium, shows how the mascot looked for much of the 1950s and '60s. Gone was the original two-person costume of the late 1940s. The original version of the mascot got into trouble in 1948, when the 'Cats traveled to Notre Dame. Irish officials wouldn't let Willie on the field. In the 1940s Notre Dame did not allow women on its football field, and two female NU students portrayed "Willie" at the time. After Northwestern complained, Notre Dame reluctantly let Willie on the field.

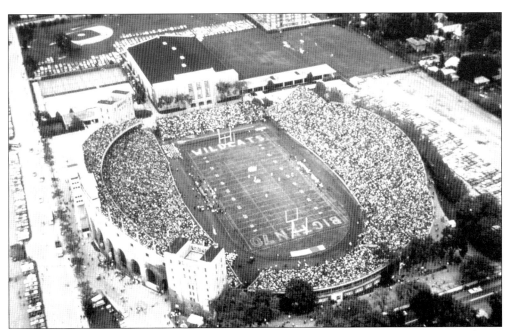

Dyche Stadium as it appeared in 1970. The school continued to use seats in the north end zone for several more years, giving the stadium a capacity of over 50,000.

Alex Agase takes the field with the Wildcats. Agase's professional football career included stints with the Chicago Rockets of the old AAFC league, the Cleveland Browns, and the Baltimore Colts.

All-American fullback Mike Adamle was the first Wildcat to rush for over 2,000 yards during his college career. Adamle was a back-to-back All-Big Ten selection and was Northwestern's MVP in 1970. He was drafted by the Kansas City Chiefs, where he played until 1972. Adamle also played for the Jets and the Bears before launching a successful career as a sportscaster.

Northwestern hosts Wisconsin, October 2, 1971. The Wildcats won, 24-11, on their way to a seven-win season. Quarterback Maurie Daigneau, defensive back Eric Hutchinson, offensive guard Tom McCreight, and receiver Barry Pearson were named All-Big Ten at the end of the season.

Willie and the NU cheerleaders take on their 1970s looks. By 1972, Willie had suited up in a football uniform and had undergone a tremendous increase in head size. He had a decade to go before putting on his necktie, and another decade would pass before Willie began wearing his now-familiar oversized purple jersey.

Fullback Randy Anderson powers his way through Michigan State at Dyche Stadium, November 20, 1971, while Donnie Haynes provides the blocking. The Wildcats beat the Spartans, 28-7. Quarterback Maurie Daigneau, Anderson, and the offense's efforts were matched only by the NU defense, particularly the secondary.

Alex Agase directs the team from the Dyche sidelines. On December 15, 1972, Coach Agase announced that he was leaving Northwestern to take the Purdue head coaching job. Agase returned to West Lafayette and coached the Boilers through four frustrating years, then took over as athletic director at Eastern Michigan. Agase would finish his career as an assistant coach with Michigan.

SEVEN

The Dark Ages

1973–1991

The bleakest era in the history of Northwestern football began with a season full of hope, and it began with a Wildcat win.

After Agase resigned as NU head coach in December 1972, athletic director Tippy Dye announced that Indiana head coach John Pont would replace him. Pont was another product of Miami of Ohio and was the first player in Miami's history to have his number retired. At Indiana he inherited a miserable program and struggled for two years before pulling off one of the greatest turnarounds in Big Ten history. Pont's 1967 Hoosier squad played in the Rose Bowl and earned him national Coach of the Year. Pont followed up that year with another winning season at Indiana. However, the Hoosiers then struggled through four losing seasons, and his program was rent by acrimony and player defections.

Pont's arrival in Evanston coincided with several projects to improve Dyche Stadium, renovating seats and the press area. The school also installed artificial turf for the first time. The $700,000 tartan turf was almost entirely paid for by the Northwestern Benchwarmers, a group that began supporting NU athletics when Parseghian came to Northwestern. To many fans, Northwestern gave the appearance of a school that was making an investment in the success of its football program.

Pont's first game as Wildcat head coach came at the newly-carpeted Dyche Stadium on September 15, 1973. Northwestern came away with a 14-10 upset win over Michigan State. NU's next opponent, however, was Notre Dame, one of the most powerful teams in the country, with a nearly unstoppable offense. The game in South Bend was Notre Dame's season opener, and *The Daily Northwestern* used NU's win over Michigan State to declare in its headline, "Undefeated NU faces winless Irish." It was the first meeting between Pont and Parseghian as opposing coaches, and Pont's former boss walked away with a 44-0 win, on his way to a national championship.

The 'Cats dropped their next two games but then knocked off Iowa, 31-15, thanks to solid play by quarterback Mitch Anderson and running back Greg Boykin. With NU poised at 2-0 in the Big Ten, the team's expectations rose—perhaps the season could play out like 1970, when the team started slowly but finished second in the conference. Unfortunately, the defense couldn't keep up with the rest of the Big Ten, and NU won only two more games in 1973.

The 1974 team, co-captained by linemen Paul Hiemenz and Larry Lilja, fared no better, netting three close wins—against Oregon, Minnesota, and Indiana—amid a sea of blowout losses. Notre Dame, Nebraska, Ohio State, and Wisconsin all scored 49 or more points against NU. The Notre Dame game was Ara Parseghian's last against Northwestern, and he retired from the Notre Dame-Northwestern series as the undefeated master: Parseghian won all four games when he was coaching Northwestern, and when he left for Notre Dame he won all nine games for the Irish.

Three long seasons had passed since Northwestern's second-place Big Ten finish in 1971, and fans were becoming anxious for a turnaround. Pont hadn't worked wonders at Indiana until his third season; season number three for Pont with the 'Cats was 1975, and expectations were

high. Running back Greg Boykin had returned after sitting out the '74 season with a broken leg, former walk-on Randy Dean had taken over as starting quarterback, and junior safety Pete Shaw was the star of the defense. The season looked like it might measure up to the expectations. The team opened against Purdue and won, 31-25. Freshman kicker Nick Mirkopulos set a Northwestern field goal record with a 49-yarder. The next week Northwestern played Northern Illinois for the first time ever, and beat the Huskies, 10-3. For the first time since 1964 NU started a season 2-0.

The Wildcats again lost to Notre Dame. When the Irish starting quarterback got injured, Notre Dame decided to put in their untested fourth-stringer, Joe Montana. Montana helped beat NU, 31-7, and went on to have a modestly successful career. The 'Cats then traveled to Tucson for their first game ever against the Arizona Wildcats. Although Arizona beat NU, 41-6, the game is notable because Mirkopulos broke his own record for the longest field goal in school history. Mirkopulos booted a successful 54-yard field goal, and the record still stands.

A week later Indiana came to Dyche Stadium. Pont's replacement at Indiana, Lee Corso, was as outspoken as a coach as he would later be as a TV commentator. He couldn't resist taunting Northwestern, canceling one team meeting the week before the game so that he could toast Indiana's impending victory over NU. The 'Cats, however, lambasted Indiana, 30-0. Boykin ran for over 100 yards, Dean threw for 164, and the offense chewed up over 40 minutes in possession, leaving the Hoosiers with little to spare. As the rout ended, Northwestern players held up paper cups in Corso's direction to offer their own "toast."

Northwestern was 3-2 overall and 2-0 in the Big Ten, and fans were again thinking that perhaps the turnaround had come at last. In a strange way, however, NU's winning record in mid-October 1975 was exactly as misleading as the winless 1957 season was during Ara Parseghian's early struggles in Evanston. In 1957, the losses obscured a program that was re-ordered, re-energized, and ready to pounce on the conference. Nearly 20 years later, NU's wins against struggling Northern Illinois and hapless Indiana put a bright coat of paint on a program that was near collapse. NU's depth was woefully thin; only a couple of key injuries would be needed to render both the offense and defense void. Of course, NU's depth had always been a problem. The size of the school, the academic restrictions and the high cost of tuition severely limited the number of scholarships NU could offer talented players. Admirably the school had held fast to its entrance and academic standards, playing against programs where the coffers— and benches—were overflowing. The Wildcat program had kept surprisingly competitive, until the mid-1970s.

By then the disparity between NU and the Big Ten was becoming too wide. Part of the problem with NU's depth was the ongoing challenge of recruiting. Even in the 1930s recruiting was an awesome task. After he left NU, Pappy Waldorf lamented the limited size of his Wildcat teams: "Overall, things were uneven at Northwestern. We were never able to offer as much financial aid as we were allowed to under the rules."[1] Waldorf brilliantly worked within these restrictions by using NU's strengths as his own, recruiting organized, smart players who already had skill and discipline. Ara Parseghian also was a savvy recruiter. When he came to NU he completely scrapped the recruiting system that was in place and began a relentless, aggressive national search for talent. But the program's recruitment program later became less shrewd, and Michigan, Ohio State, and Notre Dame began to dominate Midwestern recruiting completely. Television in the 1950s had helped NU by broadening the program's access to the entire Chicago area, including millions of potential recruits. However, by the 1970s TV was a great detriment to the program. The national networks only aired a couple of games per week, and those games were nearly always reserved for the marquee programs—again, Michigan, Ohio State, and Notre Dame—giving them even more visibility for recruitment.

Depth and increased recruiting woes were just two of the battles the program was losing by 1975. The losing seasons since 1971 had taken a heavy toll on Northwestern students' perception of the program and of varsity sports in general. Most NU students don't come to the university already rabid fans of the school's teams. Unlike many students at the state

universities in the Big Ten, who had been raised as fans of "their state's" team and brought that support with them to campus, the Wildcats did not have pre-existing support by the academically-minded student body. That support had to be rebuilt year after year. In 1975, NU was the only Big Ten football program that offered free admission to students (and would do so for 20 more years), but there was an explosion of new social alternatives for the student body. And the students' support of the team by the early '70s had changed measurably. After one NU victory the opposing players were visibly upset. A *Daily Northwestern* reporter noted, "When you play football for a state school that has a football team as one of its biggest selling points, things like that happen. A game becomes a life or death situation. That will never happen here. The student body won't let it. And that's good. The people here who don't give a damn about the football team keep the others from losing their sense of perspective."[2] This view, so wildly different from that of just a decade before, would persist on campus well into the 1990s.

Perhaps the greatest obstacle the program faced in its effort to become competitive again came from the university itself. Just as NU's 3-2 record during the first half of 1975 failed to give an accurate measure of the Wildcats and their potential and strengths, the improvements to the facilities in 1973 were not a reliable means to judge the university administration's commitment to the program. At best, those efforts were a Band-Aid applied to a mortal wound; at worst, they approached something cynical. John Pont's niece Sally Pont relates in her book, *Fields of Honor*, that soon after John Pont took the Northwestern job, NU president Bob Strotz told him privately that "he hoped Northwestern wouldn't get in the habit of going to the Rose Bowl because it might tarnish the university's academic image."[3]

Northwestern and Strotz certainly would not have to worry about such blows to the school's image in 1975. The next game for the 'Cats was against Michigan in Ann Arbor. Bo Schembechler's Wolverines exposed NU's weaknesses in a 69-0 slaughter, NU's worst day on the field since 1913. Schembechler actually tried valiantly to keep the score respectable: Michigan only passed for 32 yards before Schembechler forbade passing altogether. The Wolverines proceeded to roll up a Big Ten record 573 yards on the ground. Schembechler automatically removed from the game any player who hit 100 yards rushing. Schembechler said later, "I used every player who dressed for the game. . . . We literally ran out of tailbacks in the second half."[4] After that, the Wildcats imploded. No other game in 1975 was as bad statistically, but every one after Michigan was a loss, and NU finished 3-8. The team's deep frustration at the end of '75 carried over to the beginning of the 1976 season. The 'Cats dropped their first two games on the road and lost their home opener against Notre Dame, 44-0. They lost their next six games before meeting Michigan State at Dyche Stadium. Northwestern stunned the Spartans with a 42-21 pounding, but just 15,204 fans saw the Wildcats' only win in 1976.

When Pont began his fifth season in 1977, that victory over Michigan State was NU's sole win in its last 17 games. In addition to all the other problems the program had been facing since Pont's arrival, it now had to contend with a growing reputation as a loser, a reputation that began to wear off onto players and other students. Pont had had enough. Earlier, he had assumed the athletic director position, and after the 1977 season Pont removed himself as head coach in order to focus entirely on his administrative job. Pont brought in 31-year old Rick Venturi as his replacement. After taking the NU head coaching job Venturi began his attempt at restructuring the Wildcats by closing practices to the public and installing a pro-style open offense.

Even for the most experienced, connected and gifted coach the Northwestern job in 1978 would have been daunting. With no head coaching experience, Venturi was in entirely over his head. Fortunately, he began his tenure at Northwestern against another struggling team—the team he just left. Illinois under Gary Moeller was at its worst point in years, and the Illini would go on to win only one game in 1978. The two teams met on a blisteringly hot September Saturday afternoon in Champaign and played to a sloppy scoreless tie. During the stalemate NU lost two of its defensive starters for the rest of the year. Middle linebacker Jim Miller and defensive tackle Norm Wells both tore knee ligaments. The Illinois game was ugly, but it

proved the high point of Venturi's debut season. Michigan State trashed NU, 52-3, in the season finale. The game marked the absolute bottom in fan support for the team: 14,157 fans turned up for the Big Ten closer. To NU, winless and in freefall, the 3-8 season of 1975 began to look like a dream year. Despite the team's record, there were many determined and talented players at NU in 1978. Safety Pat Geegan made the All-Big Ten team, and sophomore linebacker Chuck Kern set a school record by notching 218 tackles.

Kern also played an instrumental role on the team in 1979 and broke his season record for tackles with 227. Venturi's second season began its 1979 home schedule by hosting Wyoming. 14,345 fans were on hand to see the Wildcats win their first game in nearly two years. Sophomore quarterback Mike Kerrigan threw for 193 yards, while Wyoming self-destructed and fumbled seven times. In the fourth quarter safety Ben Butler intercepted Wyoming in the end zone. With just over a minute left Northwestern enjoyed a 27-22 lead, but Wyoming was driving. Again the Cowboys threw into the end zone, and again Ben Butler intercepted, sealing the Wildcat win. The few fans at Dyche Stadium began to celebrate. It would be the last celebration at the stadium for a long, long time. The next Saturday NU hosted Syracuse and lost, 54-21. Northwestern had a losing streak of one.

NU lost the rest of its games in 1979, and 1980 didn't look like it would be any better for the 'Cats. The Wildcats dropped all four of its initial away games, then returned home and lost to Minnesota in a 49-21 whipping. The next Saturday, October 11, was homecoming, and Northwestern faced Ohio State. The Buckeyes had edged NU by just nine points in '79. Sadly, the margin of victory would be a little more lopsided in 1980. Ohio State scored 42 points in the first half alone, and coasted to a 63-0 rout. The team's record wasn't the only problem for Venturi. Several black players, frustrated with the season and deeply unhappy with Venturi's handling of their concerns, formed a group called BAUL, Black Athletes United for the Light. BAUL wrote a list of grievances and proposals for change and sent it to Bob Strotz. The *Daily Northwestern* published it the day before the Ohio State game, and the situation exploded. White players were incensed that BAUL had not come to them for support and felt that they, too, were under attack. The BAUL spokesman later said, "If we had known things were going to turn out the way they've turned out, we may have done things differently."

The 1980 season ended with a blowout loss to a weak Wisconsin team, NU's 20th straight defeat. Sports reporter Michael Wilbon, a Northwestern alumnus, wrote a letter to the *Daily Northwestern* expressing his disgust at Venturi and athletic director Pont: ". . . As an alum, I'm sick of it. I'm sick of hearing you say (and now I hear President Strotz has picked up the theme) that Northwestern has to lower its requirements to admit first-rate student-athletes. Lies. Lies. Lies. Having covered college football this season, I have seen or talked to talented athletes from Duke, Stanford, Howard, South Carolina State and Georgia—all of which won at least two games this year—who can easily cut the grade in our classes. . . Do us and yourselves a favor and quit before the program is irreparably damaged."[6] Some former Wildcat stars eventually joined the debate. Rose Bowl veteran Art Murakowski expressed his disgust with the program and urged the school to lower its academic standards. Former wide receiver Paul Flatley disagreed, arguing that there were more than enough good students who were competitive: NU had to recruit them properly, and with the right attitude.

Strotz himself recognized that NU football was in trouble. He still wanted a team that presented an academically superior image, and to him that image meant mediocre football (he said near the end of the 1980 season that "it must be demoralizing and disappointing to the players when they lose, lose, lose. So one would want to think that a medium number of victories would be desirable."). However, the situation had long since dipped past mediocrity— the football team had just endured the worst, most divisive season in its history and was embarrassing the school. Strotz had to act. Three days after the season ended, Strotz fired Pont, Venturi and Venturi's entire staff. Venturi had only one win to show for his three years at NU, and he had two more years left on his original five-year contract. Strotz, to his credit, acted quickly and put together an efficient search for Venturi's replacement, filling the spot

successfully within a few weeks. He eventually hired Doug Single as Pont's replacement.

Northwestern named Dennis Green its new football coach on December 23, 1980. When he came to Evanston, Dennis Green made history by becoming the first black head coach for a major college football program.[7] Green took over a program that had taken less than a decade to devolve from back-to-back second place finishes in the Big Ten to the worst team in Division I. The team did have some strengths: Chris Hinton got his first start at tight end, sophomore punter John Kidd had been given honorable mention All-Big Ten his freshman year, and Rich Raffin had switched from tight end to linebacker. Linebacker Mike Guendling and defensive back Lou Tiberi were also poised to make a contribution to the team. The 1981 team looked like an entirely new squad—it had a new, energetic coaching staff, a more relaxed, open attitude, and even new uniforms. But it still had the same losing streak wrapped around its neck, an albatross that was increasingly tenacious.

On October 3, 1981, NU hosted Hayden Fry and Iowa. The Hawkeyes rolled up 30 points— in the first quarter. Fry pulled all his starters, but the rout continued. By the end of the game every available Hawkeye in uniform had played, and Northwestern shouldered a 64-0 defeat, to this day the worst home loss in Wildcat history. After the game Fry was upset. "I'm happy we won but at the same time I'm real sad. I don't like anything like that. Northwestern doesn't need anything like that." Green was also upset, calling the game "a bunch of little guys running around, getting hit by a bunch of big guys running around," and angrily said of the team and himself, "one of these days, one of us isn't going to show up."[8] They continued to show up, however, and lost their next four Big Ten games.

By this point, NU football had become a joke. Graffiti in one Dyche Stadium bathroom read, "Bring back Mitch Anderson; Maurie Daigneau, Mike Adamle and McLean Stevenson!"— referring to the M*A*S*H actor and NU alumnus who had worked in the athletic department. Earlier someone had climbed up one of the highway signs outside of Chicago and under the phrase, "INTERSTATE 94," painted, "NORTHWESTERN 0." The Wisconsin loss was Northwestern's 28th in a row, tying the school for the longest losing streak in Division I history. A loss to Michigan State would give NU sole possession of the record. For once, the media converged on Dyche Stadium, but for reasons no fan wanted. Students wore buttons that read, "Stop State at 28." The week leading up to the game was a twisted circus of television and newspaper specials about the hapless team.

On the Thursday before the game ABC, NBC, and *Sports Illustrated* interviewed Strotz. On national television, Strotz defended his administration's athletics program. And Strotz finally stated publicly the opinion that most fans knew or suspected he held: "I think having a bad football team can help academic standards." Athletic director Doug Single was enraged at Strotz's comments and considered quitting in protest. Single fumed, "I'm not going to be athletic director at a place where losing is accepted. Bob Strotz says losing enhances your academic reputation . . . Look at the Big Ten. You have to want to win. You can't accept losing. If we accept losing, I won't be here."[9]

And so, 24,104 fans came to see the sad event at Dyche Stadium on November 7. NU gave them stringed balloons that also read, "Stop State at 28," and instructed the fans to release them when the 'Cats scored their first points. There was a risk that the balloons would never go free—NU had not scored in their last three games. The Spartans tallied 21 unanswered points in the first quarter and led, 41-0, at the half. However, in the third quarter Kerrigan fired a 14-yard touchdown pass, and NU scored its first points in over 14 quarters of football. But MSU rolled to a 61-14 win. Frustrated NU students "celebrated" the loss, chanting, "We are the worst!" Four hundred fans stormed the field and tore down the south goalpost, carrying it into the stands. They chucked it over the stadium railing. Outside the stadium they picked it back up and marched it to the NU president's house, shouting "Strotz!" President Strotz, who actually was at his house and not at the game, came outside. "We stink! We stink!" the crowd chanted. The president tried to quiet the crowd, telling the students, "we're going to beat 'em next year." The crowd shouted back, "Bullshit! Bullshit!" and then headed for Lake Michigan,

into which they dumped the goalpost and waved goodbye to it. The last two games of 1981 brought more of the same. In Columbus, Earle Bruce's Buckeyes bombed the 'Cats, 70-6. In the fourth quarter, up 63-6, Mike Tomczak threw a 34-yard touchdown pass to complete the insult. A loss to Illinois brought the season to a close. For the year the 'Cats had been outscored 505 to 32.

Green and his team had weathered a spectacularly bad year, but they began to make some progress. Before the 1982 season Larry Lilja, the Wildcats' strength and conditioning director, put the 'Cats through a rigorous weight program. Chris Hinton switched from tight end to left tackle and was an early candidate for All-American honors. Rich Raffin also returned and co-captained the team with Hinton. Green had switched Ricky Edwards from wide receiver to running back, which proved to be a stroke of brilliance. Green still wanted to elevate the passing game, and as the season neared he was unsure which of his three quarterback candidates could rise to the task. It didn't take long for true freshman Sandy Schwab to step up. The son of financial wizard Charles Schwab, Sandy was a highly ranked recruit, and he shattered nearly every Northwestern (and several Big Ten) passing record in 1982. Schwab threw 416 times, completing 234 passes for 14 touchdowns and 2,735 yards.

The 1982 season began, however, with familiar results. Celebrating its 100th year of intercollegiate football, Northwestern lost in blowouts at Illinois and Indiana, and then hosted Miami of Ohio. Again the Miami Redskins played a part in NU history, when the Wildcats—who actually had a shot at beating Miami—committed a series of crippling mistakes and let the game slip away, 27-13. The loss to Miami was the 34th in the streak. The next week Northwestern played Northern Illinois at Dyche Stadium. The 22,078 fans present expected to see a win. The NIU Huskies were coming off a 3-8 year, and the 'Cats were a larger and quicker team. In the first half Schwab completed 12 of 17 passes for 153 yards, and NU jumped out to a 21-0 lead. In its first three games in '82 the team had put on an aerial display, but had rushed for a grand total of *negative* 44 yards. Against Northern Illinois' timid run defense, the 'Cats rushed for 208 yards. With Chris Hinton providing the blocking, Ricky Edwards ran for 177 yards and a record-tying four touchdowns, and NU won, 31-6. Some players began to celebrate; others became reflective. Placekicker Rick Salvino noted, "Existentially, in the end it wasn't what people would have been or could have been, but what they were."

Students and fans would reflect later; immediately after the game their task at hand was to go nuts. Thousands of fans on the field began to take down both goalposts. Fans marched with the posts to Sheridan Road and once again found themselves at Bob Strotz's house. "Strotz!" they shouted again. This time when Strotz appeared, he was met with raucous cheers. The victory parade marched south to Evanston's South Beach, where the fans threw both posts into the lake, carrying on the strange tradition begun the previous year. Only now the mood was truly festive.

The Wildcats eventually rid themselves of several streaks. NU beat Minnesota, 31-21. The victory not only ended NU's 38-game Big Ten slide, it was the first homecoming win since 1974. Fans continued the new post-win traditions. They tore down one of the goal posts and carried it to Strotz's house for a speech. Then they marched to North Beach and "laked" the posts. A month later NU edged Michigan State, 28-24, in East Lansing, paying back the Spartans for the 1981 debacle, and ending the 'Cats' 47-game road skid as well. NU's three wins in 1982 so defied expectations that the Big Ten named Dennis Green its Coach of the Year. Chris Hinton's preseason switch to offensive lineman had paid off. Hinton was named a first-team All-American, NU's first since 1971. The Denver Broncos selected Hinton as the fourth pick in the first round of the NFL draft, making him the sixth Wildcat first round draft pick.[10]

The worst was over for the Wildcats, but the program still languished. The 1983 team beat Indiana and Minnesota, but dropped the rest of its games. The low point came at the end of the season. Northwestern hosted Illinois, a team that was 9-1, ranked fourth in the nation, and needed to beat NU to clinch a Big Ten title and its first Rose Bowl trip in 20 years. A crowd of 52,333, mostly in orange and blue, packed Dyche Stadium to watch the anointing of the Illini. It would be the last crowd of over 50,000 ever for NU's stadium. Illinois pounded NU, 56-24.

Almost all the Northwestern fans had left the stadium by the end, which was probably for the best. As the last seconds ticked away, Illini fans swarmed the turf and tore down NU's goalposts. The Illini then carted the posts out of the stadium. Aware of the NU tradition of "laking" the posts after big wins, the Illini hauled the posts down Central Street and eventually dumped them in Lake Michigan. One of the highlights of the 1983 season was the play of senior punter John Kidd, who finished with a 41.8-yard career average and earned All-American honors, the only Wildcat ever to do so specifically for punting. Kidd went on to an outstanding NFL career, playing through 15 seasons for five teams.

NU benefited from a number of very talented players during the next two seasons. In 1984 defensive tackle Keith Cruise took All-Big Ten honors. Wildcat punt return specialist Steve Tasker was drafted by the Oilers. Tasker left Houston in 1986 for the Buffalo Bills, where he played until 1997. In 2000 Tasker was named to the NFL's All-Time Team.

In February 1985, Arnold Weber replaced Bob Strotz as NU's president. Weber had been president of the University of Colorado, and he knew the value of a strong football program. During the following decade Weber would make several decisions that fundamentally affected the football program and eventually put it in a position for true renovation. As the team readied itself for spring practice in March 1986, Green stunned the school by announcing that he was leaving Evanston to return to the 49'ers. NU named Green's defensive coordinator, Francis Peay, the Wildcats' interim head coach. Peay had been an All-American at Missouri. He played for nine years in the NFL before taking jobs as an assistant coach at Notre Dame and Cal. The team, and the newly-signed recruits had been shaken by Green's departure, but Peay and his staff were upbeat heading into the 1986 season: "Our feeling about this season is one of tremendous optimism."

The 'Cats had a potent offense, featuring junior quarterback Mike Greenfield and tight end Rich Borresen. They lost their opener to Duke. A week later, though, the 'Cats hosted Army, which had won the Peach Bowl the previous year. NU held off a late rally by the Cadets to upset Army, 25-18. The Wildcats' first road game came at Princeton on September 27. Only 8,750 braved the rain to seen the Tigers take on the Big Ten, NU's only match ever with an Ivy League team. Princeton wasn't at a major college level, and NU rolled to a 37-0 win, the Wildcats' first shutout win since 1975. Princeton had seen enough and it canceled a scheduled follow-up game in Evanston. Peay's first team eventually won four games. To most schools such a record would bring disappointment. However, for a school that had come through so many terrible seasons, the team's performance was cause for celebration. It was the best finish for NU football since John Pont's first team in 1973, and *Sports Illustrated* named Peay its Coach of the Year. Northwestern quickly signed Peay to a five-year contract.

Peay was a good coach, but it eventually became clear that he wasn't the right one to solve the program's problems, and he wasn't going to lead Northwestern Football out of its Dark Age. The program continued to struggle. Student support of the team remained weak. By the mid-1980s, many students came to the stadium on gameday not for the game, but for the wild, booze-drenched tailgates, and for diversions such as throwing marshmallows at the band. When a marshmallow found its way into a tuba, the students cheered almost as loudly as they did when the 'Cats scored. During some of the early season non-conference games, when attendance was at a low and the weather was good, students would even bring books to games and stretch out across empty bleachers.

Peay's 1987 and 1988 seasons were disappointments, even by the lowered NU standards. The 'Cats squeezed out two wins and a tie in each campaign. The 1988 season would have been a complete disaster, but NU's running game helped grind out two Big Ten wins. Credit went to Peay's new running backs coach, Randy Walker, and Walker's two star rushers, Bob Christian and Byron Sanders (brother of NFL star Barry Sanders). Against Minnesota Sanders ran for a 24-yard touchdown, and the 'Cats earned a hard-fought tie in Minneapolis. At homecoming Northwestern rolled up 305 yards rushing against Wisconsin. Sanders rushed for 181 yards and a touchdown, and Christian tallied 79 yards and one touchdown as NU beat the Badgers, 35-

14. The 'Cats also upended Purdue, 28-7, when both Christian and Sanders ran for over 100 yards. By the end of the season Sanders had rushed for 1,062 yards, joining Mike Adamle and Greg Boykin as a 1,000-yard rusher. Offensive tackle Mike Baum also got a rare honor at the end of 1988. Baum was named an Academic All-American for the third straight year, the only Wildcat to win the honor three times.

Not even Walker's spectacular running corps could save the 1989 season. NU shuffled through its first winless year since 1981. The Wildcats were competitive during the first half of the season, dropping close games to Minnesota, Wisconsin, and Iowa. But on November 4 they hosted Ohio State and new Buckeye coach John Cooper. OSU wrecked Northwestern, 52-27, and the season flew off the rails. NU had its big crash in East Lansing. The Spartans took apart NU, 76-14.

When Northwestern lost its first two games in 1990, the media again began to take notice. The team had lost its last 14 straight, and students had begun calling the slump the "mini-streak." NU hosted Northern Illinois for its third game, and fans hoped that the Huskies would help the Wildcats halt their new losing skid, just as they had helped stop the 1979–'82 streak. Northern Illinois did not disappoint the crowd. Bob Christian ran for 179 yards and quarterback Len Williams passed for 171 yards as NU soundly beat the Huskies, 24-7. Fans rushed onto the field as the mini-streak ended, and they revived the victory tradition, bringing down the goalposts. The 'Cats won one more game, a homecoming offensive bonanza against Wisconsin. Christian piled up 220 rushing yards, Williams threw for 222 more, and the Badgers fell, 44-34.

The Wildcats only managed one win in their first seven games in 1991, whipping Wake Forest, 41-14. In the second quarter Northwestern scored an all-time record for points in a single quarter, with 34. In that one quarter Williams torched Wake Forest with three touchdown passes of 34, 1, and 25 yards, and he ran for a fourth touchdown. The 'Cats got their fifth touchdown of the quarter on a Dwight James interception return for 30 yards.

On October 19, 1991, Northwestern hosted Ohio State. In an effort to boost revenue, NU decided to move the game off-campus to—of all places—Cleveland Stadium. Northwestern still played host and wore its purple home uniforms, but the 73,830 fans present were overwhelmingly Buckeye fans. Still, the crowd is technically the all-time attendance record for a Northwestern "home" game. Ohio State won its home-state road game, 34-3.

After the Ohio State debacle fans were angry at NU, and players were angry as well. They were being shuffled around to help the budget, and the Big Ten was giving them no respect. They found themselves heavy underdogs in their next game, a homecoming showdown with defending Big Ten champions Illinois. Rain steadily fell at Dyche Stadium before the game, and wet students shaking their keys before kickoff cheered when the Wildcats took the field dressed in all purple for the first time in a decade. The Northwestern defense turned in its best performance in years in a spirited, emotional game. Illinois opted to keep the ball five times on fourth down, and Northwestern stopped them four of those times. In the most spectacular instance, Illinois drove to a second down at the NU 1-yard line. The Wildcat defense held through three straight goal line rushes. Mark Bensen caught for a total of 99 yards, and Northwestern upset Illinois, 17-11. The Wildcats had been beaten, badly, for much of the season, but they had not given up, and appreciative fans poured onto the rainy field and congratulated the team. It was one of the best-played games by the 'Cats in nearly two decades. Students brought the goal posts down again. It was the final time ever that fans actually tore down NU's goal posts after a win.

The 'Cats followed the triumph over Illinois by upsetting Michigan State in East Lansing, 16-13. But they lost their last three Big Ten games and finished 1991 with a 3-8 record. Francis Peay had pulled off two conference wins, but it wasn't enough. Peay's contract with Northwestern had come to an end, and Arnold Weber and athletic director Bruce Corrie decided not to renew it. The time had come to attempt again to rebuild the program, and Corrie needed to find someone to shake Northwestern football out of its sleep. He didn't know it, but Corrie was about to make the most critical hiring decision in the history of the program.

Northwestern scores against Michigan State at Dyche Stadium, on September 15, 1973. The Spartans had handed Agase his final defeat as NU's coach the previous November. NU coach John Pont and Michigan State's Denny Stolz made their coaching debuts for their respective teams at the game. The Spartans fumbled six times and were intercepted once, and Wildcat tailback Stan Key rushed for over 100 yards on the way to a 14-10 win.

The Wildcats, on their way to losing to Minnesota, 52-43, at Dyche, on November 3, 1973. The score set a Big Ten record for the most points by a losing team. It would stand for over 20 years.

With Dyche Stadium in the background, Wildcat fans enjoy a tailgate in the mid-1970s. As the records of the football team began a yearly decline, more of the game day action was found in the parking lot. By the late 1980s, NU football tailgates were social events, awash in alcohol, and frequented by many students who never actually made it into the stadium, despite the fact that students could come and go in the stadium without a ticket. Tailgating reached its peak during the 1995 season, and NU's parking lot parties made several national best-tailgate lists.

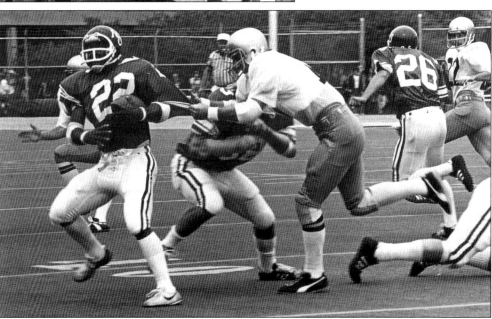

Northwestern hosts Notre Dame on September 25, 1976. Superb Wildcat running back Pete Shaw carries the ball in the photo, and split end Todd Sheets (#26) blocks. The game was the last in the renewed series with the Irish that began in 1965, and it was the last time ever that Notre Dame played a game at Dyche Stadium. In front of 44,396 mostly Irish fans, Dan Devine's team routed the 'Cats, 44-0.

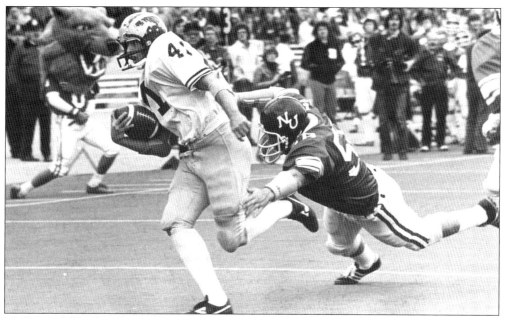

Michigan fullback Rob Lytle races toward the end zone as Willie looks on, helplessly. The Wolverines won the 1976 game, 38-7, one of NU's closer games with Michigan in the 1970s. NU's game program for the match had a frankly grim outlook: "The task of playing the nation's finest collegiate football team is not an enviable one, but that's what lies ahead for the Northwestern Wildcats this afternoon."

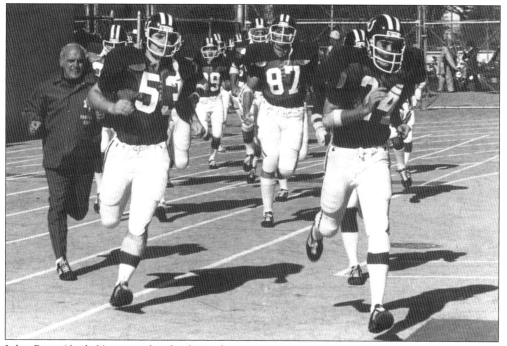

John Pont (far left) escorts his final Northwestern team to the field, 1977. Leading the charge in the photo are Jim Dunlea (53) and John Burns (24). After leaving Northwestern, Pont eventually settled in Japan, where he enjoys gourmet cooking.

Quarterback Bill Dierberger looks for an opening against North Carolina in 1977's home opener. The 1977 team, unfortunately, continued the program's five-year spiral. A few of the remaining students who attended games brought signs with them, bearing jokes like, "Mom: I don't need money. Send a team." The 1977 Wildcats seemed to be headed toward their first winless season since the 1957 fiasco. On their last game, however, they caught Illinois at its lowest point of a bad season. NU beat the Illini, 21-7, and finished 1-10 for the year.

Rick Venturi celebrates his first and only win as NU head coach, against Wyoming, on September 15, 1979. Venturi had played for the Wildcats in the mid-1960s. As a freshman quarterback in 1965 he threw the longest completed pass in school history, when he connected with Ron Rector for 80 yards and a touchdown against Illinois.[5] Venturi later served as an assistant coach under Alex Agase. In 1976, Venturi took an assistant position with Illinois, then returned to NU in 1978.

Quarterback Mike Kerrigan runs for his life in NU's 63-0 loss to Ohio State in 1980. It was the worst homecoming defeat in NU history. Venturi later said, "Our poor defense was decimated. We had to play a 6-1 because we had no healthy linebackers." Some sources credit Venturi with later creating a classic comparison based on the Ohio State game: "the only difference between me and General Custer is that I have to watch the films on Sunday."

A former Iowa running back, Coach Dennis Green later coached quarterbacks for the Hawkeyes. Bill Walsh hired Green as receivers and special teams coach for the San Francisco 49'ers. In 1980, Green left for Stanford, where he took over as offensive coordinator for the Cardinal before leaving at the end of 1980 for Northwestern. In 1989, Green returned to Stanford before becoming the head coach of the Minnesota Vikings in 1992. He coached Minnesota for ten years, then left to do television commentary. In 2004, Dennis Green was named head coach of the Arizona Cardinals.

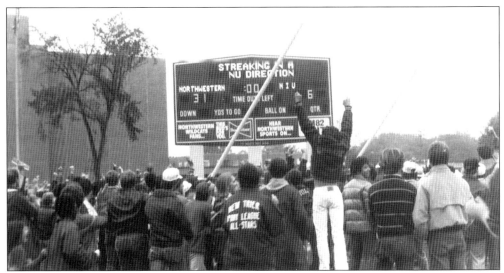

The nightmare that began in 1979 had come to an end. NU beat Northern Illinois on September 25 1982. With 34 seconds left (one for every game of the losing streak), fans yelling "Goalpost!" began to stream onto the field. The officials decided to let the clock expire during the chaos. As fans stormed the field, the team carried Dennis Green on their shoulders and into the locker room to celebrate his first win at Northwestern. He soon ran back out, onto the Dyche Stadium turf, holding up the game ball, and the crowd exploded into cheers. "I finally got one!" he exclaimed

Bob Christian carries the ball against Air Force in a night game at Dyche Stadium, September 16, 1989. Despite a winless season, Northwestern did have some very good players, including Christian and receiver Richard Buchanan. Christian scored 20 touchdowns during his career and rushed for 1,291 yards in 1989. Buchanan set the all-time NU receiving record in 1989, with 94 receptions.

EIGHT

Renaissance

1992–2004

Northwestern chose Colorado offensive coordinator Gary Barnett to succeed Francis Peay. Barnett had been a teammate of Peay at Missouri and had coached at the high school and minor college levels in Colorado before joining the University of Colorado's staff in 1984.

Barnett was shocked at how bad some things had become at Northwestern. NU's athletic budget was far behind the rest of the Big Ten. And he was unprepared for the attitude of the players, the other students, and the alumni. He later recalled in his book *High Hopes*:

> They used academics as an excuse for our poor athletic performance here, but the truth is the academics should have been a boost for athletics—not an obstruction. But they had to have some excuse, or how could anyone condone what had been going on? People acted like you could write or speak, that meant you had some congenital condition preventing you from being able to run. . . . The reality is that this had become a slothful football program that people distanced themselves from. . . the only way alumni or people on campus could deal with it was to ridicule it or disassociate from it.[1]

Barnett was determined to keep the team's academic standards. In his own way, and even without knowing the Wildcat precedents, what Barnett really wanted was to return to the shrewd recruitment and coaching approach that Waldorf and Parseghian had used so well: get good, smart players who are ready to be motivated, and motivate them to overachieve—to perform more than they, or anyone else, would have previously considered possible. That approach (and result) is truly Northwestern Wildcat Football. And Barnett, if anything, was a master at motivation.

He wanted to instill a sense of pride, even if that meant making dramatic changes. And he didn't limit the changes to the players. He wanted the other students to change their view of NU football as well. Barnett forbade students from bringing marshmallows into the stadium. He had the goalposts sunk in concrete. To Barnett, tearing down the posts after a win—no matter how monumental—was not the behavior of fans who root for a top team. The message, *expect victory*, wound through every move.

For spring practice Barnett introduced the Alumni Game in an effort to boost alumni participation in the program. Over 60 former Wildcats played alongside the varsity team in the May 1992 game. During the next couple of years the spring Alumni Game featured Ron Burton, *Sports Illustrated* columnist Rick Telander, and Mike Adamle. Barnett also initiated "Camp Kenosha," the preseason practices the team holds at the University of Wisconsin-Parkside in Kenosha, Wisconsin.

Barnett also made the most radical change to the team's uniform in decades. He kept NU's classic helmet, which made its debut with Coach Green in 1981, but he decided to outfit the team in black jerseys. Barnett wanted the team to have a new, more aggressive attitude, and the switch to black and purple would be symbolic of this shift. Northwestern was one of the first

teams to move to black uniforms, a trend that would continue among college and pro teams throughout the '90s.

Barnett and his new-look team made their debut September 5, 1992, at Soldier Field against Notre Dame. NU and Notre Dame had agreed to revive their series, dormant since 1976, with four games to be played from 1992 through 1995. Two of the games were to be held in South Bend, and Northwestern's two home games were to be moved to Soldier Field. That day, 64,877 fans and a national TV audience watched Lou Holtz's team shell NU, 42-7. The 'Cats were competitive in the first half, and wide receiver Lee Gissendaner pulled off a stunner by running a reverse 14 yards for an NU touchdown. But the Irish overwhelmed the NU defense in the second half.

The 'Cats fared even worse in their first road game. Boston College scored 35 points in the first half and coasted to a 49-0 rout. Finally, on October 3, Northwestern traveled to Purdue and beat the Boilers, 28-14, for its first win in the Barnett era. Against Purdue Len Williams threw a 70-yard touchdown pass to Gissendaner. Gissendaner also caught a 21-yard touchdown pass and returned a punt. Indiana and Ohio State easily beat the Wildcats, and NU next traveled to Illinois. It was Illinois' homecoming, and the Illini entered the fourth quarter with a comfortable 26-6 lead. Len Williams went to work and fired a 31-yard touchdown pass. On the Wildcats' next drive Williams threw a five-yard pass to Gissendaner. The Wildcat defense again stopped Illinois, and NU's next series went 67 yards and culminated with another short Williams to Gissendaner touchdown pass. Brian Leahy's extra point gave NU the 27-26 comeback win. Barnett considered the game a turning point.

The 'Cats played Wisconsin in the 1992 finale. NU forced two critical fumbles, Steve Ostrowski had 10 tackles, and the Wildcat offense rolled to a 27-25 win. Gissendaner caught for 163 yards, including a 58-yard touchdown pass from Williams. The win was the first for Barnett at Dyche Stadium, and fans ran onto the field and tried to down the goalposts. Not only were they anchored in concrete, the school had greased them before the game. Barnett raced toward the posts and tried to pull students off them. The win was NU's third Big Ten victory in 1992, its best finish in the conference since 1973. Gissendaner became Northwestern's first Big Ten MVP since Mike Adamle in 1970.

Recruiting experts were beginning to take notice of Barnett's classes. His 1993 group was ranked in the top 25 in the country and included Eric Collier, Casey Dailey, KeJuan DeBose, Pat Fitzgerald (who committed at the last minute on signing day), Chris Hamdorf, Hudhaifa Ismaeli, Paul Janus, Keith Lozowski, Brian Musso, Matt Rice, Ray Robey, Tim Scharf, and Toussaint Waterman.

Notre Dame again beat Northwestern when the teams met in South Bend to open the '93 season, but the 'Cats played the Irish close before falling, 27-12. The next week Northwestern hosted Coach Tom Coughlin and Boston College, the team that had beaten the 'Cats, 49-0, in '92. Boston College was ranked number 22, and ESPN televised the game nationally. This time Northwestern's defense held its ground, and safety William Bennett made 18 tackles. Willams and Gissendaner were again an offensive force. Williams made 17 of 21 throws, Gissendaner hauled in a 21-yard touchdown pass in the third quarter, and NU went on to beat Boston College, 22-21. It was the first time since 1900 that NU won a game against a team which had beaten the 'Cats by 49 or more points the previous season. Fans again tried unsuccessfully to bring down the goalposts.

Many fans and other viewers across the country were getting their first glimpse of Barnett's Wildcats from the nationally televised games with Notre Dame and the win over Boston College (NU's first win on national TV in three years). For two decades TV had not helped NU's visibility and recruiting. By the early 90's, however, the increase in cable coverage by ESPN, and later ESPN2 and other networks, as well as the explosion of cable subscribers, gave NU football a huge new audience. Early on, those audiences mostly watched the Wildcats lose to the traditional powers of the Big Ten. But it was visibility nonetheless, and it began to help the program.

The 'Cats actually received a few votes in the polls, for the first time since the mid 70's. They beat Wake Forest, 26-14, but then lost all their remaining games. A combination of injuries and inexperience hurt the 'Cats, and there was acrimony between the upperclassmen that Coach Peay had recruited and the younger players. Barnett had tried to work things out, but they soon spun out of control. It didn't help that, when NU was about to become a ranked team, Barnett lost his focus on Northwestern and—for the first time during his period at NU—began to think of taking another job. Barnett eyed Missouri, which needed a new head coach.

Missouri, however, looked elsewhere, and Barnett prepared for 1994. Northwestern lost Len Williams and Lee Gissendaner after the '93 season and was trying to find a new offensive dynamic. The 'Cats kicked off 1994 at Soldier Field against the Irish. This time the outcome was never really in doubt. Notre Dame quarterback Ron Powlus made his college debut by scoring four touchdowns—three in the first quarter—en route to a 42-15 win. The following week Northwestern played Bill Walsh's Stanford Cardinal to a 41-41 tie, the final tie game in NU history. The Stanford game was also on ESPN and featured 155 offensive plays. The next game was at Colorado Springs against Air Force. The Falcons led, 3-0, at the half, but quarterback Steve Schnur heaved a 59-yard touchdown pass to give NU the lead, and the 'Cats held on to win, 14-10.

NU's record was even when it met Ohio State in the '94 Big Ten opener. The 'Cats held Ohio State to just 17 points and trailed the Buckeyes by eight in the fourth quarter. Quarterback Tim Hughes threw a short touchdown strike to Dave Beazley with five minutes to go. NU opted to go for two to tie, but the attempt failed. The Wildcats lost big to Wisconsin the next week, then they stunned Minnesota and pounded Indiana. By the first week of November 1994 the Wildcats' record was still even, and they had a legitimate shot at a winning season and a bowl game.

That shot ended with blowout losses to Illinois, Michigan State and Iowa. Iowa destroyed NU, 49-13. After the game reports reached Barnett and his staff that running back Dennis Lundy, who had fumbled against Iowa, might have fumbled on purpose. Rumors that Lundy had been gambling began to spread. When Barnett confronted Lundy and was told that he had been gambling, but did not fumble on purpose, Barnett suspended Lundy for the last game of the season—the last of his career. Barnett also brought the issue to athletic director Rick Taylor and to Northwestern's legal council. The school called in the NCAA and the FBI to look into the matter.

With Lundy out for the final game, against Penn State, true freshman Darnell Autry started at running back. Autry was explosive: his 39 carries was the most against Penn State in its history, and Autry gained 171 yards. It wasn't enough to stop the second-ranked Nittany Lions, though, and NU fell, 45-17.

By the spring of 1995 the pieces were coming together for Northwestern football's rebirth. Incoming NU president Henry Bienen shared Arnold Weber's view that the athletic program reflected on the university, and the university did not have to weaken its academic standards to achieve greatness on the field. Dyche Stadium was crumbling, and the school had no indoor football facility. In May NU launched the Campaign for Athletic Excellence, which hoped to raise over $20 million to pay for a full-blown renovation of the football facilities.

Barnett's 'Cats had three wins his first season, two his second, and three wins in his third season. The record showed little progress from the last two stagnant decades. However, many of the 1994 losses had been close. The team morale heading into 1995 was improving. 1995 was Barnett's fourth year, and the team comprised his players, his recruits. Barnett is fond of storytelling. One fable he often used to describe the seasons leading up to 1995 is that of the stonecutter who keeps hitting away at a large rock. The stonecutter hits the stone 100 times, but it remains intact. On the 101st strike, the stone crumbles. "What caused the stone to crumble? It wasn't the 101st strike, but the 100 that came before it." Barnett, his staff, and his players were nearing the 101st strike. They had a focused, intense spring practice. During the summer the team conditioned by climbing an Evanston hill nicknamed Mt. Trashmore, which

soon became part of NU football lore. On top of Mt. Trashmore, Larry Lilja had placed a small Rose Bowl flag.

In July 1995, redshirt freshman Marcel Price was accidentally shot to death by a friend at a party. As the team began preseason practice, the Wildcats were devastated by the loss of their teammate. Barnett and the team decided to wear a patch inscribed with "Big Six," Marcel's nickname, on their uniforms. They would wear the patch for the next four years, the years that Marcel Price would have played.

The Wildcats took the field on a sunny Saturday afternoon at Notre Dame Stadium on September 2, 1995, wearing their new white road jerseys with the "Big Six" patch. Heading to the stadium before the game, Barnett told his players that, when they won, they should not carry him off the field. "Act like you've done this before." The NBC telecast of the game began with a glowing tribute to the rebirth of Notre Dame Football, at the time ranked ninth in the country. The 'Cats were 28-point underdogs, and it was supposed to be Lou Holtz's 200th career win. Holtz's celebration would have to be put on hold, however. It was Northwestern's day. It was Northwestern's year.

As the game started the Irish had little trouble picking up a first down and driving to midfield. On first down from the Irish 48, however, Randy Kinder fumbled and Danny Sutter recovered for the 'Cats. On the first play after Sutter's recovery, Autry ran up the gut for a 16-yard gain, followed by runs of 14, 7, and 4 yards. That last burst gave NU a first down and goal. On third down Steve Schnur threw to Dave Beazley in the end zone for a touchdown, and Sam Valenzisi nailed the extra point. The mostly-Irish crowd of 59,075 was stunned into silence. On first down, Hudhaifa Ismaeli sacked Irish quarterback Ron Powlus for a 10-yard loss. Two series later, on fourth down and seven from the NU 38, Lou Holtz decided to go for it. Ron Powlus passed to Robert Farmer, but the NU defense stopped him for only a six-yard gain.

After an Irish field goal made the score 7-3, Darnell Autry returned the Irish kickoff to the NU 37, and the 'Cats began a methodical drive to the Notre Dame 20. During the drive fullback Matt Hartl and receiver Brian Musso both caught 18-yard passes from Schnur. Valenzisi kicked a field goal to give Northwestern a 10-3 lead. The Irish rebounded quickly, driving to the NU 5-yard line before Farmer ran left for the score. Kevin Kopka's point after try sailed wide right, and the Wildcats clung to a 10-9 lead. Toward the end of the second quarter Powlus and the Irish had a chance to rally, but Casey Dailey's 8-yard sack of Powlus snuffed out the drive. The 'Cats took their lead into halftime.

In the third quarter Steve Schnur rifled a pass to D'Wayne Bates, who streaked in for the touchdown. With Valenzisi's kick Northwestern enjoyed a 17-9 lead. Notre Dame again drove to midfield, but on a third down NU linebacker Pat Fitzgerald deflected Powlus' pass, and Notre Dame punted. Midway through the fourth quarter, Notre Dame had a first down at the NU 46 and began a determined drive. Powlus threw for two first downs, and Mark Edwards ran for a first down and goal. Two plays later Randy Kinder scored, and Notre Dame was two points away from tying. The Irish lined up for the conversion. Powlus took the snap, but tripped as he moved back. His knee hit the 7-yard line, and the conversion failed. Notre Dame had one last chance with four minutes left. On fourth down and two, on the Irish 44, Holtz decided not to punt. This was Northwestern, after all—surely the Irish could get the two yards they needed to win the game. Randy Kinder took the handoff and ran up the middle—where he was stopped cold by Matt Rice. NU won, 17-15. Except for a couple hundred fans dressed in purple in the visitor section who were going berserk, Notre Dame Stadium was silent.

A week after the game the AP poll ranked Northwestern number 25. It was the first time the 'Cats had been ranked since December 1971. The ranking would not last long. On September 16 NU hosted Miami of Ohio. It was the first time NU had played Miami since 1982, when it handed the 'Cats their 34th and final loss in the losing streak. Randy Walker, NU's former running backs coach, had left NU to take the Miami head coaching job in 1990. Walker, a Miami alumnus, had his team in top condition.

The Wildcats initially pounded Walker's troops. In the third quarter NU regained a 21-point

lead, when Rodney Ray picked off Miami and ran for a 20-yard touchdown. Walker's players were disciplined, and they were far from folding. In the fourth quarter Miami reeled off three straight scores. The third, a two-yard run with just over two minutes remaining, put Miami one point away from tying NU. Walker wasn't looking for a tie. He went for two, but the NU defense held, and it seemed like NU would pull out a close win. NU regained possession and tried to grind time off the clock. Faced with fourth down, NU went to punt. The snap was low, and it rolled. And rolled. It rolled all the way to the NU 1-yard line. Miami kicked a chip-shot field goal to win the game and knock NU back to earth.

The same question was on the minds of fans and casual observers everywhere: faced with such a defeat, would NU give up and go into a shell? Or would the 'Cats regroup and continue to play like they did against Notre Dame. NU began to give its answer the next week, when it beat Air Force at Dyche Stadium, 30-6. It was NU's first home win since 1993. A week later NU, in its third straight home game, opened the Big Ten season by hammering Indiana, 31-7. During the game Brian Musso returned a punt 86 yards, and no one returned Paul Burton's record-tying 90-yard punt. After the Indiana game NU got back its number 25 ranking.

Michigan was next—seventh-ranked, undefeated Michigan. NU had not beaten the Wolverines in Ann Arbor since Parseghian's powerhouse in 1959. In front of 104,642 fans, Michigan opened the scoring midway through the first quarter by kicking a 41-yard field goal. It looked like Michigan would lead by 10 in the second quarter, when the Wolverines drove to the Wildcat 1-yard line for first down and goal to go. Pat Fitzgerald, on the next two plays, tackled Tim Biakabatuka for loss. Michigan settled for a 6-0 lead. Sam Valenzisi kicked two field goals, including one in the last second of the half, and NU stunned the crowd by taking a six-all tie into the locker room. In the third quarter the Wolverines engineered an 80-yard drive that climaxed with Griese's 3-yard touchdown run and gave Michigan a 13-6 lead. NU answered with another Valenzisi field goal, and the 'Cats were down by four. On the next NU drive Barnett and offensive coordinator Greg Meyer sprang one of the greatest trick plays the 'Cats have ever used. Schnur threw a lateral to D'Wayne Bates. Bates was a quarterback in high school, and he could throw well. He certainly threw well against Michigan. Bates fired off a flanker-option pass to wide-open tight end Darren Drexler, who hauled in the pass at the Michigan five. It was not the last time Bates would play quarterback against Michigan: three years later he would actually take a snap from behind center against the Wolverines. On third down Schnur tossed the ball into the end zone to Matt Hartl, who clutched it as he fell, giving the 'Cats their only touchdown, and the lead.

Michigan drove again to midfield. On third down Fitzgerald slammed into Griese, sacking him and knocking the football out of his grasp. Ismaeli recovered it, and NU was in a position to put the game away. Schnur connected with Bates for a 46-yard pass, and Valenzisi nailed his fourth field goal of the day. NU now led, 19-13. Later in the fourth quarter Michigan had one final shot at scoring. The Wolverines had a first down at the NU 34. Two incomplete passes and a recovered fumble later, Michigan faced fourth down and one chance left. Griese completed a pass—to NU safety William Bennett. NU won, and its ranking skyrocketed from 25th to 14th, its biggest one-week jump since 1950. The media, not to mention other teams, were starting to respect the Wildcats in a way that no one had in over 20 years. Barnett remained resolute about how he saw the program. After the Michigan win, Barnett said, "Someone said to me the other day, 'You're playing with the big boys now.' I said, 'No, we are the big boys.'"[2]

Barnett's big boys next beat Minnesota, and needed just one more victory to ensure their first winning season since 1971 and obtain bowl eligibility. They got it against Wisconsin in Dyche Stadium's first sellout since the 1983 Illinois fiasco. Chris Martin intercepted the Badgers' first attempt on offense, Darnell Autry broke Mike Adamle's record by rushing over 100 yards in his eighth straight game, and the NU defensive second-stringers preserved a 35-0 shutout at the end of the game. NU rose into the top ten teams in the country, ranked eighth. The 'Cats were ripe for a letdown, and almost suffered one the following week at Illinois. The Illini led most of

the game, and enjoyed a 14-10 lead well into the fourth quarter. The Wildcats drove 58 yards, and Autry lunged into the end zone with a little over six minutes to go to give NU a 17-14 lead and the win.

NU rose to sixth-place in the AP Poll, and when defending Big Ten champion Penn State came to Dyche Stadium the next week, so did ABC. During the pre-game discussion, ABC commentator Keith Jackson paid tribute to the 'Cats: "Television used to come here because of the opposition. Today, we're here because of Northwestern." Northwestern, for its part, didn't disappoint. In front of their second straight sellout crowd of 49,256, NU orchestrated an early 73-yard scoring drive capped by a short touchdown run by Autry. On defense, Fitzgerald had 17 tackles and a sack, Ismaeli had two sacks, and Chris Martin had nine tackles and an interception as Northwestern overpowered Penn State, 21-10. NU sold out Dyche Stadium again when it hosted Iowa. Brian Musso returned a Hawkeye punt for a 60-yard touchdown, Autry scored a touchdown in the third quarter, and Hudhaifa Ismaeli recovered an Iowa fumble in the fourth quarter which he raced back for a 31-yard touchdown. Ismaeli's spectacular play came with just under three minutes left, and NU beat the Hawkeyes, 31-20. Unfortunately, the 'Cats lost their defensive leader, Pat Fitzgerald, who had made 10 tackles but broke his leg in the third quarter, ending his season.

Only a game at Purdue stood between the fifth-ranked 'Cats and the Big Ten championship. Chris Martin ran an interception back 76 yards for NU's first score. Not to be outdone by the defense on explosion plays, Schnur connected with Bates in the second quarter for a 72-yard touchdown pass. In the third quarter Chris Martin blocked a Purdue punt, resulting in a safety, and Schnur drove into the end zone to give the Wildcats a 23-0 lead. A fourth quarter touchdown by Purdue made the score 23-8, but that was all the Boilers could offer.

The Wildcats were Big Ten champs, but it wasn't yet known if they were to share the title with Ohio State. NU and Ohio State did not play each other in 1995 and 1996. Ohio State had one game to go, against Michigan, and if it beat the Wolverines, it would go undefeated for the season. The Buckeyes and NU would share the title, but because of its better overall record, second-ranked Ohio State would go to the Rose Bowl. NU had to hope that Michigan would win. On the Saturday after Thanksgiving ABC carried the Michigan-Ohio State game, but also had a camera at the Nicolet Center in Evanston, focused on the Wildcat players who had gathered to watch the game. When Michigan won, 31-23, the NU players began to celebrate. They were sole Big Ten champs for the first time since 1936, and they were Rose Bowl bound. Michigan sent a bouquet of roses to Evanston, with a two-word note: "You're welcome."

The publicity for the team was unprecedented all season, but when Northwestern accepted the Rose Bowl invitation, the frenzy exploded. Chicago's Hancock Building glowed purple. Earlier in the season Northwestern had instituted a new tradition with its own tower. After NU won a game, the clock face of NU's Rebecca Crown Tower glowed purple instead of white. Northwestern appeared on the cover of *TV Guide*. Barnett and the players appeared on the *Tonight Show*. Much of the coverage rehashed the team's less-than-glorious recent past, and noted that the last bowl game the 'Cats had played was the 1949 Rose Bowl. The implication was that NU had not been *good* since 1949. However, the bowl drought was due as much to poor timing as to NU's poor play. The Big Ten, from 1947 through the mid-'70s, played only in the Rose Bowl. By the time Big Ten teams were eligible for other bowls, NU's football fortunes had slumped. If the conference limits had not been in place, NU's winning teams under Parseghian and Agase would have made it to the postseason as well.

The Rose Bowl television coverage opened with none other than Moses. Northwestern alumnus Charlton Heston introduced the game: "For all of us who ever walked the halls of Northwestern University as students, this New Year's Day is a heartlifting experience. For nearly half a century we had to watch as others cheered their alma maters in college football bowl games. Now at last in 1996 it's our turn again. Whatever happens, it will be a great day for the Purple and White." He was right.

Gary Barnett hated the term "moral victory." He considered it defeatist. However, there have

been two instances in the history of Northwestern Football when the phrase was apt and deserved. Northwestern's two inspired losses in 1924, when the team truly became "Wildcats," was one instance. The second was when the team made it to the Rose Bowl on January 1, 1996, and played the game it did.

The Trojans kicked off the scoring when quarterback Brad Otton passed for a pair of first downs and drove into NU territory. Eventually LaVale Woods drove into the end zone, and USC led 7-0. The 'Cats responded later in the first quarter, with Schnur throwing to Bates. The duo completed three passes, setting up a short Autry run for the touchdown. In the second quarter Southern California went on a tear, scoring on a 21-yard pass play and kicking a 30-yard field goal. On third down Brian Musso raced to midfield and was tripped up. As Musso's knee touched down, the ball came loose. The refs did not blow a whistle, and USC picked up the ball and streaked in for a touchdown and a 17-point lead. One play, one questionable call, resulted in a 14-point swing against NU. The 'Cats managed to recover some of the ground lost in the last seconds of the half. Tim Scharf and Ismaeli forced and recovered a USC fumble, setting up a Brian Gowins field goal to make the score 24-10.

After an excellent halftime show by John Paynter and the Northwestern marching band, the 'Cats drove and set up Gowins' second field goal. On the ensuing kickoff Gowins executed a completely unexpected onsides kick, recovered by Josh Barnes at the NU 48. The possession ended in a Darnell Autry touchdown, and NU was on the rebound, down only 24-19. But Otton and Johnson paired again for an explosive play, a 56-yard touchdown pass that put USC up by 12. The Wildcats were unfazed. Schnur, on first down, rifled a pass to Bates for 46 yards. After a few rushing plays, Schnur lurched into the end zone for a touchdown. The Wildcat defense, now completely fired up, stoned Otton, and USC punted. Early in the fourth quarter, down 31-26, Autry powered his way to another touchdown, and Northwestern took a 32-31 lead. The Wildcat fans in the stands and across the country went crazy. NU's fourth quarter lead in the Rose Bowl lasted three minutes and 52 seconds. A long Trojan drive resulted in a field goal, and USC scored again with three minutes left in the game to take a 41-32 lead, and the win.

Northwestern fell in the final AP polls, but only to eighth place, their first top-ten finish since 1948. Barnett was named national Coach of the Year by nearly every poll. Darnell Autry had placed fourth in the Heisman Trophy balloting, the highest finish for a Northwestern player since Otto Graham placed third. Sam Valenzisi and Pat Fitzgerald were named All-Americans.

Some reporters, convinced that NU football couldn't climb so far out of its hole through coaching and talent alone, accused the school of lowering its admissions. NU, however, had stood by its standards. Barnett bristled at the charge: "I don't like the assumption that because we had success in football we must have forsaken our standards. Like our defensive tackle Matt Rice once said: 'We're no dumber now than when we stunk.'"[3] In fact, Barnett's teams were academically *better* than the Wildcat teams before them. By 1997, NU football players had the second-highest SAT scores in Division I, just behind Stanford.[4] And former President Strotz's (and the University of Chicago's) theory that athletic futility enhanced a school's academic reputation was put to rest for good: in 1995, there were 12,918 general freshman applications to Northwestern. In 1997, after the Rose Bowl, the number shot to 16,685. Average SAT scores among all freshmen at NU rose 19 points in those two years.

Expectations for an encore season were understandably high in 1996. Schnur, Autry, Hartl, Bates, Fitzgerald, and so many others from the '95 season still had a year or more to go. SportsChannel televised the Spring Game live, with Barnett offering color commentary from the Dyche Stadium booth. Fitzgerald, still out with the broken leg he suffered in the Iowa game, was expected to recover fully in time for the new season.

Northwestern opened the season at Wake Forest and were stunned by the Deacons, 28-27. After the game the Wake Forest fans tore down one of their goal posts. Barnett was obviously upset after the game: "These are hard lessons. Apparently we have to keep learning them over and over." The 'Cats got back on track with their second road game, pasting Duke, 38-13.

Northwestern had lost seven straight to Duke. Autry continued his streak of 100-yard games, rushing for 157 yards. In the following weeks NU enjoyed similar wins in its home opener against Ohio University, which it whipped, 28-7, and in its Big Ten opener against Indiana, a 35-17 win.

Northwestern had stormed back to number 22 in the polls. The rematch with Michigan was next, and Dyche Stadium sold out. By the fourth quarter Michigan's 16-0 lead made back-to-back wins against the Wolverines seem impossible. But two minutes into the final period, Levell Brown, on his first carry of the season, rushed into the end zone. Barnett went for two, and Schnur fired to Bates to bring NU within eight. On Michigan's next offensive play Kevin Buck popped the ball loose, and Brian Gowins eventually kicked a field goal. Michigan's drive stalled, and Gowins got another opportunity to kick. He made a 33-yarder with just over five minutes to go to trim Michigan's lead to 16-14. After a Michigan punt NU began its final drive, but faced a fourth down and nine, out of field goal range. The Wildcats had no choice but to go for it. Schnur fired a pass to Brian Musso. The pass was a little off the mark, but Musso made a one-handed circus catch and hauled in the ball for the first down. With 13 seconds to go, facing a 39-yard field goal, Gowins took the field and split the uprights. The crowd burst into screams and cheers, but quickly fell silent. The officials ruled the play dead. The referee claimed that Paul Janus had snapped the ball before the officials were ready. Gowins was forced to kick the winning field goal a second time. Michigan and NU players stood silent and helpless on the sidelines and watched as Gowins repeated his kick flawlessly. Fans poured onto the AstroTurf and celebrated.

NU shot to number 15 in the country. A week later Northwestern almost had a letdown when Minnesota rallied and scored 24 second half points. The 'Cats, however, held on to beat the Gophers, 26-24. Northwestern then traveled to Madison and got into a shootout with Wisconsin. They traded blows until early in the fourth quarter, when Wisconsin scored two touchdowns in just over a minute to jump to a 30-20 lead. Adrian Autry (no relation to Darnell Autry) had replaced Darnell at running back, and he rushed for a touchdown with seven minutes to go. Wisconsin, however, had the ball and the 30-27 lead with under a minute in the game. Trying to run out the clock, and rather than take a knee, Ron Dayne fumbled. Eric Collier recovered for NU. Schnur ran for 21 yards, and on the next play threw a 20-yard touchdown pass to Bates. The Wildcats escaped with a 34-30 victory.

Against Illinois Adrian Autry scored the winning touchdown with a minute to go, and NU edged the Illini, 27-24. The 'Cats enjoyed a number 11 ranking and the Big Ten lead when they traveled to Penn State. Joe Paterno's team did what Michigan's could not—they got revenge, beating the 'Cats, 34-9. The next week Northwestern, still upset over having its 13-game Big Ten winning streak broken, went to Iowa and took out its frustrations on the Hawkeyes. In the second quarter the 'Cats pulled out the same trick play that worked so beautifully at Michigan in 1995. Schnur fired a lateral to Bates, who threw downfield to Darren Drexler, wide open in the end zone. Darnell Autry rushed for 240 yards and four touchdowns, and the 'Cats routed Iowa, 40-13.

Northwestern was 6-1 in the Big Ten when it hosted Purdue in the last game of the season. NU and the Boilermakers were tied, 24-24, with two minutes left. Purdue had the ball and could take the game with a field goal. The Boilers fumbled, however, and NU recovered. Brian Gowins nailed the game-winning field goal with four seconds left. The win over Purdue was the last game played at Dyche Stadium, and the last NU home game played on AstroTurf. It was also the last time that the Wildcats wore uniforms with "northwestern stripes," the tradition that NU had made famous.

Ohio State, still undefeated in the conference, played Michigan a week later. The Wildcats again found themselves cheering for the Wolverines, and again Michigan came through, beating the Buckeyes. With the loss, Ohio State was forced to share the Big Ten title with Northwestern. Barnett was the first NU coach since Dick Hanley in 1930–31 to win back-to-back Big Ten championships. Northwestern was also headed to its second straight January 1

bowl game. The 'Cats would play Tennessee in the Citrus Bowl. On the very day that NU accepted the Big Ten trophy and its invitation to the Citrus Bowl, Wildcat defensive coordinator Ron Vanderlinden announced that he was leaving NU, to become head coach at Maryland. Matters were not helped when rumors swirled that Barnett was also looking at other coaching jobs, just as he had right before the Rose Bowl.

With just over two minutes to go in the first half of the Citrus Bowl, the Wildcats tied Tennessee. The Volunteers, however, would score 10 points in those remaining two minutes, and would proceed in the second half to overwhelm NU, winning 48-28. Peyton Manning was brilliant. He threw for 408 yards, no interceptions, and four touchdowns. The loss, however, did little to NU's ranking, dropping the 'Cats from 11th to 15th. Darnell Autry finished seventh in the Heisman Trophy balloting.

The Wildcats lost a lot of their high-profile talent in 1997. Darnell Autry skipped his senior year to enter the NFL draft, and Fitzgerald and Schnur had graduated. (Autry would return to NU in 2005 to continue to work for his degree.) Two of the Wildcats' quarterbacks from 1994, Tim Hughes and Chris Hamdorf were still on the team and split the QB duties. In addition to Coach Vanderlinden, two other assistant coaches had left. The Wildcats began the 1997 season by hosting Oklahoma in the Pigskin Classic. NU held the game at Soldier Field, partly because crews were still finishing the renovations to the school's stadium. In May NU had renamed its stadium Ryan Field, in honor of Pat Ryan, who had donated millions to the renovation project. But by dropping William Dyche's name from the stadium, the school upset some alumni and fans.

The Pigskin Classic was not exactly a classic match up. Even with the drop in veteran talent from the previous season, NU still overpowered Oklahoma, 24-0. The Sooners drove deep into NU territory five times, only to come away with nothing. Gowins kicked three field goals, including a 40-yarder. The 'Cats then traveled to Wake Forest and again lost to the Demon Deacons. Barry Gardner forced a Wake Forest fumble and terrorized the Deacon backfield, but it wasn't enough to stop Wake.

Northwestern hosted Duke for the first game at the renovated stadium. Fans getting their first glimpse of Ryan Field came away impressed. The 71-year old stadium looked spectacular, and the new facilities were state of the art. The Wildcats, however, did not look spectacular in the first half against Duke. The Devils led 13-3 at the half. In the third quarter the offense finally rolled and edged Duke, 24-20. NU claimed its 12th straight home win. It was Duke's 15th loss in a row.

The 'Cats dropped their next four games and took a 2-5 record into homecoming. The season was disappointing, but the homecoming game against Michigan State would be a classic. Against the Spartans, the NU defense sprang to life. Josh Barnes intercepted a pass, Barry Garnder caused another fumble, and Thor Schmidt had a sack. Adrian Autry rushed for 175 yards and scored ran for a 15-yard touchdown. NU led 19-17 in the fourth quarter, but Michigan State drove late and set up for a 28-yard field goal with seconds left to win the game. As the kick sailed toward the goal, Anwawn Jones leapt and blocked the ball, saving the win for NU. Northwestern went on to claim a 5-7 record for the season.

In early 1998 the Wildcat men's basketball program was hit by a gambling scandal, and the investigation began to widen to the 1994 football team and to circle back to Dennis Lundy, who had earlier testified before a grand jury that he had not gambled on Northwestern. The 1998 preseason was also plagued by even more rumors that Barnett was ready to take another job. Barnett's job interviews eventually led to several committed NU recruits defecting, including star quarterback John Navarre after the '98 season, who instead signed with Michigan.

With the FBI investigating former players and Coach Barnett's wanderlust making headlines, the distractions proved too great. Northwestern weathered a 3-9 season in 1998, and went winless in the Big Ten. On November 21, the Wildcats closed the season at Hawaii and routed the Warriors, 47-21. Barry Gardner and D'Wayne Bates were drafted by the NFL in the second

and third rounds, respectively. They were NU's highest draft picks since Matt O'Dwyer went in the second round in 1995.

In December 1998 Dennis Lundy was indicted on perjury charges, along with former Northwestern players Christopher Gamble, Michael Senters, and Gregory Gill. Lundy eventually admitted to fumbling on purpose against Iowa in 1994 and betting on the Notre Dame and Ohio State games. Barnett and athletic director Rick Taylor publicly railed against the four. Taylor called their actions a "betrayal of the very fabric of sport." The four had disgraced themselves on the field and dishonored their team so badly that Taylor revoked their football letters, and had their records stricken from Northwestern's books. The school, Taylor and Barnett took withering criticism from the media and alumni. However, the NCAA and the government both praised how the university had handled the mess. Herbert Collins, special agent-in-charge of the Chicago field division of the FBI said, "I publicly commend the university for choosing not to look the other way."[5]

In January 1999, Colorado coach Rick Neuheisel resigned and went to Washington. Instinctively, all eyes moved toward Barnett. Just as he had with openings at UCLA, Georgia, Notre Dame, Texas, Oklahoma, and the Detroit Lions, Barnett danced around the issue and soaked in the attention. Then he sent an e-mail to all his players, assuring them that he would be at NU to take the players back to Pasadena. Less than a week later Barnett announced he was leaving for Colorado. Running back Brian Marshall complained, "He gave us his word. When anybody goes back on his word, you lose respect for him. How can you trust him?" Barnett replied, "I think the only deception is if you knew you were deceiving them when you were doing it."[6] Barnett certainly knew what he was doing a week later, when he welcomed three of NU's recruits to Colorado. Barnett's legacy with Northwestern is a profoundly complicated one. Barnett was the right coach at the right time, and he revived the program. But his constant job interviews, the manner of his exit from Evanston, and his poaching of NU players soured many fans forever.

When Barnett finally decided to resign, Rick Taylor and NU were ready, and they announced the very next day that they were replacing Barnett with Miami of Ohio coach Randy Walker. Walker made clear his differences from Barnett at the start. Alluding to Barnett's constant contact with other schools, Walker said, "I'm not a '1-800' guy . . . the job some guys have is never quite good enough." Walker had an interest in history, was a firm believer in team conditioning and discipline, and prized loyalty and determination. If Barnett sometimes seemed like Phil Donahue, Walker was Patten. When players complained in practice about wearing their helmets at all times, Walker shot back, "we're soldiers. Keep your helmets on. We're going into battle. I don't think they took their helmets off at Normandy."

But the General was starting with a team that was deeply divided after Barnett had left. Ironically, Walker was just as shocked at the condition of the team when he arrived as Barnett was back in 1991. Walker began making significant changes to off-season conditioning. Defensive end Dwayne Missouri said a year later, "quite honestly, that wasn't something we were used to. We were used to coming out on Saturday, playing the best we could, kind of getting away with stuff at practice. So when Walker came it was like, 'Oh, wow. Everything's about to change.'"

The 1999 off-season didn't just bring change; it brought tragedy. The Northwestern Athletic Department was rocked by three untimely deaths. In June former Wildcat football player Bobby Russ, during a traffic stop, was accidentally shot by Chicago police. In July a white supremacist shot former NU basketball coach Ricky Birdsong during a rampage that targeted African-Americans and Jews. And on August 30, 23-year old Matt Hartl, who had valiantly fought to stay with the Wildcats through illness, lost his battle.

Walker's first year looked a lot like 1998. The 1999 season started with Northwestern hosting, of all teams, Miami of Ohio. Walker's former team, trained and conditioned by him, savaged his new team, 28-3. Fans, while bitterly disappointed at yet another loss to Miami, hoped that they saw in the RedHawk players a sign of things to come for Northwestern. Things

did begin to look up the next week at Ryan Field, when the 'Cats beat Texas Christian, 17-7. A trip to Duke followed, and NU avenged their humiliating loss to Duke in '98 by taking Duke into overtime. The game was Northwestern's first overtime game, and the 'Cats won it when quarterback Nick Kreinbrink connected with Sam Simmons for a 27-yard touchdown. But the 'Cats lost their first three Big Ten games, and their conference losing streak grew to 11. On October 16, NU hosted Iowa for homecoming. Quarterback Zak Kustok, a transfer from Notre Dame, raced into the end zone for the game-winning touchdown. The play was a preview of what NU fans would enjoy throughout 2000. However, the 'Cats just weren't at that level yet, at least not consistently. They dropped their remaining games and wound up 3-8.

Few outsiders expected anything at all from Northwestern in 2000. Practically the same group of players returned from the '99 squad: Zak Kustok, Damien Anderson, Sam Simmons, Dwayne Missouri, Austin King, Billy Silva, Kevin Bentley, Napoleon Harris, and others. When NU shelled Northern Illinois in a night game at Ryan Field to start the 2000 season, it didn't raise many eyebrows. Nor did the Wildcats' 38-5 blowout victory over Duke. When Northwestern lost a road game to Texas Christian in a 41-14 laugher, it confirmed to many fans that this was the same Wildcat squad that struggled in 1998 and 1999. But it wasn't the same squad. It was a far better conditioned squad, and it had an offense that was about to knock the Big Ten upside down. During the preseason Kevin Wilson, Walker's offensive coordinator, had reworked the offense based in part on discussions NU had with the Rams. Wilson moved the 'Cats into a no-huddle, spread offense which Kustok controlled from the shotgun.

On September 23, Northwestern played top ten-ranked Wisconsin at Camp Randall Stadium. NU struck first, when Kustok kept the ball and ran 28 yards for a touchdown. One would have thought that the Camp Randall announcer had just declared the reinstatement of prohibition: 78,597 hostile screaming voices went still. Wisconsin claimed the next three scores, and the 'Cats trailed 16-7 at the half. The Badgers continued to roll at the start of the third quarter until Dwayne Missouri smacked into Wisconsin quarterback Brooks Bollinger from the side, sending the ball into the eager arms of Kevin Bentley. Bentley ran it in, and NU surged within two points. After a Badger touchdown and a Tim Long field goal for NU, the 'Cats entered the fourth quarter down 23-17. They took a brief lead when the NU line blocked every Badger in sight, and Damien Anderson streaked 69 yards into the end zone. Wisconsin answered with a touchdown almost immediately, and the shootout was underway. Kustok then launched a 28-yard touchdown pass to Derrick Thompson. With 51 seconds in the game, Wisconsin booted what looked like the game winning field goal. Kustok guided the 'Cats into field goal range with two seconds left. Tim Long kicked a 46-yard field goal, his longest to date, and the game moved into overtime. The teams swapped touchdowns, and NU found itself down a field goal in double overtime. Damien Anderson streaked, virtually untouched, 13 yards into the end zone, and NU won its biggest game since 1996.

Northwestern followed the win by traveling to East Lansing and whipping ranked Michigan State, 37-17. The team returned to Ryan Field and mauled Indiana, 52-33, the highest amount of offense from Northwestern in 40 years. Anderson ran for 292 yards, and four touchdowns. Sam Simmons, Teddy Johnson, and Kevin Lawrence also scored. After a loss to Purdue, NU traveled to Minnesota and suffered a second-quarter breakdown. The Gophers scored 21 in the second quarter and led 28-14 at the half. In the third quarter Minnesota scored again, and NU found itself down 21 points. Kustok and company then began the greatest comeback in Northwestern history. He found Simmons for a 13-yard touchdown pass. Early in the fourth quarter Kustok lunged into the end zone to bring the 'Cats to within seven. With just over a minute left Kustok again ran in to score. With the game tied NU regained the ball in its own territory. On fourth down, with three seconds left, the 'Cats lined up for a last play, "Victory Right." Kustok took the snap and, before being decked to the turf, heaved a shocking bomb to the end zone. In the Victory Right play, three of NU's receivers streak to the endzone, with two of them in position where the "catch" should be made. However, there was to be no catch; instead, Kunle Patrick jumped over the defenders and tipped the ball, volleyball-style, to Sam

Simmons, who was relatively unguarded. Simmons made the catch, staggered to ensure that he had possession while in the endzone, and raced off the field, spiking the ball in triumph.

The win made NU bowl eligible and increased the team's ranking to 21. The next week NU played Michigan at Ryan Field. Walker said before the game, "they'll have to kill us to beat us." He was right. In one of the greatest games ever played in Evanston, NU found itself down 51-46 with three and a half minutes left. Kustok began to drive. He unleashed a bomb to Kunle Patrick for 20 yards. Kustok then kept the ball and ran for 21 yards. On third down Kustok hit Teddy Johnson on a slant for 36 yards. On first and goal Damien Anderson brought the ball to the Michigan 6. The next two plays failed, and NU was down to its last play. On fourth and goal from the 7-yard line, Kustok threw to Teddy Johnson for an apparent touchdown. However, the officials called NU for an ineligible receiver downfield. They backed NU up to the 12-yard line for its fourth down. As the crowd hushed, Kustok found Anderson wide open in the end zone. Anderson lost the ball in the Ryan Field lights, and it dropped to the grass. With a minute and a half left, Michigan took over and needed one first down to burn enough time to win. On second down Wolverine star Anthony Thomas ran up the middle and fumbled. Raheem Covington recovered, and the fans at Ryan Field went into hysterics. Kustok, from the Michigan 30, completed passes to Anderson, Johnson, and then to Simmons for the score. 47,130 fans turned the stadium into a deafening circus. Kustok then passed to Johnson for the two-point conversion, and NU lunged ahead, 54-51. Michigan had a last-second attempt at a field goal, but the snap was bobbled, and NU won.

The 'Cats had emotionally exhausted themselves, and let down in their next game. Iowa beat NU, 27-17, denying the 'Cats a return to the Rose Bowl. NU still had a shot at a share of the Big Ten title. All the 'Cats had to do was beat their last opponent, Illinois. That they did, and in spectacular fashion. Anderson ran for four touchdowns. Kustok ran in for two himself, and he threw for another, as the Wildcats routed the Illini, 61-23, and won the Big Ten championship. The team doused Walker with Gatorade and raced to the student section to lead them in a round of "Go U Northwestern."

The Wildcats had earned their third Big Ten title in just six seasons, but—as with the previous two—a bowl win just was not meant to be. Northwestern earned an invitation to the Alamo Bowl, where they faced Nebraska, the preseason number one team in the nation, and fell, 66-17. The loss dampened NU's title celebration, but the amount the team had managed to accomplish was staggering. Northwestern's offense had been ranked the third best in the country. Damien Anderson was named an All-American and finished fifth in Heisman Trophy balloting.

When Randy Walker's name began popping up as a possible candidate for the Ohio State head coach opening, Walker crushed the rumors immediately. He might have grown up watching OSU football, but he was *Northwestern's* coach. For the first time since the season following the 1949 Rose Bowl, Northwestern was a consensus preseason favorite to win the Big Ten. The 'Cats began 2001 ranked 16th. However, on August 3, 2001, the team suffered its greatest loss, a month before the season began. During a preseason workout session, senior safety Rashidi Wheeler collapsed and later died at Evanston Hospital. In its first home game, Northwestern honored Wheeler and retired his number 30 jersey, the first retired number in the history of NU football. The players also wore a patch during 2001 with Wheeler's initials. The raw emotions from losing a teammate, and the controversy that surrounded Wheeler's death, stayed with the team throughout the season.

The 2001 season opened promisingly: NU won three of its first four games and was ranked number 16 in the country. The 'Cats had played a thriller with Michigan State. The Spartans took the lead late in the fourth quarter on a 64-yard punt return for touchdown. They had been thwarted most of the day by NU's spectacular linebacking corps, particularly Billy Silva and Kevin Bentley. Kustok led the next charge, running for 24 yards. The 'Cats found themselves with a fourth down near the MSU 20-yard line and just over a minute left. Kustok kept the ball for the first down and then unloaded to Kunle Patrick in the end zone with just 29 seconds left. NU led 24-20, and it appeared to be a final score. But the game was far from over. Northwestern

committed a personal foul after kicking the extra point and had to kick off at its own 20. The Spartans returned the kick 84 yards, reached the end zone, and went insane. Michigan State players raced from the sideline onto the field. The officials called MSU for unsportsmanlike conduct and set the Spartans' troubled kicking crew back 15 feet. The kick was not good, and Michigan State led by a narrow margin of 26-24.

Zak Kustok said after the game, "I go into every game thinking it's going to come down to me having to win the game and having the confidence in myself to do that." What Kustok did was unleash Victory Right once again. Fifty-six yards down the field Kunle Patrick tipped the ball, and Jon Schweighardt made a spectacular catch. With three seconds left, Wildcat kicker David Wasielewski kicked the 47-yard field goal to stun the Spartans, 27-26, as time expired.

NU climbed to 14th, but was brought back down the following week, when Ohio State added yet again to its mammoth winning streak against Northwestern. The Buckeyes had not lost to NU since 1971 and were steadily becoming Northwestern's most hated opponent. NU rebounded from its 38-20 loss to Ohio State by beating Minnesota, 23-17, at homecoming. NU regained a spot in the national rankings, and everything seemed to be OK. However, a heartbreaking 38-35 loss the following week to Penn State in the last minute put the team on the wrong track. So often NU had pulled off the last second stunner; now the 'Cats had been stunned. NU never fully recovered. After a close loss to Purdue, NU suffered blowout losses to Indiana and Iowa, and dropped close games to Bowling Green and Illinois. The team had started the season 4-1 and ended it 4-7.

After 2001, the Wildcats lost Kustok, Anderson, Simmons, Bentley, and linebacker Napoleon Harris. The Oakland Raiders drafted Harris in the first round of the 2002 NFL draft, NU's first first-rounder since Chris Hinton in 1983. It was clear that 2002 would be a rebuilding year for Northwestern, but few knew just how tough that rebuilding would be. The 'Cats went 3-9, winning close games against Duke, Navy and Indiana, and suffering several blowout losses. Perhaps Northwestern's best performance of the year, however, came in a tough loss to Ohio State in a night game at Ryan Field. The Buckeyes, on their way through an undefeated season and a national championship, trailed 6-0 after the first quarter. Wildcat quarterback Brett Basanez threw for 283 yards, and the NU defense harassed OSU, causing Buckeye star Maurice Clarett to fumble three times.

Fans were cautiously optimistic for 2003. The Wildcats, though still young, were returning many key starters, including Brett Basanez, running back Jason Wright, Kunle Patrick, offensive linemen Matt Ulrich and Trai Essex, defensive linemen Luis Castillo, Colby Clark and Loren Howard, and linebacker Pat Durr. The team began well, beating Kansas, 28-20, on the road. Northwestern played its home opener against Air Force, a team that had beaten NU, 52-3, in 2002. The 'Cats ran onto the Ryan Field grass wearing their new uniforms. The team had finally abandoned Barnett's black jerseys and for the first time since 1991 would wear purple. The 'Cats took a 21-7 lead into the fourth quarter, but collapsed in a hail of interceptions and fell, 22-21. The team, still reeling from the Falcon game, lost in a blowout to Miami of Ohio as Ben Roethlisberger passed for 353 yards. After beating Duke for the fourth straight time, Northwestern lost to Ohio State and Minnesota.

After dropping the Minnesota game, the 'Cats were 2-4, but reached a turning point in their next game. In a thrilling game at Indiana, Jason Wright scored four touchdowns, including one to send the game into overtime and one in overtime to win it. Bolstered by their never-quit performance in Bloomington, Northwestern returned for homecoming and hosted number 17-ranked Wisconsin. The Wildcat defense shocked the crowd and the Badgers by limiting Wisconsin's scoring to just one touchdown. Linebacker Tim McGarigle had nine tackles, and Loren Howard menaced the Badger backfield all day. Wright ran for 97 yards, and running back Noah Herron rushed for 104.

NU capped the third period by putting the game away, using a "fumblerooskie" play that Walker had successfully used against Purdue in 2001. Kicker Brian Huffman came on to kick his second field goal. Eric Batis took the snap, (accidentally) put the ball on the ground, and

then snapped the ball to Noah Herron between his legs. With Batis scrambling to his left toward the end zone and Herron standing still like he'd just thought of a really good recipe for clam dip, the Badger special teams bit hook, line, and sinker and flooded left. Herron then sprang into action and raced to the Wisconsin 3-yard line. Two plays later Wright flew past the goal, and NU won, 16-7. "You can only dust [that play] off every few years," Walker said after the game. "I'm not the most creative guy, but I'm the world's greatest plagiarist. We took it from Ball State about ten years ago."

The Wildcats lost to Purdue and Michigan and beat Penn State and Illinois, finishing the regular season 6-6. That record was good enough to earn Northwestern its fifth bowl invitation, Coach Walker's second with the Wildcats. NU lost to Bowling Green, 28-24, in the Motor City Bowl in Detroit.

The 2004 squad boasted the most powerful offensive and defensive lines that the 'Cats had fielded in years. Zach Strief, Matt Ulrich, Trevor Rees, Ike Ndukwe, and Trai Essex started on the offensive line, and Loren Howard, Barry Cofield, Luis Castillo, and Colby Clark started on defense. Although the team had lost Jason Wright to graduation, Brett Basanez, Noah Herron, Tim McGarigle, Mark Philmore, John Pickens, Marvin Ward, and many other talented veterans had returned. Coming off a bowl year, expectations were high.

The season began with one of the most thrilling, and heartbreaking, games of the Walker era. Playing at Texas Christian, the 'Cats took the game to double overtime, and NU fell, 48-45. NU's bad luck continued the following week, when Arizona won, 30-21. After edging Kansas for a win and losing big to Minnesota, the 'Cats were 1-3 and faced seventh-ranked Ohio State at Ryan Field. 2004 was the 33rd year of the Wildcats' drought against Ohio State. The series with the Buckeyes was in many ways the last vestige of Northwestern football's Dark Age. Northwestern hosted Ohio State at night, the ninth night game in the history of the stadium. The game sold out—NU's first sellout since the 2000 Michigan game. The atmosphere was right for a game for the ages, and the Wildcats delivered. In one of the most electrifying upsets in college football, NU beat the Buckeyes, 33-27, in the very first overtime game played at Ryan Field.

The Wildcat resurgence continued the next Saturday, when NU and Indiana slugged through two overtimes before the 'Cats prevailed, 31-24. After falling to Wisconsin, Northwestern beat Purdue for the first time in seven tries, 13-10, when Herron plunged into the end zone with just over 30 seconds to go. The 'Cats also beat Penn State for the first time at Beaver Stadium and set an NCAA record by playing their fourth overtime game, a 28-21 win over Illinois. November losses to Michigan and Hawaii left Northwestern with a 6-6 record. Luis Castillo became NU's second player since 2002 to be a first-round NFL draft pick when San Diego selected him in April 2005.

While the Wildcats' efforts in 2004 did not get them to a bowl game, they did help to build on something that Northwestern football has struggled to maintain—consistent success. 2004 was Walker's third season to hit the six-win mark. If Walker manages a fourth year with six or more wins, he would be the first Northwestern coach in over 100 years to do so. And he will accomplish it with a team that remains first and foremost what it has always been: a group of students that keeps the university's academic standards and earns the school's degree.

The challenge of doing so is always daunting. The risk of failure is always looming. But the rewards of success are perhaps more thrilling—certainly more entertaining—in Evanston than almost anywhere else.

Gary Barnett took over as the Wildcats' head coach on December 18, 1991. Within a month he uttered the two phrases that would forever be linked with his time at Northwestern. During the press conference announcing his hiring, Barnett promised that the team would, at all times, "expect victory." On January 11, 1992, Barnett introduced himself to the student body at a Wildcat basketball halftime presentation. Barnett suddenly said, "We're going to take the Purple to Pasadena!"

Len Williams prepares to throw against Michigan State, Halloween 1992 at Dyche Stadium. The game should have been a 29-27 win when Brian Leahy kicked a 34-yard field goal with three seconds left. The TV replays showed that the kick was good, but the officials ruled it wide, and NU fell, 26-27. Williams is Northwestern's all-time leader for passing yards, touchdowns, and completions.

Northwestern's captains, William Bennett, Sam Valenzisi, and Rob Johnson, take the field for the coin toss at Michigan Stadium, October 7, 1995. In one of the greatest games in NU history, the 'Cats beat Michigan, 19-13. Shocked Michigan fans applauded the NU players after the game. One of the Michigan fans present was former coach Bo Schembechler, the man whose team in 1975 ripped NU, 69-0. Schembechler later discussed NU's resurgence and noted, "only two coaches could have turned around the Northwestern football program. One was Vince Lombardi; the other is Gary Barnett." Barnett considered the triumph over Michigan even greater than the Notre Dame win—Michigan was, after all, a Big Ten opponent.

(left) Darnell Autry was the first Wildcat to have back-to-back seasons with over 1,000 rushing yards. Autry broke the school records for points scored and yards rushed in a season against Penn State in 1995—with two games to go in the year. The following week *Sports Illustrated* put Darnell on its cover, the first *Sports Illustrated* cover featuring Northwestern since 1963. Autry ended his NU career with 3,793 yards and 35 touchdowns.

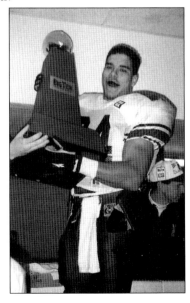

(right) Darnell Autry holds the Big Ten trophy in the Purdue locker room, November 18, 1995. Against Purdue Autry ran wild, rushing for 226 yards. Northwestern won its 10th game of the year, its eighth Big Ten game, and the Big Ten title. The NU fans in the bleachers at Purdue began chanting "Big Ten champs!" and the NU players strode over to the stands to cheer them on. The Big Ten commissioner had made the trip to West Lafayette and presented the team with the trophy after the game.

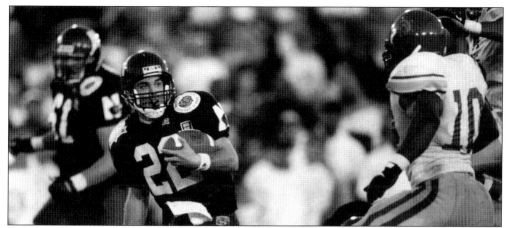

Brian Musso looks for room against USC in the 1996 Rose Bowl. NU was the underdog despite its number three ranking. A sellout crowd of 100,102 saw one of the most anticipated games in college football history. Estimates on the number of Northwestern fans in the stands ranged from 50,000 to 65,000; the game brought together the largest number of Wildcat fans ever assembled. When they entered the stadium and saw "NORTHWESTERN" painted in purple and white on the Rose Bowl grass, many fans became emotional. Among those NU fans were 30 members of the 1948 team, and former coach Bob Voigts, who had won the '49 Rose Bowl.

WHEATIES ® first featured Northwestern football in 1935, when the cereal's maker printed a photo of Coach Lynn 'Pappy' Waldorf on the back of its box. Sixty years later, WHEATIES ® again honored the school and helped celebrate the Wildcats' return to gridiron success by releasing a special box for the Big Ten champs. As with the Wildcats themselves, the WHEATIES ® box did not feature a single individual star, but paid tribute to the entire team.

The 'Cats try to block a 1996 Michigan field goal. The Wolverines were one year away from a national championship, and they were eager for revenge after being embarrassed by NU in Ann Arbor in 1995. At first it looked like Michigan would get that revenge. The Wolverines kicked two field goals in the first quarter, one in the second quarter, and scored a touchdown in the third quarter—all while completely shutting down NU's offense. NU stormed back in the fourth quarter to win, 17-16.

(left) Pat Fitzgerald terrorizes the Michigan backfield at Dyche Stadium, 1996. Fitzgerald was named national Defensive Player of the Year in 1995 and '96, the first repeat winner in the history of the award. He also became the first Wildcat to be named a first-team All-American two years straight. After the 2000 season, Randy Walker brought Fitzgerald back to NU. Fitzgerald began coaching defensive backs and eventually became linebacker coach.

(right) D'Wayne Bates hauls in a pass against Illinois at Dyche Stadium, October 26, 1996. Bates set the all-time Wildcat reception record, catching 210 passes from 1995 through 1998. He tallied 3,370 receiving yards and got 100 receiving yards in 15 games at NU. In all Bates still holds 13 Wildcat records.

Steve Schnur takes a snap in the 1997 Citrus Bowl. Tennessee had played in three of the last four Citrus Bowls, and superstar quarterback Peyton Manning was shattering school records. Just before the game many of the Wildcat players, including Darnell Autry, came down with flu. In the first quarter Manning unleashed a dizzying attack, throwing two touchdown passes and running 10 yards for another. Northwestern's second-quarter comeback was just as fierce. Autry (who remained ill and would take an IV during the game) burst in for a touchdown, Schnur fired a 20-yard touchdown to Brian Musso, and Autry ran 28 yards for another score, but NU eventually fell, 48-28.

Matt Hartl carries the ball against Oklahoma in the 1997 Pigskin Classic at Soldier Field. After the 1996 Rose Bowl Hartl was diagnosed with Hodgkins disease. He underwent chemotherapy and radiation during the '96 season, but returned to the team in 1997. He only had one fully-functioning lung and took oxygen on the sidelines when he wasn't playing. Heroically, Hartl would start for 11 of NU's 12 games in 1997. In 1998, he suffered a recurrence of the disease. The Wildcats named him a co-captain of the 1998 team, even though he could no longer play. Hartl lost his fight in 1999.

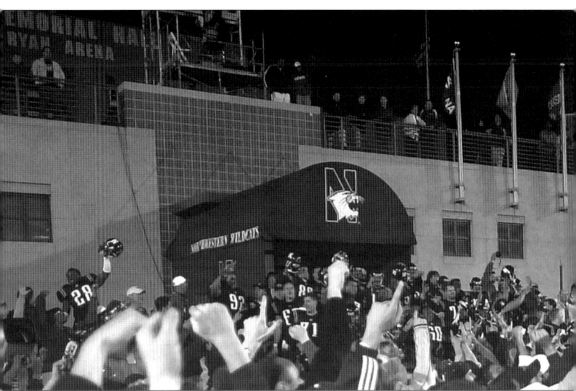

Fans celebrate the monumental win over Michigan, on November 4, 2000. The Wolverines were tied with Purdue for the Big Ten lead, and the game against NU became one of the most anticipated games of the year. ABC showed the game live, and those who tuned in saw one of the most thrilling games ever played. Ryan Field was sold out, and the atmosphere was

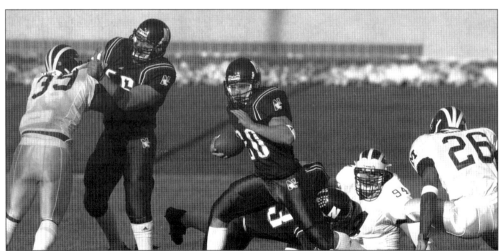

Damien Anderson runs against Michigan in 2000. On NU's first possession, Anderson tore up the middle for gains of 23 and 39 yards, and Zak Kustok brushed aside the Michigan defenders to score. The Wolverines got the ball, drove methodically and scored, and the pattern for the offense-happy game was set. Michigan scored another touchdown in the first quarter, and Anderson opened the second quarter with a touchdown.

electric. When the 'Cats won, 54-51, students and fans exploded onto the field. Northwestern had rolled up 654 yards of offense, the most ever given up by a Michigan team. The win was among the biggest in the history of Dyche Stadium / Ryan Field, and it propelled NU to a ranking of 12 in the AP Poll.

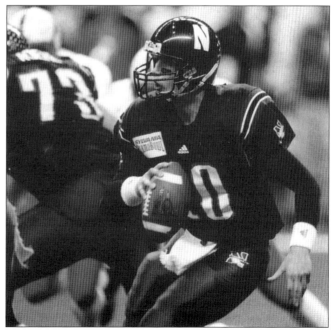

Zak Kustok leads Northwestern in the 2000 Alamo Bowl. NU got off to a good start early against Nebraska. After trailing in the first quarter, 7-3, Kustok found Teddy Johnson for a 10-yard touchdown pass, and NU led 10-7 in the second quarter. However, from there Nebraska dominated the game and cruised to a 66-17 win. For Kustok it was a disappointing way to end a season in which he set a school record for total offense, racking up 2,894 yards. In 2001, Kustok shattered his own record with a mind-blowing 3,272 yards.

Jason Wright carries the ball in the 2003 Motor City Bowl. The Wildcats led Bowling Green for the first three quarters, and Jason Wright ran wild, eventually rushing for 237 yards. But Bowling Green quarterback Josh Harris threw for 386, including a touchdown pass with just over four minutes to go that gave the Falcons a 28-24 win. Wright was named the game's co-MVP along with Harris. Wright had a tremendous season, rushing for 1,388 yards, his second-straight season over 1,000. He was NU's MVP in 2002 and 2003, the first back-to-back MVP since Ed Sutter in 1990–1991.

Running back Noah Herron storms past Penn State en route to the Wildcats' first win at Penn State, November 6, 2004. Herron rushed for 1,381 yards in 2004, the fifth-highest in NU history. Coach Randy Walker has had a 1,000-yard rusher 24 times in his 29 years coaching.

Coach Randy Walker leaves Ryan Field in triumph after NU knocked off Purdue, on October 30, 2004. It was NU's first win over the Boilermakers since the 1996 Big Ten title season. After the 2000 championship season, Walker was named the Big Ten's Coach of the Year and the Region 3 Coach of the Year by the American Football Coaches Association.

In overtime, on his 33rd carry of the game, Noah Herron (#33) scores NU's 33rd point, ending 33 years of frustration. NU finally beat Ohio State, 33-27, on October 2, 2004. As overtime began, NU's exhausted defense took the field and took the Buckeyes to fourth down, forcing them to bring in their excellent kicker, Mike Nugent. In any other game Nugent would have responded, and OSU would have taken its first lead of the game. This, however, was Northwestern's night at last. Nugent missed, and the 'Cats took over. Brett Basanez ran 21 yards to the OSU 3-yard line, setting up Herron's historic score.

125

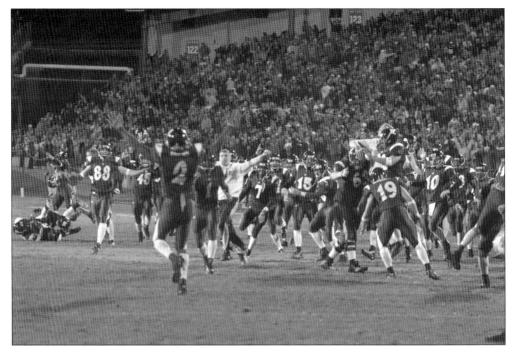

Wildcat players race onto the field following the winning score in overtime against Ohio State in 2004. The teams waged a close battle all night. Northwestern regained a ten-point lead in the fourth quarter on a 13-play march to the goal that featured huge gains by Jonathan Fields, Shaun Herbert, and Noah Herron. Ohio State cut the NU lead to seven and looked to tie the game, until cornerback Jeff Backes—an Ohio native—intercepted the Buckeyes in the end zone. Ohio State finally managed to even the score with under two minutes left, but couldn't hold on.

Players continue their celebration after the game in the Wildcat locker room.

NOTES

Introduction

1. Murphy, as quoted in the *Daily Northwestern*, May 26, 2004
2. Quoted by the Associated Press, Oct 1, 2002

Chapter One: The Methodists Fight

1. *Chicago Tribune*, Feb. 23, 1876
2. *Chicago Times*, Feb. 23, 1876
3. The *Tripod*, Feb. 24, 1876
4. The *Northwestern*, Nov. 30, 1882. The games described in The *Northwestern*'s account mark the official beginning point for NU's team. NU does not officially recognize earlier games, including the 1876 game against the Chicago Football Club, because they were not against other colleges. However, NU does have in its official record other games that are not intercollegiate (for example, games with the Chicago Wanderers, the Chicago Athletic Club and the Denver Athletic Club).
5. Walter Paulison, *The Tale of the Wildcats*, Northwestern University, 1951, p. 22
6. Arthur Wilde, *Northwestern University: A History*. The University Publishing Society, 1905, vol. 2, p. 170
7. *Chicago Tribune*, Oct 2, 1892
8. *Chicago Tribune*, Oct. 30, 1892
9. *Chicago Tribune*, Nov. 6, 1892
10. The Intercollegiate Conference of Faculty Representatives was initially nicknamed the Western Conference, and later became known as the Big Eight, the Big Nine, and—of course—the Big Ten (which did not became the conference's formal name until 1988). For simplicity's sake "Big Ten" is used throughout this book, even for periods during which the conference had less than ten teams and was called something else.
11. As of 2005 Northwestern officially only counts nine of its wins in the 1903 season, and counts its match against the Chicago Dental College as a loss. However, all contemporary accounts of this game (including the *Chicago Tribune* and the *Daily Northwestern*) indicate that it was an 18-11 Northwestern victory.
12. Northwestern Athletics Special Committee Report, quoted by Paulison, p. 132

Chapter Two: The Purple Returns and NU Rebuilds

1. *Chicago Tribune*, Nov. 25, 1916
2. *Northwestern Syllabus*, 1920 (referring to 1918 season), p. 39
3. Paulison p.134
4. Paulison p. 37
5. *Chicago Tribune*, Nov. 16, 1924

Chapter Three: The Golden Age

1. *Chicago Tribune*, Nov. 7, 1926
2. *Chicago Tribune*, Nov. 23, 1930
3. Reid later graduated from Northwestern Medical School and became a professor of surgery at the school. In 1951 he became the Wildcats' team physician, a position Dr. Reid held for over three decades.
4. For a couple of games in 1928 NU wore a new purple jersey. The purple version, however, did not have the northwestern striping. The team continued to use the white jersey with striping and a plain purple jersey until 1937, when the purple jersey for the first time also sported northwestern striping.

Chapter Four: Spread Far the Fame

1. Eddie Robinson with Richard Lapchick, *Never Before, Never Again: The Stirring Autobiography of Eddie Robinson*, Thomas Dunne Books, 1999, p. 61.
2. Steve Cameron and John Greenburg, *Pappy, the Gentle Bear*, Addax Publishing, 2000, p. 106
3. *Daily Northwestern*, Nov. 25, 1947

4. *ibid.*

Chapter Five: Transition and the Era of Ara

1. *Daily Northwestern*, Oct. 30, 1947
2. *Daily Northwestern*, Nov. 23, 1954
3. This incident was recounted by Lou Saban, in Jeff Miller's *Going Long*, McGraw-Hill, 2003, pp. 49-50.
4. Northwestern had lost other games in "one-game seasons," such as in 1886; however, 1957 was the first multi-game year that NU dropped all its contests.
5. Quoted from Bill Jauss' article, "Our 10 Best Games of the 20th Century," which Jauss wrote for Northwestern in 1999. Jauss' other picks for the best games of the century were: the 1924 "Wildcat" game against Chicago, NU's wins over Minnesota in 1930 and 1936, the 1949 Rose Bowl, NU's loss to Ohio State in 1970, the comeback win against Illinois in 1992, the mammoth win against Notre Dame in 1995, the 1995 Michigan game, and the 1996 Rose Bowl.
6. As quoted in the *Chicago Tribune*, Oct. 21, 1962
7. *Daily Northwestern* Oct. 23, 1962

Chapter Six: Agase and Big-Time Football

1. *Daily Northwestern,* Nov. 23, 1970
2. All of the College All-Star games from 1934 to 1976 were played at Soldier Field, except for 1943 and 1944. During World War II the *Tribune*, NFL, and other organizers worried about having a large, night football game played so close to downtown Chicago, so they moved the game to Dyche Stadium, figuring that the suburb setting would help security. The 1943 All-Star game was played in August, but the wooden light stands that were used for the game were still standing when Northwestern began its season on September 25 against Indiana. The school decided to take advantage of the convenient light rigging and moved the game to night.
3. *Daily Northwestern,* Nov 12, 1971
4. *Chicago Tribune*, Nov. 14, 1971
5. *Daily Northwestern*, Nov 15, 1971
6. *Daily Northwestern*, Nov. 22, 1971

Chapter Seven: The Dark Ages

1. Steve Cameron and John Greenburg, p. 103
2. *Daily Northwestern*, Sept. 21, 1973
3. Sally Pont, *Fields of Honor*, Harcourt, 2001, p. 146
4. *Daily Northwestern*, Oct. 20, 1975
5. Venturi held the record until 1972. Against Michigan State, Mitch Anderson completed a 94-yard bomb to Jim Lash, setting a record that still stands.
6. *Daily Northwestern*, Nov. 13, 1980
7. Just one year before, Willie Jeffries became the first black head coach in Division I football history, when he took the Wichita State job.
8. *Daily Northwestern*, Oct. 5, 1981
9. *Daily Northwestern*, Nov. 9, 1981
10. The previous Northwestern first-round NFL picks were Otto Graham in 1944; Vic Schwall, 1947; Ron Burton, 1960; Fate Echols, 1962; and Cas Banaszek, 1967.

Chapter Eight: Renaissance

1. Gary Barnett, *High Hopes*, Warner Books, 1996, p. 17
2. Rick Gano, Associated Press article, Oct. 9, 1995
3. Barnett, p. 17
4. The top five teams' SAT scores in 1997: 1. Stanford 1,051; 2. NU 1,037; 3. Duke 1,012; 4. Vanderbilt 974; 5. Rice 969. Other teams' rankings: 11. Purdue; 12. Notre Dame; 37. Michigan; 69. Ohio State. Source: 1997 NCAA Division I Graduation-Rates Report.
5. NCAA News, Dec. 21, 1998
6. Marshall and Barnett's comments, as reported by ESPN, Feb. 6, 1999